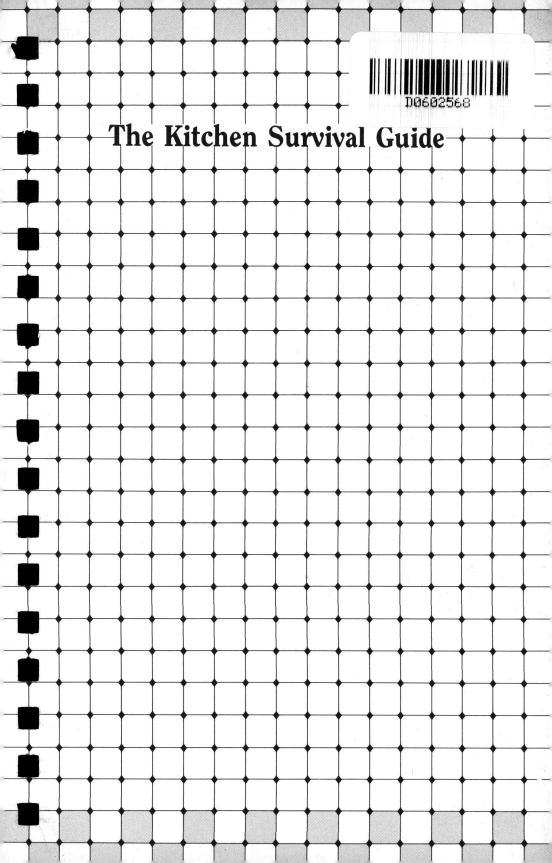

The Kitchen Survival Guide

Other books by Lora Brody

Growing Up on the Chocolate Diet: A Memoir with Recipes

Indulgences: One Cook's Quest for the Delicious Things in Life

Cooking with Memories: Recipes and Recollections

THE
KITCHEN
Survival Guide

A Hand-Holding Kitchen Primer
with 130 Recipes to
Get You Started

Lora Brody

William Morrow and Company, Inc.

New York

It is the policy of William Morrow and Company, Inc., and its
imprints and affiliates, recognizing the importance of preserving
what has been written, to print the books we publish on acid-free
paper, and we exert our best efforts to that end.

Library of Congress Cataloging-in-Publication Data

Brody, Lora, 1945–
 The kitchen survival guide / Lora Brody.
 p. cm.
 ISBN 0-688-10587-4
 1. Cookery. I. Title.
TX651.B72 1992
641.5—dc20 91-40663
 CIP

Printed in the United States of America

First Edition

3 4 5 6 7 8 9 10

BOOK DESIGN BY RICHARD ORIOLO

For Jon in Taipei, Max in Madison, and Sam in Newton.
Dad and I look forward to great meals
from your kitchens.

CONTENTS

4: Fueling the System

INTRODUCTION

Why I Wrote This Book

Several things happened recently that made me realize that I couldn't just turn my kids loose in the world and expect them to be able to feed themselves as safely, efficiently, nutritiously, and deliciously as they were fed at home.

The first thing that happened was one Sunday morning while I was making French toast, I accidentally set my potholder on fire. The fire traveled quickly to the butter in the pan, creating a great deal of smoke, a dramatic flame, and major hysteria from the crowd of hungry observers. Now, we're not talking about a major inferno here, but from the reaction of the twentysomething crowd screaming directions from behind the safety of the kitchen counter, you'd have thought this was a replay of the Chicago fire.

There were screams of "Water!" countered by admonitions of "Hit it with a dish towel!" I calmly reached to the shelf next to the stove for the large yellow box of baking soda that is kept there for this very purpose and emptied its contents on top of the pan and potholder. This immediately put out the fire.

"Guess we can't eat those now, huh?" was the disappointed reaction. My reaction was how will these kids know how to put out a kitchen fire if I don't write it down somewhere? As a matter of fact, how will they know how not to repeat my mistake of carelessly putting the potholder down too close to the burner if I don't tattoo it on their foreheads?

The second thing happened when I observed a very bright college-aged friend of mine making lunch for his younger sisters. He took out two boxes of macaroni and cheese mix and two small pots. He filled both pots with water and placed them on the stove. When the water came to a boil, he added one box of macaroni to each pot. When the macaroni was cooked, he got out two strainers and emptied one pot into each. With that, I couldn't stand it any longer and pointed out that he could have saved himself a lot of cleanup time if he had just used one large pot and one large strainer. "Hey, you can do that?" he asked incredulously. A genius in physics doesn't necessarily mean a genius in the kitchen. Someone had to spell it out.

The final thing happened shortly after my eldest son left for college, taking his appetite with him. He soon discovered that the school food service doesn't serve rare tenderloin and asparagus with lemon butter. He also realized that the thin, oversalted greasy liquid they called soup wasn't in the same solar system with the thick, flavorful, bursting-with-personality, gut-satisfying dish he got at home, and that homemade brownies from Mom's kitchen were a hands-down winner over the packaged variety.

He was a good sport for about half a semester, manfully chowing down hydrogenated peanut butter slathered on overprocessed white bread that had all the personality of advanced calculus. He winced at, but gagged down grayish mystery meat, overcooked and unidentifiable vegetables, and gelatinous rice that was cooked some time the previous month and reheated in the microwave.

Then he came home for Thanksgiving and headed straight for the fridge, blowing me a grateful kiss in thanks for stocking up on all his favorites. Ah, yes, he was so relieved to spot the jar of pea soup, the brisket sliced and ready for sandwiches, my famous caraway coleslaw, and the plate of fudge brownies. As he pulled out the Cheddar and chili meat loaf, the grainy mustard, and several slices of my whole-wheat bread, he broke the news, "Mom, that school food is killing me. Next semester the guys and I are getting an apartment so we can cook!"

So he can cook? This child, whose only relationship to the oven is the clock, is going to cook?

He learned to read, he learned to tie his shoes, he learned to play the stock market, and he learned to speak Chinese. I suppose he can learn to cook. I figured that if I wrote down everything I thought he and all the other kids like him needed to know to cook good food it would save on long-distance phone bills and kitchen fires. Here's hoping.

Why You Need
This Book
and How to Use It

Please forgive my presumptuousness. Perhaps some well-meaning but misguided person foisted this book on you and in reality you're happy as a clam getting take-out from your local Kentucky Fried Chicken or from your corner yuppie food shop that sells tortellini salad for $14 a pound.

I hope this is not you. I hope you've tried take-out or the school's food service or a steady diet of Stouffer's and Lean Cuisine and you're fed up without really being fed at all.

Okay, so you want to learn how to cook. Great. Not only will you be able to vent your creative energy, you'll have fun, you'll win friends and impress relatives, you'll save money, you'll feel better, *and* you'll get to eat delicious food whenever you want it.

I've written this book as a teaching tool. You can use it to cook even if you have trouble boiling water and after you learn how to cook you can keep it as a handy reference source.

My advice is to read Part One before you even start to think about recipes. That's where you'll find all the basic information you

need, from how to clean your oven, to how to pick out a ripe melon, to how to make dinner for someone who's a vegetarian. Cooking terms are explained in detail along with tips on how to organize and run your kitchen. Consider this the advice part of the book. The goal of the four chapters in this part is to teach you how to turn the recipes in Part Two into not only edible, but downright tasty food, in as short a time and with as little work as possible.

Spend some time thinking about how and what you feed yourself when you read Chapter 4, Fueling the System. Remember, if it's Mom's cooking that you miss, then chances are she wasn't serving you meatballs and dinosaur-shaped pasta from a can. She was thinking about nutrition and so should you.

When it does come time to peruse the recipes, don't be put off by the fact that some of them seem lengthy. These are "teaching" recipes, meaning I have left nothing to your imagination. I don't assume a new cook knows what an old-hand does, so everything is spelled out in detail.

Feel free to scribble in the margins, underline, take notes. If you love a recipe (or hate it), then write that down next to it. Did you make it for a friend who thought it was the best thing she ever tasted? Write that down, too, so you can make it for her again. Did the cookies take longer in your oven than the recipe said? Write that down. Was the chicken better baked or fried? And what was that wonderful vegetable dish you served with it? Write it all down.

Finally, once you get better at this cooking business, it will become fun. You'll feel great about your new-found talents and want to share the results with everyone you know. And, don't forget to feed your Mom.

O N E

WELCOME TO
YOUR KITCHEN

1

Setting Up and Equipping Your Kitchen

Standard Issue Appliances: How to Cope

❤

So, you dreamed of a microwave and what you got was an oven that might have come over on the *Mayflower*. Don't panic. Let's survey the scene and see how bad the damage is. Are the essentials present and functional?

Refrigerator

It should be *cold* inside. Not just a trifle chilly, but actually cold enough to keep fresh milk for at least one week. This means about 40 degrees, or as cold as possible without freezing the milk or lettuce. If in doubt buy a refrigerator thermometer (cost: less than $3 in a hardware store or supermarket). Hang it from an upper rack (where

the air tends to be warmer) and consult it if the egg salad left over from last night makes your stomach feel like the War of the Worlds.

If the temperature is above 40°F. try the obvious: Fiddle with the dials. If this doesn't do the trick, you may need more Freon blown in. The repairman may tell you it's going to be cheaper to buy a new refrigerator. If the refrigerator is located in an apartment you rent rather than one you own, a new refrigerator supplied by your landlord is definitely cheaper . . . for you. Good luck with the landlord. Make sure to approach him with a written explanation and estimate from the repairman.

Conversely, the refrigerator part of the unit should not freeze the things stored there. If this happens, try fiddling with the dial in the direction of warmer. If you don't have an automatically self-defrosting refrigerator, try defrosting the freezer (see following section called Freezer). Sometimes ice will clog up the works, making the thermostat run amok.

Your refrigerator will work more efficiently if you don't jam as much food as you possibly can into it. (This is not your gym locker.) You want to let the cold air flow over, under, and around the food. Try to remember Mom's favorite refrain, usually delivered in a soft melodic voice, *"Don't stand there with the refrigerator door open!"* Mom didn't say this to deprive you of taking your sweet time in choosing cold nourishment. She was only trying to keep the temperature down, which prolongs the eating life of food. Since you're footing the food bills these days, doesn't that make sense?

Let hot foods cool off before putting them in the refrigerator. Divide large dishes into smaller containers; add some ice cubes to hot liquids. The exceptions are highly perishable foods like fish and egg-based sauces . . . such as hollandaise, which, in all likelihood, you won't be cooking anyway and should be put in the refrigerator immediately. You won't give anyone ptomaine if you let that pot of scalding hot chicken soup sit on the counter for a half hour so that it doesn't heat up everything else in the refrigerator. A good and quick trick is to change pans: Pour the hot soup into two smaller pans pre-rinsed with cold water and add some ice cubes.

Be conscientious about cleaning out the beast. Last month's leftover meat loaf isn't doing the scenery a bit of good and, God knows, you're not going to eat it. Same goes for that container of yogurt marked April 1987.

Keep all the like foods together in a preassigned area so you'll know ahead of time that the raspberry jelly is on the top shelf on the left side near the orange marmalade. Knowing ahead of time what

foods are where means you won't even think of using the fridge as a TV and you won't hear the echo of Mom's voice . . .

Clean the inside of the refrigerator with a clean sponge soaked in a solution of warm water and a squirt or two of dishwashing liquid. Remove the drawers, shelves, and bins and scrub them in the sink in hot, soapy water. Dry them completely before replacing them. Don't forget to scrub out the inside of the door, including the egg and butter compartments.

An open box of baking soda is the first thing that goes into your clean refrigerator. It will absorb most smells. Replace the box every time you wash out the fridge. Dump the contents of the old box down your kitchen sink to rid it of any odors.

To clean that nasty, sticky, greasy dust off the top of the refrigerator, spray it with a heavy-duty all-purpose cleaner (or a mixture of one part ammonia to ten parts water), let it sit for a few minutes, and then wipe clean. Paper towels are best for this job. Spray the door and sides, if they are reachable, as well, and wipe them down.

Freezer

That small unit at the top of your refrigerator, the one filled with a frozen lava spill of smelly old ice, is a good place to keep ice cream, orange juice concentrate, and ice cubes. (If you are fortunate enough to have a frost-free freezer then skip this section. If not, keep reading.) But first you have to clean it out. Now, I'm not blaming you for this mess. I know that it was the previous tenant who left those fossilized half-eaten hot fudge sundaes and plastic packages of Lean Cuisine, but it's your mess now, baby, and if you want ice cubes, defrost you must.

There are several different techniques available to you, but first you have to turn off the refrigerator!

If you are just moving into this kitchen and haven't grocery shopped yet, then you are golden. Simply leave the turned-off refrigerator and freezer doors opened until all the ice melts. Make sure to put pans at the bottom of or underneath the freezer to catch the water.

If you have already stocked the fridge, then you are going to have to empty it and the freezer of all food. Store the food in a thermal picnic chest or wrapped in newspaper in a cardboard box. Worry only about frozen foods and items like milk. Everything else

can sit covered with several layers of newspaper in a cool place (like the sink) for an hour or so. There are two ways to tackle the freezer:

1. *The hammer and chisel method.* Very dangerous since chances are excellent that you'll miss and drive the chisel through the coil, releasing the Freon, effectively killing your refrigerator. Use the hammer and substitute a plastic ice scraper for the chisel. Use this method only to make some room to implement the second method.

2. *Trays of hot water method.* Into the small holes you've carefully dug with your hammer and ice scraper insert metal trays of very hot water. The best type of metal tray to use is an old-fashioned ice cube tray since metal conducts the heat so well. If you have a manual defrost refrigerator the odds are good that you'll have some of these old-fashioned ice cube trays. Alternatively, use a metal loaf pan or small roasting pan.

 Keep replenishing the hot water until melt-down is achieved. To really speed things up, set an electric fan on top of a stepladder (you might have to add some phone books to position the fan so that it blows directly into the freezer). The current of air at room temperature will make short work of the ice.

 Some misguided people use the *hair dryer* technique, which I don't recommend. One small drop of water into the dryer and you will never have to worry about defrosting another refrigerator again.

 After all the ice has melted, wipe down the inside of the freezer with a damp sponge.

 If you should lose electric power. Without power, a full upright or chest freezer will keep everything frozen for about two days. A well-functioning freezer on top of a refrigerator will also keep food frozen for two days, and a half-full one will keep food frozen for one day as long as *you don't keep opening the door to make sure everything's still frozen*. A refrigerator will keep food cool for about 4 to 6 hours, depending upon the kitchen temperature. Block ice can be added and will keep food on the shelves cold for longer. Make sure to remember a tray to catch drips from the ice. Dry ice can be added to the freezer unit. Touching dry ice with your bare hands will result in burns. Take care not to breathe in the fumes.

 When the power comes back on, any food that still contains ice crystals or that feels refrigerator-cold can be refrozen. Discard any thawed food that has come to room temperature and has

remained there for more than 2 hours (this does not include bread and bread-type products). Discard any food that has a strange color or odor. If it looks as if your power will be out for a long time, wrap your food in several layers of newspaper and ask a friend to store it in his or her freezer or refrigerator.

One more thing about the refrigerator: There is a space under your refrigerator analogous to a dark, damp basement where people grow mushrooms. Here dustballs grow, and they grow BIG. Every once in a while run a broom through this space—your mother will be impressed—and when you drop your cuff link or contact lens under there you won't be grossed out when you go to retrieve it.

Stove

This appliance is usually divided into two parts—the cooktop and the oven. The cooktop looks pretty straightforward, but what most new cooks ignore is that gray (or black) area under the burners where spilled food has collected. Lift up the burners, this goes for a gas stove as well as an electric one, and pull out the liner pans. If they are not encrusted with burned-on food, you're fortunate. Line the pans with foil (the heavy-duty kind, shiny side down) and go about your merry way. If you have the worst-case scenario, haul out them out and put them in the sink. Moisten with warm water and sprinkle liberally with one of the following: chlorine bleach cleanser; dishwasher detergent (not dish detergent; I mean the stuff that goes in the dishwasher, if you're lucky enough to have one); or oven cleaner. Forget about the pans for a couple of hours or overnight, then attack them with a steel-wool soap pad or a stiff scrub brush. If you have used oven cleaner, then wear rubber gloves. Make sure to cover the liner pans with foil (as above) before returning them to the stove. Try to remember how awful that job was and that the best way to avoid doing it too often is to not invite spillovers. If they do happen, wipe them up immediately before they become baked-on messes.

A dirty stove top can be made to look much better. Go after all those greasy brown stains and spots with cleanser, a sponge, and elbow grease.

Now for the inside. If you have a self-cleaning oven, go for it. If you have a self-cleaning oven and no instruction manual, look up appliance companies in the *Yellow Pages*, call the one with the biggest ad, see if it sells the brand of stove you have, and ask how to proceed.

Manual clean oven, unfortunately, does not mean that a guy named Manuel will come and clean your oven. It means you buy a can of nonaerosol oven cleaner (who wants to stick his or her head in such a tiny space after having just blasted it with IQ-lowering agents?), a pair of sturdy rubber gloves, and several steel-wool soap pads. Use a metal scraper or large screwdriver to remove as much of the baked-on food as possible; this gets easier after the oven cleaner is applied. Spray the wire racks with heavy-duty cleaner, or for really tough cases, dampen the racks, sprinkle with cleanser, and then, after about half an hour, scrub with a soap pad. Take heart, some time that day you will have a clean oven.

To keep it that way, cover a large baking sheet with foil, shiny side down (a shiny side up will confuse the thermostat in the oven). For a gas oven lay the covered baking sheet on the oven floor. For an electric oven lay the sheet on the bottom rack. *The sheet should not be so large as to block the flow of hot air in the oven.*

Make sure that the oven door closes tightly.

A note about oven temperature: Most ovens fluctuate wildly between what the dial says and what actually is going on inside. Try cooking a few dishes in your oven. If, after the designated cooking time, they are either raw or burned, assume you have a problem. You have three choices: play with the dial, in an attempt to second-guess the oven; have a repairman come and calibrate the oven; or, get a good oven thermometer—that's a mercury thermometer, not one with a little metal pointer—and adjust your dial accordingly. I favor the last choice since the first is like playing blindman's bluff with your oven and the second will cost a bundle and will cost yet again and again if your oven is old and won't hold the calibration.

While you're getting to know your stove, check out the broiler, if there is one. Some electric ovens with glass doors must have the doors open when broiling or the glass will crack. Again, you can call an appliance store for information. In most cases it is smart to keep the door open as you should be watching the dish most of time the broiling is going on: Broiling can turn into burning in a matter of seconds.

The window on the oven door can be cleaned with cleanser and a steel-wool soap pad. I strongly recommend keeping a box of baking soda next to the oven to dump on any grease fires that come your way.

Spend a few minutes cleaning out the exhaust fan over the stove. (Here's hoping you have one.) Turn off the power at the service entrance or fuse box. If possible, remove the grill and soak it in liquid

dishwashing detergent. If it doesn't come off, wipe it down with a soapy sponge. Unplug and remove the fan and motor unit and place it on newspaper or a grocery bag. You don't want to get it wet, so wipe it down with paper towels until as much grease and dirt as possible are removed. Wipe out and clean the fan opening with paper towels and replace the cleaned fan and motor unit. Replace the grill. If you have the type of exhaust fan that has filters, remove and soak them in a mild detergent solution. Dry and put back in the cleaned unit. If the filters are too disgusting, they can be replaced at a hardware store or from an appliance store that carries your brand. Bring along the old filter to assure an exact replacement.

After you've done all this, make sure there is a smoke detector in a strategic place and that the battery works. If you turn the alarm off after you burn toast, make sure to remember to always turn it back on.

Microwave

Whether you inherited Mom's old one, found one built into your kitchen, or went out and bought one, you should feel lucky. A microwave oven can be a great time-saver. If you've picked up a secondhand one, you should invest $4.00 for a microwave leak tester. The one I have has a little smiley face and a little frowning face. If the smiley face lights up when you pass it in front of the turned-on microwave, then you can nuke with impunity. If the frowning face appears, your father's pacemaker will do the mambo.

Make sure the door closes completely and securely. If you are fortunate enough to have the manual, then spend some time reading it. If not, experiment by seeing how long your microwave takes to do things like heat a cup of water (so you'll know how long to expect a cup of tea to get hot). I usually leave my microwave set on high and adjust the timer to get my desired cooking results.

The biggest danger of using a microwave is the burns you can get from the foods cooked in it. Remember, just because the dish is cool, the food can still be dangerously hot, especially when you have steamed something and are about to lift the plastic wrap off the top of the container. Always lift the edge of the wrap that is farthest away from your face. Keep your fingers out of the way of that first blast of scalding steam as well. Be very careful of hot oil, too.

Never use metal, and this includes Baggie ties, in the microwave.

And if you should see sparks flashing in the unit, stop the oven and check to see what metal got in there.

If you don't have a microwave turntable, then remember to rotate the food by hand several times during the cooking process to ensure that it will be evenly cooked. When cooking large pieces of food, use a meat thermometer to make sure the food is cooked throughout. Be sure to remove the food from the microwave, insert an instant-read thermometer into the thickest part, and remove the thermometer before putting the food back into the microwave for additional cooking. Remember, metal cannot go into the microwave.

Wipe off spills immediately with a damp sponge or wet paper towel. Don't be tempted to use a metal scraper to remove encrusted food in a microwave, as you can seriously damage the unit.

To rid the microwave of unpleasant odors, wipe the interior down with a solution of 4 tablespoons baking soda to 1 quart warm water. Don't ever use a commercial oven cleaner in a microwave. If you have a removable glass tray, keep it free of grease and crumbs and rinse it with soapy water every once in a while.

Sink

If you have a dull, scratched stainless-steel sink, rub it gently with very fine steel wool, then buff with a soft cloth. If you have a stained porcelain sink, moisten the stain with water and sprinkle it with an abrasive cleanser. Let the cleanser remain for a couple of hours; the stain should bleach out. You can also try filling the sink with hot water and adding a cup of bleach. Leave this overnight if possible. If you have a very old, cracked, and stained porcelain sink, avoid chlorine bleach; it will make the stains worse. Try lemon juice instead.

To get rid of smells in the drain, dump in half a box of baking soda and wait a few minutes before flushing the drain out with water.

Dripping faucets are annoying and waste water. Check to see if the washer needs replacing. If it's a washerless faucet, trot off to your local hardware store with the brand of faucet and someone there will sell you new innards to make the drip stop.

Never pour fat down the drain. Things like bacon grease, fat from the top of soups, and frying oil should be kept in a covered coffee can that gets stored under the sink and when full is tossed away. No need to stockpile these.

If the drain is clogged, don't immediately reach for a can of potent drain cleaner. That is an easy way to remove your skin as you

clean your drain. Instead, remove the stopper or strainer. Clean out any material stuck in the top of the drain or in the stopper. Fill the sink about half full. Place a plunger over the drain and rapidly pump it up and down about 10 times, abruptly lifting it out of the water on the last stroke. If the water goes down, then the drain is unclogged. If not, repeat the operation until either it works or you are totally exhausted and frustrated. If you are in the latter condition, you're going to have to have a look at the trap—the curved bit of pipe under the sink.

Clear out all the stuff from the under the sink in the cabinet (if there is one). Place a bucket under the trap. Use a wrench to unscrew the plug of the trap and let the water in the pipe pour into the pail. If there is no plug, then remove the trap itself by unscrewing the two coupling nuts, beginning with the higher one. (Remember to set all the parts aside in a safe place.) Clear the stoppage by hand or with a bent coat hanger. Replace the trap.

If you are still plugged, you will need a snake. This twistable bit of wire, available at a hardware store for about $7, is also good for unclogging toilets. Place the end of the snake in the drain and, twisting it clockwise, push it into and pull it out of the drain until you reach the obstruction. Clear it. If all this fails, I'm afraid it's time to call the plumber. Please see the advice about choosing plumbers in the following section.

Garbage Disposal

If you are lucky enough to have one, be very careful not to abuse it with hard indigestible items like olive pits and celery stalks (the strings get wrapped around the blades and gum up the works) and beef bones. Don't ask it to chew more than a few mouthfuls at a time; cut garbage like cantaloupe rind into digestible pieces; and make sure to run the water when you run the disposal. If the unit gets jammed, first feel around it inside (I'm sure I don't have to remind you *never* to stick your hand into a moving disposal) to try to figure out what the culprit is. See if you can wiggle it loose. Next, look under the sink to see if there is a reverse switch. If not, try moving the blades with a long-handled screwdriver or broom handle. The final resort is to call a plumber. He's someone who made his first million without an MBA. Try to find one who isn't into heavy gold chains or polo ponies. The best way to find a good plumber is to ask around and get one from a personal recommendation. It helps to sound desperate and extremely solvent when you phone.

Dishwasher

Boy, you really are lucky. Be conscientious about removing detritus from the bottom of the dishwasher. Broken glass, grapefruit seeds, fossilized peas, and stray pieces of silverware can spell an early demise to the unit. Take care to keep the holes in the revolving arms unclogged as well so that water can flow through. Never, never use liquid dish detergent in place of dishwasher soap. Your machine will start foaming at the mouth and give your kitchen floor a bubble bath. You can save electricity and, therefore, money by turning off the machine midway through the drying cycle, opening the door, and letting the dishes air dry. (This only works if you have been really careful about putting all the dishes in upside down so that they don't collect dirty dishwater.)

Pay attention to where you place fragile things like a wine glass, since it can be easily chipped when the pressure of the water hits a heavier object next to it and smacks into the glass. If this happens, don't just stick your hand down blindly into the drain in the bottom to fish out the shards. Use a wet paper towel wrapped around the end of a screwdriver or tongs to fish out the pieces. And while you are down there, remove those errant grapefruit seeds and pieces of old labels that have accumulated.

Work Space

Refrigerator, stove, and sink are the main arenas of cooking. The adjunct arenas are counters, cabinets, and/or pantry. Scrub down the counters with cleanser and a soap pad, then go them over with a damp sponge. If your counter is your work space (as opposed to an island or table), try to keep it free of all nonessentials. I keep a toaster, coffeepot, knife rack, and blender on my counter. This is not the place for spices, napkins, or the stray bottle of soy sauce. The less clutter, the easier to clean and keep clean.

Use the brush attachment of a vacuum cleaner on all the cabinet shelves and any drawers, then wipe them down with a damp sponge. I think lining shelves is a silly waste of time, but if you're into Contac paper, go for it.

Lighting

Both natural and artificial lighting can make a kitchen a nicer, more welcoming, environment. Remove the glass globe from the overhead,

if there is one, and give it a good scrubbing. Replace the old light bulb with a brighter one. Replace any flickering, dying florescent bulbs. Wash the windows and wash, replace, or simply remove the curtains. Let as much sunshine in as possible.

Ventilation

Consider the ventilation. That odor of sautéed onions may be mouth-watering tonight, but tomorrow morning it will put a damper on your coffee. Open the kitchen windows when cooking pungent foods and even think about placing a fan in the window so that the kitchen air is drawn out. If your kitchen has an outside door, leave that opened when cooking as well. Remember to turn on the exhaust fan if there is one connected to your oven.

General Organization:
A Battle Plan

When planning where things will be stored in your kitchen (including in the refrigerator), divide the items up into three categories: Things you will use every day, like coffee, salt, butter, napkins, plastic wrap, and bread; things you use often but not every day: peanut butter, catsup, mayonnaise, crackers, and matches; things you will use only once in a while: vinegar, honey, ground nutmeg, pina colada mix, and anchovy paste. By the way, this is an example of *my* personal use list. Your list will be different. Put the every day items right in the front of the fridge, on the closest cabinet shelves, in the most accessible drawers. Place the often-used items behind them and the least-used items in the taller cabinets (the ones you might need the step stool to reach) or in the very bottom drawers.

Think of setting up your kitchen in the same spirit you might have set up your office or arranged your bedroom, with your convenience and comfort at the very top of the list.

Place your knives in a knife rack (not in a drawer where they will rub against each other and become dull and be a potential source of emergency room visits) near your work space where they will be within easy reach. While we're on the subject of knives, never leave them in the sink and don't put them in the dishwasher. This dulls them, causes them to rust, loosens the wooden handles, and makes

the unloading process downright dangerous. Always wash and dry knives right after you use them and put them away, either in a knife rack or on a magnetized strip screwed to the wall. Cut only on wood or one of those wonderful white plastic (polyethylene) cutting boards. Cutting on metal, marble, or glass wrecks knives; in other words, don't be tempted to carve the roast on the china serving platter.

If you have carbon-steel knives—the ones that lose their shine and get rusty if you don't dry them immediately—you can sharpen them with a gadget called a steel. You can brighten carbon-steel knives up with cleanser and a soap pad or a combination of lemon juice and salt. Buy a steel in a kitchen supply store or hardware store and ask the clerk to show you how to use it.

Stainless-steel knives are almost impossible to sharpen at home. However, they do hold an edge longer. If you use your knives a lot, do yourself the favor of having them sharpened professionally twice a year. You can find knife sharpeners listed in the *Yellow Pages*, or ask your butcher where he or she gets knives sharpened.

I also use those inexpensive plastic-handled paring knives and then throw them out when they get dull. Don't ever mistake a knife for any of the following things: a can opener, a screwdriver, scissors, paper cutter, an oyster shucker, a paint scraper, or a chisel.

Keep vegetable peelers and other like gadgets (the garlic press, corkscrew, timer) near your work space as well. This area should be close to the sink, which should, unless Stretch Armstrong designed your kitchen, not be too far from your stove.

Those new polyethylene cutting boards are a marvel. The one I use is 8 by 16 inches. It is a large enough work space but still fits in the sink or dishwasher when it needs a good scrubbing. Should you need to rid your cutting board of the odor of chopped garlic or onion, scrub it with baking soda.

I mentioned a step stool earlier. Even better is a small, sturdy folding ladder that you can tuck away next to the refrigerator or in a broom closet. If you make it easy to climb up high, then you can utilize all your kitchen space.

Here's a list of things to store under the sink:

- steel wool
- soap pads
- extra sponges (you'll want a sink sponge and a separate floor sponge)
- empty coffee cans (for grease, which should not go down the drain)
- extra box of baking soda
- assorted cleaners and polishes

- dish rack (unless you keep it out all the time, in which case you'll want it right next to the sink)
- detergents (liquid and dishwasher if you have a dishwasher)
- rubber gloves
- garbage bags
- plastic trash receptacle lined with a garbage bag
- cleanser
- scrub brush

In the interest of keeping your counter free of clutter, mount a paper towel rack on the inside door.

A list of what not to keep under the sink:

- 150 plastic containers without matching lids
- your collection of brown paper grocery bags (these are havens for cockroaches)
- poisons of any sort—ant traps, insect sprays, and so on (even if you don't own a puppy or have a baby, someone else might bring one to your house one day)
- anything that isn't directly related to washing the dishes or cleaning up the kitchen, like that 20-pound sack of charcoal briquettes

I think you get the idea.

Gearing Up: Equipment You Can and Can't Live Without
▼

Years of cooking have taught me a few things: No one but Mom notices that the dishwasher needs to be emptied; chocolate pudding usually burns onto the bottom of the pan; and no matter how much kitchen equipment and how many gadgets you own, you basically use the same things over and over. Everything else collects dust.

Each equipment category is divided into three lists. The first list is called "Essentials." Consider these things the bare bones—the stuff you really need. This is followed by a list of nonessential but very handy items. I call this list "Sweeteners" because while you can function without these items, they will make life a little sweeter. Finally, in the event you have a huge apartment, a roommate who loves to wash up, or an unlimited budget, I've included a "Wish List" for some of these categories.

Dishes and Glassware

Since you are planning to cook, in addition to needing something to eat off of, you will need something to serve from. Eclectic is in and mix and match is au courant. You'll save money if you don't feel obliged to collect matching sets of things. Start by seeing what Mom might be willing to give away, then check out what's on sale in department stores and what looks good at tag and yard sales. Another great source for dishes is "seconds" shops, which sell imperfect items. Just make sure that you examine each item for cracks or other serious flaws.

Six of each item is a good number. If you plan to feed more people, borrowing from a neighbor is perfectly acceptable. Just remember to return the dishes with something good to eat tucked inside.

Essentials

- dinner plates, 10 to 12 inches in diameter
- salad/dessert plates, 8 inches in diameter
- bowls for cereal, soup, pasta, and ice cream
- mugs for coffee/tea and soup
- glasses for water, juice, and soda

Sweeteners

- coffee cups and saucers
- bread-and-butter plates (smaller than salad plates)
- wineglasses
- 1 creamer and 1 sugar bowl
- 1 water pitcher
- 2 serving platters
- 1 salad bowl

Utensils

Essentials

- dinner forks
- salad forks
- teaspoons
- soup spoons
- knives
- 1 large serving fork
- 1 large serving spoon
- salt and pepper shakers
- large carving or chef's knife (see page 19)

22

Sweeteners

- additional serving pieces including: extra serving fork (large carving fork), extra serving spoon, ladle, slotted spoon, wedged-shaped pie server
- chopsticks
- steak knives

Wish List

- tongs
- small butter knives

Tableware

Essentials

- tablecloth (one that is definitely wipeable, a good-quality felt-backed plastic one, for example)
- napkins, paper or cloth (as long as they also are washable)
- serving dishes or bowls; large soufflé or other ovenproof dishes are good for this
- place mats, washable or wipeable
- hot plates, made of cork or wood, to protect the surface of your table; these are also called trivets

Sweeteners

- serving/clearing tray
- cake plate
- frameproof lidded casseroles
- salad bowl and salad servers
- extra place mats and another tablecloth
- teapot

Wish List

- electric warming tray
- punch bowl and ladle
- napkin rings
- vase for flowers
- candlesticks
- ice bucket
- carafe

Pots and Pans

Okay. You've got the table set. Next we'll stock up your kitchen with some equipment. Always buy the best you can afford. I don't mean you have to buy $100 pots, but keep in mind the heavier the pot and the stronger the knife and the more durable the cookie sheet, the longer each will last. The better the pot or pan, the better your chances will be of not burning whatever it is you are cooking in it. When I got married I blew $40 at Sears on a matching set of yellow plastic-handled utensils. Within a month I had melted each handle into a misshapen glob.

Take the list that follows to a reputable kitchen supply shop or department store and get a salesperson who is knowledgeable about the equipment to help you.

Steer clear of aluminum cookware. It discolors when it interacts with acids such as tomato and lemon and, as it does, it changes the taste of the food. It's also very lightweight, which means food cooked in it burns much more easily. Stainless steel is more expensive but worth it. I am still using the Revere Ware I got for a wedding present almost twenty-five years ago.

If you are willing to put the effort into taking care of cast-iron pots and pans, then go for them. You must make sure to scrub them carefully with a stiff brush and dry them by setting the pans over hot burners until all the moisture evaporates. Otherwise they will rust. They are extremely heavy and may be hard to lift when full, but the iron added to your diet from using them should make you strong enough to elevate an elephant. You can remove rust by scrubbing with a steel-wool soap pad, then dry as instructed above.

The new space-age materials are good for some things. I recommend Teflon- or SilverStone-coated frying pans as long as you are careful to use only wooden or plastic utensils when cooking (they won't scratch the surface) or be willing to replace the pans when all the surfaces are shot. Don't be tempted to use rubber scrapers; they'll fray immediately, and finally melt. I have a $20 nonstick omelet pan that I couldn't live without. Not only can I make great omelets in it—they never stick—it's also great for nonfat cooking as well as sautéing.

A note about pot covers: It looks great to have a matching set of covers for your pots, but the lack thereof does not render said pots useless. You can save a lot of money if you buy one large and one medium *flat* pot cover and use them on all your pots. The lids don't have to fit snugly, except when you make rice—more on that later.

An overnight soaking in a solution of household bleach will rid a kitchen sponge of odors and food stains. You can also run sponges through the dishwasher on the upper rack.

Essentials

- a large slope-sided frying pan, 10 to 12 inches in diameter
- a medium slope-sided frying pan 7 to 8 inches in diameter (get a Teflon-coated version that can double as an omelet pan)
- a 1-quart saucepan (I use a nonstick one; it's great for cooking hot cereal, boiling an egg, and heating up a can of soup)
- a 2- or 3-quart saucepan
- a large kettle or soup pot with a lid (besides making soup in this pot you might want to boil a lobster in it, cook pasta, or mix up a big salad for a party)

Sweeteners

- an electric frying pan, thereby adding another burner to your stove
- wok (usable on both gas and electric stoves)
- a collapsible metal steamer (a convenient but not essential way to make nice, crisp vegetables)
- a double boiler (for keeping things warm without overcooking them)
- nonstick skillet (for making pancakes, French toast, and grilled cheese sandwiches)

Wish List

- 1½-quart saucepan
- tops for all the pots heavy deep straight-sided skillet, 3 inches deep
- fondue pot
- slow cooker
- pressure cooker
- omelet pan
- microwaveable dishes, if you have a unit (these should be freezer-to-oven-to-table types that can also be used to serve food cooked in a conventional way)

A note on how to clean and care for your pans: As I mentioned, when cooking with nonstick coated pans, use utensils made of wood (or plastic). Wash the pans with hot, soapy water. Do not use steel

wool, cleanser, or other abrasives to clean the surface of the pans. If something is really burned on, boil water in the pan until the food comes off. These pans can go in the dishwasher.

To clean stainless-steel pans, use hot soapy water. For burned-on food, wet the burned area and sprinkle with cleanser. Let sit for a while and then scrub. Or, try the boiling-water method, but add some cleanser or dishwasher detergent to the water. For really difficult stains you might have to repeat this several times.

No matter what, don't be tempted to ignore burned-on food. What will happen is that soap and more food will be attracted to this uneven surface and the result will be an even more unpleasant mess. The best approach is to avoid burns by keeping a careful eye on the things you are cooking, stirring often, making sure there is enough liquid in the pan, regulating the heat, using the right pan for the job, and not overcooking.

General Cooking Equipment and Gadgets

Essentials

- 2 mixing bowls, either glass or metal—one 4-cup, another 8-cup. These can also be used as serving bowls. If you have a microwave, buy glass bowls that you can use in it as well.
- metal or plastic measuring cups—1-cup, ½-cup, ⅓-cup, ¼-cup capacity
- 2-cup glass measuring cup for liquid
- measuring spoons—a tablespoon, teaspoon, half-teaspoon
- timer
- 6-cup loaf pan, for bread and meat loaf
- 8-inch medium mesh strainer (use as a sifter as well)
- 9-inch round cake pan or 9-inch square pan (the latter either glass or metal)
- cookie sheet (make sure to get a heavy-duty one since the cheap kind will warp in the oven)
- canister set for sugar and flour
- assorted wooden or heavy plastic spoons (regular and slotted)
- 2 rubber spatulas (1 large and 1 small). Do not use these to stir while cooking. The rubber will disintegrate.

- metal, wooden, or plastic "pancake" turner (otherwise known as spatula, but not to be confused with the above item to which it has absolutely no resemblance)
- large ladle
- tongs (will render spaghetti serveable)
- knives (see page 19): 1 paring knife, 1 serrated knife (should be long enough to slice a large loaf of bread), 1 long (8- to 10-inch) chef's knife
- knife rack or holder
- knife sharpener (needn't be an elaborate affair, see page 19)
- kitchen scissors (so you won't be tempted to use your knives for anything inappropriate)
- large roasting pan, at least 3 inches deep
- strainer or colander
- potholders
- rotary-type egg beater
- polyethylene cutting board
- dish drying rack and drain board
- vegetable peeler (if you are left-handed, make sure you get one that will work for you)
- can opener (both rotary and church key)
- meat thermometer
- oven thermometer
- assorted plastic storage containers with tight-fitting lids (save empty peanut butter jars—both plastic and glass; they make great storage containers)

Sweeteners

- extra mixing bowls
- 10-inch springform pan
- 10-inch tube pan with removable bottom
- soufflé dishes (not just for making soufflés, but for baking and serving most hot dishes and casseroles)
- refrigerator thermometer
- wire cooling rack (for cakes and breads)
- cake tester
- wire whisk
- potato masher
- 13 × 11-inch Pyrex baking pan

- grater
- flour sifter
- manual citrus juicer
- rolling pin
- teakettle
- corkscrew
- pepper grinder

Wish List

- kitchen scale
- instant-read thermometer
- lemon zester
- garlic press
- heavy-duty jelly-roll pan, 17 by 11 inches
- set of Corning Ware (or other comparable cookware) for cooking, freezing, and serving
- clam knife
- electric teakettle (especially good if you have a limited number of burners on your stove)
- salad spinner
- electric can opener

Small Appliances

While you can survive without most of these things, they certainly make life easier. The only essential in my book is a *coffee maker*. There are perfectly wonderful nonelectric coffee makers. There is the Melitta, in which coffee grounds are placed in a funnel-shaped paper filter that sits in the neck of a heatproof but not flameproof glass carafe. Boiling water is poured slowly over the coffee grounds and the coffee drips into the carafe. The carafe cannot sit directly on the burner so you have to use a hot plate, or place the carafe in a pan of gently simmering water to keep the coffee hot.

If your budget will allow for one and you don't mind a production, you might consider a Mellior. Here, coffee is placed in the bottom of a glass container, boiling water is poured over it, and then a plunger is pressed down to filter out the grounds. These machines don't come cheap and they don't make a lot of coffee. Your friends who took their junior years in Paris will all tend to have one.

Percolators are electric coffee makers that heat water and then force it up to drip through grounds that sit in a metal basket inside

the top of the pot. Percolators of 4-, 6-, and 12-cup capacities are available.

The other choice is an automatic drip coffee maker—sort of an all-in-one affair into which you place water and coffee, then press a switch. The water drips through the grounds into a pot, and a heat unit under the pot keeps the brewed coffee hot until you are ready to serve it. All and all, initial investment aside, this is a fairly inexpensive way to make good coffee.

While I'm on the subject, when buying already ground coffee make sure you get the right grind for the machine you are using. Keep the grounds (or whole beans) in a airtight plastic bag in the freezer. This will keep them fresh for months. Use a tablespoon or coffee scoop when measuring out the grounds—1 rounded spoonful for each cup of coffee (throw in an extra spoonful or two if you like stronger coffee)—and use only cold water to make coffee. Hot water confuses the machine's thermostat.

Brewed coffee doesn't keep well, so don't make it and hold it over heat for more than one hour. Reheated coffee tastes terrible; it's better to brew a fresh pot then drink reheated coffee.

The only other essential you might consider is a toaster or toaster oven. A toaster oven lets you bake, broil, as well as toast small quantities of food, enough for one or two people.

Sweeteners

- blender
- hand-held mixer

Wish List

- food processor
- corn popper
- coffee grinder
- electric mixer

Tool Drawer

Every well-stocked home needs a tool drawer. Since my tool drawer is in my kitchen, I regard the following as essential:

- hammer
- assorted nails
- thumbtacks
- tape—Scotch, masking, and electrical
- glue—Elmer's type or rubber cement and super
- stain remover

> **I**f you accidentally burn food onto the inside of a saucepan, fill the pan with water to cover the scorch, then add ¼ cup baking soda. Bring the mixture to a low boil and continue boiling until the burned food lifts off.

- screwdrivers—Phillips and regular
- pliers and wire cutters
- tape measure
- string or twine
- extra fuses and batteries
- flashlight
- adjustable wrench
- plunger (I don't keep this in the kitchen drawer, but I'll bet someday you'll thank me for suggesting that you get one)

Rules of the Kitchen

You have to have the right attitude about these rules. If you see them as an extension of your mother's nagging, then you won't appreciate that they are here to make your life consummately more manageable. Even though they may smack of Mama's maxims, try to think of them as things you might have figured out for yourself if you had more time. I'm just helping you out by writing them down.

1. *Everything has its place.* This means the egg beater always resides in the second drawer from the left of the sink, and the three metals bowls nest together inside the cabinet next to the refrigerator. This rule will expedite cleanup after you cook. It means if from your sickbed you ask your friend to bring you a cup of tea and three Oreos you can direct him with impunity to the tea bags (right next to the instant coffee on the shelf to the right of the sink), and the Oreos (in the blue cookie jar on the counter near the toaster).

2. *Put stuff away.* The counter top is an easy catch-all for all kinds of nonessentials from the one extra battery left over from the four-

pack to that can of chicken soup you probably will have for dinner the day after tomorrow so why put it away today. Stuff (as comedian George Carlin is so fond of pointing out) is like a disease that collects innocently at first and then becomes a raging out-of-control nightmare. *Don't let this happen to you!* Put the stuff away.

"Put stuff away" also applies to food. Things that are not canned, boxed, bagged, or bottled usually (with the exceptions of some fruits) need to be refrigerated or frozen. Don't leave uncooked meat or fish unrefrigerated. Refrigerate cooked foods and dairy products as quickly as possible as well. Obviously there are some exceptions. When a recipe calls for softened butter, it's okay to leave a stick of butter on the counter for several hours if your kitchen is cool.

3. *Keep it clean.* It's infinitely more pleasant to work in a clean space. Aside from the aesthetics, there is the health concern. Food poisoning is no joke. At best, it can make you and the people you've fed horribly sick; at worst, it can kill you. When utensils, work spaces, and storage areas are clean (and I mean really clean), then the chances of food poisoning are considerably reduced. Before you start to cook, wash your hands thoroughly with soap and hot water. Dry them with paper towels or on a clean dish towel.

Speaking of dish towels—bacteria can live very happily in kitchen dish towels, dishcloths, sponges, and dirty potholders. Wash them often. Sponges can go in the dishwasher on the top rack. Replace sponges every month or so.

Don't use a knife to cut up chicken or fish and then use it to cut other food without washing it first in hot water with soap. And don't reuse the same bowls for food preparation and serving until you scrub them out first.

To wash dishes, clear the space on both sides of the sink and empty the sink. On one side place the things to be washed (if you have a dishwasher, use the opposite side since clean things will go above the dishwasher). Before you place the dirty dishes, pots, and so on near the sink, scrape all the scraps into either a plastic-lined garbage pail or into the disposal—watch out for bones and olive pits! If you have eaten food that tends to stick onto plates (like eggs), it's a good idea to get some water on them as soon as possible.

If you have used a good-sized pot for making part of the dinner, place it in the sink and add a healthy squirt of dishwashing

detergent. Fill the pot with *hot* water. Hot water starts the detergent up, which removes the grease. Hot water is what also rinses dishes completely free of soap. I use water so hot that I have to wear gloves. Trust me, it will make the cleanup faster and more efficient. The only exception to using hot water all the time is when washing flour off dishes. Hot water will activate the protein in the flour and make a gooey intractable mess. Use cold water for this job. When the last traces of the flour are gone, rinse with hot water. Dump all the silverware and cooking utensils, *except sharp knives*, into the pot to soak for a while. If the pot takes up the whole sink, put it on the counter. Sprinkle cleanser on any burned-on food in other pots or pans, add a little water, and let soak while you do the dishes.

The trick is to leave the sink empty of everything but the group of dishes you are washing at one time. This will prevent breakage and give you space to work. Start with the largest plates. Place them in the sink, rinsing each with hot water as you do so. Use a sponge or scrub brush to wipe off the food. Rinse with hot water and place the clean dishes on a dish drain. For stubborn spots use a special scrubbing sponge with a heavy-duty plastic pad. Move on to the smaller plates and bowls.

Tackle the glasses next. Don't spare the soap and hot water. Place the glasses on the dish drain, too. Next comes the silverware. Empty the soaking pot into the sink. Scrub each piece and rinse well.

By now you may be getting tight for space on the dish drain. If you don't want to take the time to dry anything at this point, place a clean bath towel on the counter or table, wash the serving dishes, pots, and pans and place them upside down on the towel to dry. Remember, don't ignore burned-on stains and bits of food, or they will never come off and will end up making your equipment look old and scruffy. Even if those pot lids don't look dirty, but you have used them to cover pots of cooking food, they need to be washed as well.

Empty the sink, clean the food trap covering the drain, scrub down the sink with some cleanser, and rinse it out. Wipe down the sink with a damp paper towel and hang onto it for wiping down the counter.

Dry all the dishes and put them away. Ditto with the other things. Wipe down the counter. Put away the bottle of dish detergent, hang the dish towel up to dry (unless it's gotten a lot of use, in which case throw it in the wash). Turn out the kitchen lights

and begin to understand why your mother went nuts when she saw you and forty of your closest friends heading toward the kitchen just after she finished cleaning up.

If you have a dishwasher, see page 18.

4. *One job at a time.* Until you are a really experienced cook, stick to one task at a time. Don't be yakking on the phone or running on the treadmill between quick peeks in the pot. Tackle one dish (this doesn't count washing the lettuce and putting together a salad and dressing while your goose is cooking). Good cooking deserves all your concentration.

5. *Read the entire recipe before you start.* Assemble all the ingredients called for. This way you won't be halfway through a recipe to realize that you don't have chocolate chips to put in the batter for chocolate chip cookies. And, if you don't understand a cooking term, you'll know enough to look it up before you have to execute it. And *follow directions:* You may think I'm being picky when I say "mix" in the recipes that follow and you feel like beating. If you beat that muffin batter instead of gently mixing it, then you will be able to use those muffins for batting practice because you will have overexercised the gluten (protein) in the flour and made them tough instead of tender.

6. *Have a healthy respect for heat and other things that can hurt you.* Fire makes food warm, chewable, and inviting. It can also cause serious and terribly painful injury. Make it a habit to turn all pot and pan handles away from the front of the stove so they won't catch on your clothing, tip over, and scald you. This also prevents them from becoming attractive targets for curious little hands. Never cook over an open flame with long hair hanging down around your face. Hair is horribly flammable—you don't have to have you hair *in* the fire to ignite it. Keep the stove and oven area free of flammables: Those curtains may look charming but they are easy fuel for a stove fire. Don't cook in flowing sleeves, especially bathrobes or nightgowns. Remember that if you do accidentally set yourself on fire try to keep your wits. Don't run. Wrap your arms around you, curl into a ball, and drop and roll onto the kitchen floor.

If you have a grease fire in the oven, throw in the contents of a box of baking soda—the one you're supposed to keep next to the stove for just such emergencies—and immediately close the oven door. If you have an electric oven and can pull out the plug

or throw the circuit breaker, then do that. If you have a fire in a pan, throw in the baking soda and put a cover on the pan. If you don't have a cover, grab a cookie sheet: Your aim is to deprive the fire of oxygen. *No matter what, do not use water* and don't be tempted to carry the pan to the sink. You will only burn yourself. If you have a fire in the microwave, turn off the unit, unplug it or pull the circuit breaker, and keep the door closed until the fire is extinguished.

The second you feel that a fire is out of your control is the time to call the fire department. After you place the call, round up everyone in the house and leave.

First aid for minor burns is cold water. A minor burn is one that is raised and red and sore. Any burn that has blistered or blackened needs immediate medical attention. The sting of minor burns can be alleviated by placing the affected area under cool running water, or by applying an ice pack.

Make sure there is a *working* smoke detector nearby installed according to the manufacturer's instructions. Check to make sure the batteries are working. Have the telephone number of the fire department posted on a card in the kitchen. On that card should be the police number as well as poison control.

While I'm on the grim subject of injury, remember to maintain a healthy respect for your knives. Sharp knives are efficient tools that can also render nasty, painful cuts. Mind your fingers while you are chopping. If you are slicing an onion and your eyes are filled with tears, it's not easy to watch that knife blade. Take the time to clear your eyes before proceeding. Don't use your onion-stained fingers to do this as they will only make matters worse.

If you insist on using a cleaver, make sure the hand that is holding the food is as far away as possible from the cutting edge of the knife and that your fingers on that hand are curled under.

Speaking of eyes: A common injury to eyes comes in the seemingly benign form of a champagne bottle. Never, never open a bottle of champagne with the cork pointed at you or any other person. The force of the gas can put someone's eye out. After you loosen the foil and wire, cover the top of the bottle with a dish towel, and with one hand gather the edges of it tightly around the neck of the bottle. Point the bottle up, toward an unpeopled corner of the room, and slowly twist the bottom of the bottle with your other hand until the cork comes loose. I know I don't have to tell you not to shake the bottle at any time.

Use common sense when using electric appliances. Replace frayed cords, and never pull a plug from a wall by the cord itself, but always by the plug. Water and electricity are a potentially deadly combination. Keep them far apart.

7. *Clean up as you go along.* When you start a kitchen job—let's use making mashed potatoes as an example—do the job to completion. Then wash the utensils used to do this job before starting the next. Before beginning to make something, read the entire recipe to make sure you have all the ingredients on hand. To make mashed potatoes you'll need to boil water. Get out the pot and fill it with water. If you have an electric stove, you might want to turn the burner on so it can heat up while you wait for the water to run hot from the tap. Make sure to use a burner that is as large or slightly larger than the bottom of the pan. Select a pan that will hold all the potatoes and lots of water without boiling up over the stove. Place the pan of hot water on the stove (handle pointing toward the back of the stove), add a teaspoon of salt, and cover the pan.

Get out a cutting board, a peeler, and a sharp knife—one long enough to slice through the potatoes. Scrub the potatoes well to remove all the dirt and pesticides. Even though you are peeling the potatoes, it makes for a much neater job to get the dirt off first. Peel off all the skin, dropping the peels into the sink if you have a disposal, or into the garbage pail. Look around for peel that missed the pail. Use the round end of the peeler to dig out eyes, spots, and stray pieces of peel. Wash the potatoes under cold water and cut them into chunks. Carefully place the chunks in the boiling water, taking care not to splash yourself, lower the heat so that the water bubbles gently, and set the timer for 20 minutes. Scrub the cutting board clean and set it on the drying rack. Wash the knife and peeler and dry them well. Put them away. Wipe down the sink. Get out the other ingredients—butter and milk or cream—for the mashed potatoes and measure them out. Set a strainer or colander in the sink and select a serving bowl for the final dish. Get out the potato masher, a serving spoon, and the potholders.

When the timer goes off, use the potholders to protect your hands. Pour the potatoes into the strainer and shake off any excess water. Place the butter in the warm pan. Swirl it around so it melts. Pour in the milk. Add the potatoes and mash well. Season with salt and pepper and mash again. Spoon the potatoes into the

serving dish, and cover to keep warm. Immediately add soap and hot water to the cooking pan. Swish the potato masher around in the soapy water to remove most of the left-on potatoes. Scrub the masher with a sponge. Wash out the pan and cover. Place pan, cover, and masher on the dish drain to air (or towel) dry, then put them away.

This description took a lot of words. I could have made the potatoes in less time than it took to talk you through it. Eventually you will be able to do it fast and efficiently as well. Believe me, you will be amazed at how fast the cleanup can be if you train yourself to do it as you go along. There is nothing as depressing as facing a sink full of dirty pots and pans along with the dishes at the end of a delicious meal. This system suggests an easy way of avoiding a big cleanup.

8. *Keep a shopping list.* As you run out of things jot the items down on a shopping list. When you start to plan a meal look up the recipe, check to see what you already have on hand, then add the items you need to buy to the list. Remember to bring the list when you go shopping. It will help you be more efficient and save you money, too. If you are a coupon clipper, make the list on the back of an envelope, and put the coupons inside. When you go shopping just take the envelope. Try to keep a list of things you have stored in the freezer. This will save you time and spare you the effort of looking for those green beans you thought might be lurking there.

9. *Try to have fun.* I remind myself a little of the joke about the elderly gentleman sitting on a curb in Miami Beach. He's sobbing his heart out. A young policeman comes along and asks him what's wrong.

"I got married last week to the most beautiful woman," he sobs.

"Well, that's great," says the cop. "So why are you so unhappy?"

"She's young and loves to cook and is a fantastic housekeeper," the old man goes on, tears streaming down his lined cheeks.

"Gosh," says the policeman, "what could be the problem?"

"She wants to have sex ten times a day!" wails the old man.

"This is a problem?" asks the cop.

"No, no. That's not the problem!"

"Then what on earth *is* it?" demands the policeman.

"I can't remember where I live!"

Please remember to have a good time in the kitchen.

Cooking can be a relaxing, rewarding, and creative activity. It should go way beyond just getting nourishment to your mouth. It can mean being surrounded by good friends or the simple company of a good book or music. It takes time to learn how to be an efficient cook, but far less time to be a good cook. Don't panic and threaten to throw in the dish towel if you can't get the eggs to come out at the same time as the toast does, or if the roast is on the tough side. Keep trying and take time to pat yourself on the back for doing so. If you need inspiration, you should know that when I got married the only thing I knew how to cook were frozen fish sticks. I made them the same way every time—burned black on the outside, still frozen solid within. See, there is hope for us all.

2

Setting Up
and Stocking Up

Stocking Up: Would My Mother Be Caught
Dead in This Supermarket?

▼▼

If you're anything like me you're tired of shopping already. Take a little rest before the next project. Have an ice-cream cone or double espresso because you're going to need a boost to get through the next phase.

Here is where we put food in the kitchen. We're going shopping for all of the essentials and some frivolous stuff as well. Before you leave for the grocery store check to make sure you've created space in your kitchen to accommodate all you're going to be hauling home. Is the refrigerator in the receiving mode or is it jammed to the gills with six-packs of beer and soda? Are the cabinets cleared out and dusted and wiped down? Are the counters cleared off so you can unload bags of groceries?

They are? Good, grab your list and let's go. List? No sweat, there's one that begins on page 45 of this chapter. I suggest you eyeball it and cross off items you already have, wouldn't be caught dead eating, or are allergic to. Never do a large shop without a list. It will cost you time and money and aggravation since you'll forget at least three things you need and have to run back to get them.

Leave the family, the roommate, the friends at home. This is not a social occasion and the more people you go with the more money you will spend for things that you never thought of buying in the first place. Eat before you go shopping. Hitting the supermarket with an empty stomach makes for all kinds of impulse shopping: You'll be reaching for that box of pistachio pudding before you remember that you hate all green food that is not vegetables. Keep an eye on unit price stickers. Economy packages and brand names can be surprisingly expensive. Avoid individually packaged servings. They are also expensive. Check for seasonal sales; what's fresh now is what's cheapest now. Usually produce that is piled up in the front of the aisle is what's in season. Ask the produce clerk for the good buys that week.

Become a label reader. For more information about what to look for, check Chapter 4 on nutrition, Fueling the System.

Great. Let's go. Whoa. Wait a sec. Hold the phone. Exactly which grocery store are we going to? Let's consider the choices. If you live in exurbia or in the real country, miles from a (gasp) mall or shopping center, chances are your choices are severely limited. Don't use up gallons of precious gas driving hundreds of miles to a large city to shop unless your only choice is a trendy country store catering to tourists.

I have friends who live on Nantucket Island, thirty miles from the mainland. The prices in the island grocery store are out of sight, so once every three months my friends take the ferry to the mainland and do a massive shop. Ultimately this saves them money.

Whether you live in the country or the city or on Mars, stay away from those cutesy boutique markets for anything but the smallest items. The same thing holds true for convenience stores and your friendly corner market. You will be paying a premium for the goods at these places.

The most economical stores for large grocery and household item shopping are the big warehouse-type markets where they buy in huge bulk and pass the savings on to you. At these places you are expected to bring your own bags (or purchase them for a nominal fee) and pack them yourself. These stores are vast, unfriendly ex-

panses, aisle after aisle packed with things that you never thought you might need stacked right next to things you do need. *Stick to your list*, or you'll get into real trouble!

If you don't have a local warehouse-type store, then head for the largest supermarket you can find. If you have the time and inclination to clip coupons, then bring them and save yourself some money.

I do have one quirky but sensible rule I use to size up a market. I look for bright lights so I can see if the place is clean. If the lights are too dim to tell, then I'm out of there. If there are bright lights and the place is dirty, I'm out of there, too. There couldn't be enough of a discount to get me to shop for food in a dirty market. Same goes for smells. If it smells as if something's rotten, then something probably is. Find another store.

For some strange reason all supermarkets put the produce section right in the front so you are tempted to buy all those fragile items like tomatoes, peaches, and grapes first. This means they travel on the bottom of the cart so that you can then place things like detergent and canned soup on top of them. Save the produce aisle for last.

Bulk Shopping

Should you buy in bulk? See those neat bins that hold everything from bran flakes to carob-coated raisins? See the little scoop so you can fill your bags up with soy-roasted peanuts and whole-wheat pasta? The pros of bulk shopping are: Some people have fun playing with the bins and scoops. Sometimes it's cheaper.

The cons are: It's not cheaper because most of the things in the bins need to be stored in glass or plastic containers or they will get stale within days, but you didn't get anything but a little paper or flimsy plastic bag to store your stuff in. Because playing with the bins and scoops is fun, you usually buy way more than you need. You have to be very careful to make sure that bulk food, which is *never* dated, is fresh. Taste before you buy any (but don't let the manager see you since he'll think you came to his store to graze and that will get him very annoyed).

This bulk-storage business leads me to another pet peeve, which is Son of Bulk Storage or Organic Bulk Storage. This selection can be found in the health food section of your supermarket. You can tell the difference because these items are labeled ORGANIC and cost twice as much as the nonorganic bin fodder. I used to think it was great

to buy until one day I discovered that my kitchen had become infested with meal moths and grain bugs. I had trucked these suckers home, unwittingly, in the brown rice and organic split peas I had bought at the market. I learned, after paying several hundred dollars to have my house fumigated and after throwing out every contaminated item in my kitchen, that there is a reason for preservatives and benign pesticides.

If you can't live without organic grains, lentils, and flours, you must store them either in glass jars with screw-on lids (washed-out peanut butter jars are great) or in the freezer.

The one organic product that I love (and it doesn't attract creepy crawly or flying housemates) is peanut butter. If your store has a peanut butter machine and you can grind your own, then treat yourself. If you're trying to cut back on calories, pour off some, or most, of the oil that rises to the top. This will make the peanut butter harder to spread, but I figure you get to eat more of it since it's less fattening without the oil.

Store Brand vs. Name Brand

Many large supermarket chains have their own store-brand products that tend to be cheaper in price than name brands. Many of these generic items are genuine money savers and the quality doesn't fall too far below the name brands. Items like noodles, tomato paste, fabric softener, and grape jelly are fine, unless, of course, you are hooked on the taste of Smucker's. I am a real snob when it comes to things like canned tuna, catsup, and paper towels. Take paper towels as a case in point. I know from experience. My husband insists on buying generic (store-brand) paper towels and I buy a name brand. The name brand does a better job. Which makes more sense, using more of the cheaper one or fewer of the more expensive kind? These philosophical discussions keep our marriage alive. My advice is to experiment with paper towels (not marriage). Try substituting store brands. If you don't see a difference or if the difference isn't worth the extra money, then you're all set.

Fresh vs. Frozen

No doubt about it, it's easier to rip open a bag of frozen green beans, plop them into boiling water, cook them for two minutes, and serve

them. It's also easier to ensure that there are vegetables in the house if you store them in your freezer where they won't get mushy, moldly, and rotten. However, tastewise, I'll argue that that fresh is better; pricewise, ditto. When I was a new cook I used frozen vegetables until I learned how to manage the fresh variety. If you are pressed for time and want to keep things simple, then use frozen. Peas, corn, beans, tiny onions, and those exotic baby carrots that you shouldn't waste time peeling yourself probably survive the process the best. Frozen chopped spinach can be a life-saver when you're making spinach soup or stuffing something with spinach. Do me and yourself a favor though, and give fresh a chance, too. Remember that you pay a premium for frozen products, especially the fancy vegetables in those butter sauces. The other thing you're getting is a lot of extra salt—not a healthy additive.

Speaking of cost and price, try to stay away from frozen entrées. They cost a lot, are loaded with salt, and are a lazy excuse for food when you are perfectly capable of cooking something simple and certainly more nourishing.

I have to admit that frozen waffles and French toast do show up in our house on rushed school-day mornings. There are recipes in this book for almost-from-scratch waffles and pancakes. You can make extra and freeze them yourself. Not only will you save money, but you will get to see how much better yours taste in comparison to the store-bought frozen ones.

Frozen orange juice concentrate is fine, too, unless you are a woman who doesn't drink milk and has no other source of calcium. Buy calcium-enriched "fresh" orange juice available by the carton.

Canned vs. Fresh

As you get used to cooking, you will see how much more flavorful fresh ingredients are than canned ones. Obviously canned products, like frozen items, are more convenient, but what you gain in time you lose in taste. The major exceptions are canned tuna, canned tomatoes for making sauces, stews, soups, and casseroles, and canned soups, notably Campbell's, which you can use as ingredients in other dishes or doctor up to taste truly wonderful on their own. I recommend College Inn chicken and beef broths as ingredients when making some soups or sauces. The low-salt versions are better than the regular ones.

Convenience Foods

As far as mixes go, I am a great fan of things like Bisquick and some brownie and muffin mixes that I add things to so that they taste more homemade. The packages of instant cereal are time-savers but are so overloaded with sugar and salt that they taste awful. Try using some quick-cooking oats to make oatmeal one Sunday morning. You'll become a convert.

Speaking of salt, get in the habit of reading labels to learn exactly what's in the product you are buying. Check out the nutrition section of this book. Learn about things to stay away from and make sure you take that knowledge to the store with you.

Additional Shopping Tips

- Buying meat and produce in bulk can save money only if you use it all. If there is a sale on whole chicken and you need parts, you must be willing to cut up the chicken yourself at home. This sounds simple, and it will be *after quite a bit of practice*. Skimping on the grade of meat (choice versus prime) works only if you are willing to take the time to cook the lesser grade slowly so it becomes tender. Buying regular ground chuck rather than diet lean means you will end up throwing significantly more fat down the drain after cooking it.
- Read the expiration dates on items like bread products, eggs, dairy products, meat, and poultry. If you get something home and it smells off or tastes funny and you're not planning a return trip to the market, store the bad news with the receipt taped to it in the freezer and pull it out when you go back. Normally, you don't have to make much of a fuss to receive a refund.
- Check produce for soft or brown spots, mold, or rot. Lettuce heads should be heavy and firm; fruit, solid and flawless. Look at the bottom of that basket of blueberries, strawberries, or raspberries; do you see any mold? Until you learn what to look for ask the produce person to select a ripe melon—it should smell sweet and you should be able to push the ends in very slightly. If you are buying fruit for the coming week, look for slightly underripe items. Apples, by the way, are ripe once they are in the store. Greenish-yellow bananas will ripen at home in a few days if stored at room temperature (see information on storage that follows for more tips).

44

> **A** dampened paper towel or folded dishcloth placed under a mixing bowl will keep the bowl stable while you work with it. Do the same with a slippery or warped cutting board.

- If you buy items off the bargain shelf, be aware that they are there for a reason, and it is not just to save you money. Eyeball them very carefully. If fruit flies are buzzing, walk away. Avoid cans that are dented or have bulges or rusty spots. Don't be tempted to buy a package that's opened. Check carefully for leaks from damaged containers since one drip of ammonia could ruin your whole bag of groceries.
- Seasonal farmer's markets are great for shopping. You can get produce and vegetables cheap. Take your time, select unblemished items, and try not to buy more than you really need. If you have to throw anything out after it spoils, it isn't a bargain anymore.

I've tried to divide this list with the set-up of a supermarket in mind, with like items together. I have grouped the essential items first; quirky things that are nice to have in a kitchen follow them.

One last thing: even though you may want to eat the ice cream more than anything else you are going to put in your basket, buy it last.

Baking Aisle

- baking soda (several boxes)
- baking powder
- cornstarch
- flour (5 pounds, all-purpose)
- sugar (5 pounds, granulated)
- confectioners' sugar (1-pound box)
- dark brown sugar (1-pound box)
- corn syrup (light)
- bread crumbs (unseasoned)
- Bisquick or pancake mix
- powdered skim milk
- cocoa powder (unsweetened)
- unsweetened baking chocolate

Seasonings/Herbs/Spices/Flavorings

- salt
- pepper
- peppercorns (if you want to grind your own)
- vanilla extract
- cinnamon (ground)
- nutmeg (ground)
- cloves (ground)
- ginger (powdered)
- basil
- oregano
- chili powder
- dry mustard
- paprika
- bouillon cubes (beef, chicken, and vegetable)
- bay leaves

Oils, Vinegar, and Other Condiments

- cooking oil (corn, safflower, or peanut)
- olive oil
- vinegar (red wine and white)
- solid vegetable shortening (one small can)
- nonstick vegetable cooking spray
- mayonnaise
- catsup
- soy sauce
- Tabasco or other hot pepper sauce
- Worcestershire or A.1. Steak Sauce
- honey
- mustard (Dijon type)

General

- dried onion soup mix
- white rice (not the instant kind)
- brown rice (if you haven't had it, give it a chance)
- tomato paste (the kind in the tube is great)
- tomato sauce (The choice is enormous and enormously confusing. I tend to go for plain. You can always doctor it up.)
- peanut butter
- jelly
- canned tuna
- raisins

- tea bags
- coffee
- coffee filters
- cocoa (sweetened or instant)
- chocolate syrup
- cereals (dry and hot)
- canned chicken or beef broth
- canned soups
- dried noodles and pasta

Refrigerated and Frozen Items

- milk
- eggs
- butter or margarine
- grated cheese (Cheddar or Monterey Jack for tacos, casseroles, and macaroni and cheese; Parmesan or Romano for Italian dishes)
- frozen orange juice concentrate
- frozen vegetables
- yogurt

Produce Staples to Keep on Hand (also see pages 49 to 60)

- potatoes
- onions
- garlic

Paper and Cleaning Products

- plastic garbage bags
- plastic food storage bags (I love the Ziploc kind that you close by running your fingers across the top. They're more expensive but you can wash them and use them over and over.)
- plastic wrap
- sandwich bags
- aluminum foil
- paper napkins
- paper towels
- waxed paper
- muffin tin liners
- sponges
- matches
- cleanser
- steel-wool soap pads
- dish detergent
- dishwasher detergent
- oven cleaner
- general liquid cleaner

Miscellaneous

- toilet brush
- toilet paper
- laundry detergent
- vacuum cleaner bags
- stain remover
- fuses

- batteries
- flashlight
- extra light bulbs
- duplicate keys (from the hardware store)
- Band-Aids

Find a kitchen drawer in which to store the last several items along with a screwdriver and a list of emergency telephone numbers. Include your health insurance information and number and a person to contact in case of emergency. Tell your roommate or neighbor where you keep all this information.

Comfort Foods

Here is a list of extras, comfort foods, that I like to keep around for when the mood strikes. Feel free, of course, to add your own favorites. Some of the other items, like hummus, are for the more adventuresome cook.

- chocolate pudding (or vanilla or any other flavor that lights your fire—instant or not)
- applesauce
- canned fruit cocktail
- popcorn (microwaveable or stove top)
- chips
- chocolate chips
- pretzels
- crackers and cookies
- macaroni and cheese mix
- marshmallows
- brownie mix
- canned chicken noodle soup

- Campbell's Cream of Tomato Soup
- cheese slices
- Carnation Instant Breakfast
- frozen waffles
- ice cream
- frozen yogurt
- salsa
- hummus
- pita pockets (store in the freezer)
- red Jell-O
- chunky peanut butter
- ginger ale
- Oreos

- anchovy paste, for great Caesar salad dressing (comes in a handy tube)
- yeast in individual envelopes (you may want to try baking bread or making your own pizza dough). *Check the expiration date.*
- frozen bread dough (if you want "homemade" in a hurry)
- frozen pie crusts
- molasses
- bottled salad dressing (for the times you don't make your own)
- dry sherry for cooking (*never* buy anything called "cooking sherry" or "cooking wine"; they're filled with salt)
- white wine for cooking (get a jug of dry chablis)

Choosing and Storing Fruits and Vegetables: Is This a Tomato or a Baseball?
▼

A knowledgeable clerk in a market with a good selection of quality produce will be your best resource when learning what's good and what is not. Don't be shy about asking if the cantaloupes are sweet; get help picking out a ripe avocado. Ask questions so you'll know what to do next time.

Apples: While apples are available year round they are best (and cheapest) during the late summer and throughout the fall. Apples should be firm and smooth, with no brown or soft spots. Red, green, or yellow? Depends on your taste. Granny Smith (hard and bright green) are tart; golden Delicious are crisp and sweet, red Delicious ditto, but both can be mealy off season. As with all produce, the more you shop the more familiar you will become with the different varieties. The challenge is to remember which one it was that you liked so much.

Apples will keep in the refrigerator, in a cool, dry basement, or on a porch for many weeks.

Asparagus: Nothing is more delicious during the spring than tender stalks of steamed fresh asparagus. Look for firm, very green stalks with tightly closed tips. If the tips look dry or the little buds are

separated, then skip them. Choose stalks of the same thickness as you want them to cook evenly. Wrap the bottom of the stalks in a damp cloth or paper towel, place in a plastic bag, and refrigerate. Asparagus with thick stalks will have to be peeled. If for some reason you aren't able to use the asparagus while it's still very fresh, cook it and serve it cold the next day. This is true also for beans, corn, and peas, all of which are highly perishable. All are wonderful chilled, or in salads.

For more information about cooking asparagus and other vegetables, see Vegetables and Vegetarian Dishes beginning on page 215.

Use asparagus within 2 days after purchase.

Avocados: Don't spend a lot of time looking for soft avocados in the market; someone has already bought them. You'll most likely have to ripen them at home. There are two varieties of avocados to choose from; Fuerte, the larger, thin-skinned, smooth, and shiny green type; and Haas, the nubby, almost black, smaller type. They taste pretty much the same. Look for unblemished ones without any mushy spots. To ripen, place them in a paper bag and set the bag on the counter. When they yield to gentle pressure, they are ready to eat. At this point they can be stored in the refrigerator for a couple of days.

A cut avocado turns black almost immediately when exposed to air. Rub the flesh with a slice of lemon, or sprinkle with lemon or lime juice to prevent discoloration.

Bananas: Buy yellow, firm fruit, free of brown spots and bruises. Ripen green bananas at room temperature. They are ready to eat when uniformly yellow, without any traces of green. Dark brown spots on the peel after ripening don't always mean the fruit will be brown within, and, unlike many fruits, slightly overripe bananas are sweet and delicious. Don't throw away overripe bananas. Use them to make banana bread, or peel them and cut them into pieces to use to make frozen fruit shakes.

Beans: Both green string beans and yellow (sometimes called wax) beans are best in the summer and fall. You want crisp, brightly colored beans that break with a snap when bent. Avoid limp, soggy, dull-colored ones as well as giant-sized, super-long beans, which tend to be pulpy and dry. Large beans with ridges and bumps will be mealy and tough.

Store in the refrigerator in a plastic bag for 2 or 3 days and wash just before using.

Berries (strawberries, blueberries, raspberries, and blackberries): Summer is peak time for these kinds of fruits. They become prohibitively expensive and not nearly as flavorful off season. These are high-end items so you want to take particular care in choosing them. The colors should be vivid. Avoid whitish or pale-colored fruit. The berries should be plump and firm, not mushy and wet looking, and there should be no visible mold. Turn the container upside down and check the berries on the bottom. If the container is wet or stained, choose another one. Plan to use the berries the day you buy them because refrigeration diminishes the taste. If you must refrigerate them, do so only for a day or so. Rinse gently and briefly with cool water just before serving. If you can't use the berries within one day of purchase, you can freeze them for later use. The best way to do this is dump the whole container into a freezer bag. Don't wash them before freezing them because you'll get ice crystals on the fruit that will make the berries soggy when defrosted. You can defrost the berries either in the sealed plastic bag, or by spreading them out on a baking sheet.

Broccoli: Look for firm, dark green heads with tightly closed buds and no signs of dryness or brown or yellow spots. Check the stems; they should not look tough and stringy or dried out.

The stems, incidentally, are delicious, but take more time to cook than the tops. You might try peeling off the tougher outer skin on the stems with a vegetable peeler or paring knife before cooking.

Store broccoli in a plastic bag in the refrigerator for up to a week.

Cabbage (green, red, and Savoy—the one with the curly leaves): These can be used interchangeably. The one mistake people make with cabbage is buying too much. Select a head that is the right size for the dish you are making since unless you are willing to munch on the excess, you'll be wasting money. Look for firm, round heads without cracks, wilted leaves, and bruises. The better cabbages will still have their outer "wrapper" leaves that will have protected the inner leaves, keeping them moist and bright in color. Discard these.

Store in a plastic bag in the refrigerator for up to a week.

Carrots: I prefer to select loose (as opposed to bagged) carrots. That way you can really see what you are getting. Choose smooth, firm, bright orange carrots and avoid those that look wilted, dried out, limp, or are cracked. Huge carrots tend not to be as sweet and flavorful as smaller ones even though they are easier to peel, meaning

51

they are easier to hold onto during the process. Let the produce clerk cut off the greens and throw them away. You don't need them at home. Don't waste money on those trendy baby carrots. If you have to buy bagged carrots, take a good close look at them to make sure they aren't wilted and limp.

If you are making a recipe that calls for baby carrots—I call this vegecide, harvesting vegetables before their time—don't waste your time peeling the little suckers. You can get them frozen.

Store carrots in the refrigerator. They will keep for several weeks. If you forget about them and even if they are no longer crisp and firm, you can use them in a stew or in soup anyway.

Cauliflower: Look for creamy white, firmly compact flowerettes (that's what the top of cauliflower is called). Avoid heads that have yellow or brownish areas. You will pay a terrific premium for the precut cauliflower or, for that matter, any precut prepackaged fresh vegetables, not to mention all the lovely chemicals that are sprayed on them to keep them looking fresh. The chemicals don't work anyway, since once the stores cut up those vegetables they dry out almost immediately.

Store cauliflower in plastic wrap in the refrigerator for up to a week. If brown spots develop, just trim them off. Wash just before cooking.

Celery: Light green, crisp, and firm stalks with fresh-looking leaves on top are what you want. Avoid cracked, broken, dried-out, or limp stalks and any with brown marks. Stay away from the bunches with wilted yellow leaves.

Wrapped in plastic and refrigerated celery keeps up to 2 weeks. As with carrots, don't discard old celery. Use it in soups, stews, casseroles, and some salads like tuna or egg salad.

Corn: Fresh sweet corn is a heavenly treat. Its season is summer and the best place to buy it is at a farm stand. Peel back the husks and look for neat rows of fat, firm, pale yellow, or creamy white kernels. Stay away from the really large, darker yellow kernels, an indication of corn that is old.

You really shouldn't store corn at all. Bring it home, boil the water, and enjoy. Once corn is picked, the sugar in it immediately starts turning to starch and even refrigeration can't slow the process down very much.

Cucumbers: I hate the waxy coating found on most cucumbers. It acts as a preservative and can be peeled off with the rest of the skin.

My favorite time to eat cucumbers, however, is in the summer when they are bountiful and come without the wax. Look for firm, dark-green, unblemished cucumbers. Feel for mushy spots, particularly at the ends. Avoid yellowish cukes. The extra-long seedless cucumbers have no taste and they are expensive! Stored in the vegetable bin of the refrigerator, cucumbers will keep about 1½ weeks.

Eggplant: This delicious vegetable got slapped with an unfortunate name. Try blocking out its name and select a uniformly deep-colored, smooth, shiny-skinned, unblemished one. It should feel firm and heavy in your hands. Choose the size according to what you plan to make: a large one if you want nice-sized slices for layering in a casserole, or small, similarly shaped ones if you want to stuff them.

Eggplant will keep up to 1 week in the refrigerator. Use before it dries out and wrinkles up.

Fennel: This is a wonderful, underutilized vegetable that is sort of like celery but with a faint licorice taste. Select firm white bulbs with fresh-looking (not wilted) green tops.

Stored in a plastic bag in the refrigerator, fennel will keep several days. When you cut it to use raw in a salad, rub the bulb part with lemon juice to keep it from turning brown.

Garlic The whole unit is called the head; the individual pieces are the cloves. Since small cloves of garlic are a pain to peel, look for the larger heads. Squeeze the heads gently to make sure they are very firm. Avoid heads with powdery black rust or with dried-out cloves. If you have a cool kitchen, you can store garlic in a small bowl or open crock on the counter, or in the bins with your potatoes and onions. If green shoots appear, poking out from the top of a clove, it means the garlic won't be as pungent. Simply snip off the greens and discard.

Garlic will keep at room temperature (in a dry, cool place) for several weeks. If you want to keep it longer, loosen the peels by gently smashing them with the side of a chef's knife. Slip off the peels and place the garlic cloves in a jar of olive oil. Cover. The oil absorbs the garlic flavor and is great for making salad dressing. Keep the oil refrigerated and don't worry if it turns cloudy. You can also buy pre-chopped garlic in oil in jars. While it's convenient, I think fresh tastes better. Take care that you don't overdo it in your dish.

Grapes: Green, red, or blue/black grapes are available year round. They are grown domestically in the summer and fall and their prices are considerably lower as a consequence during these times. They

are also imported year round. When choosing grapes, look at the stems to make sure there is no rot or discoloration. Check to see that the grapes are solidly attached to the stems. Do not wash grapes ahead of time.

Store in a plastic bag in the refrigerator. Grapes will keep for several days, with Thompson (seedless grapes) green having the longest shelf life.

Grapefruits: Grapefruits are at their best when in season, from December to May. Look for firm, shiny skinned, regularly shaped ones without soft spots. While the pink variety can be sweeter than the white, it is most important to select heavy, thin-skinned fruits; they generally are the sweetest.

You can store grapefruits at room temperature for a few days or in the refrigerator for several weeks. My favorite way to eat one is to first peel off the yellow skin and most of the white pith with a sharp knife. Leave some of the pith, it's a great source of fiber. Use a serrated knife to cut the grapefruit in half, then slice it into bite-sized pieces. With the addition of a little brown sugar or maple syrup, you have a super breakfast, low-calorie dessert, or snack.

Lemons: They should have smooth, shiny skin, without blemishes or soft spots. The lemons with the lumpy skin and the thick bulbous ends with have the least juice, so buy the thin smooth-skinned ones.

Lemons stored in the refrigerator will keep for several weeks. To get the most juice out of a lemon, really roll it under your hand on a hard, flat surface just before cutting.

Lettuce: There are many, many different types of lettuce, iceberg being the most commonly used. I love iceberg lettuce even though there are some food snobs who insist on denigrating it. It's filling and crunchy and you don't have to wash it. Just discard the very outer leaves. It also keeps much longer than other kinds of lettuce.

Choose iceberg lettuce by weight, not size. The head should feel heavy and solid in your hand; it should be free of any wilted, brown, or spotted leaves and the stem end should not look dried out.

If you're feeling adventuresome, consider red leaf, Boston, Romaine, or Bibb. Look for fresh-looking, unwilted leaves and check the stems for rot. They should not look and feel slimy. Don't be content with the heads stacked at the top of the heap. Dig around until you find a full, fat head. After all, most often you're paying by the head, not by the pound.

Store lettuce, unwashed, in the refrigerator in plastic bags. Be careful not to stack anything on top of it. Wash very carefully just before using and spin, shake, or pat dry.

Limes: As with lemons, look for smooth, unblemished skins that are free of brown spots. Try to pick heavy limes as they will be the ones with the most juice. Remember the lemon juice trick and roll the lime around under your hand on the counter to extract the most juice out of it, too.

Store limes in the refrigerator for up to 4 weeks.

Melons (cantaloupe, Persian, honeydew, and Crenshaw): Selecting a ripe melon can be tricky, so I suggest you ask the produce clerk for assistance the first few times. Melons, and this is more true with cantaloupe than honeydew, should yield slightly to pressure when pressed at both ends. Make sure to choose melons free of soft spots. A melon should smell nice and sweet. This means it is ripe or nearly ripe.

It's better to buy slightly underripe melons and let them ripen at home on the counter. You can refrigerate ripe melons for a day or two before serving.

Mushrooms: Choose loose mushrooms (as opposed to the packaged ones) so you can see exactly what you are getting. Look for clean caps that are firm and dry. Check underneath the caps to see that the gills haven't detached from the stems, which indicates old mushrooms. Try to avoid excessively dirty mushrooms as they are a pain to clean, and remember that larger mushrooms are easier to slice than small ones. The best way to clean mushrooms is *not* under running water. It is also unnecessary to peel them. Actually that is a waste of time and food. Wipe the mushrooms clean with a piece of dampened paper towel shortly before cooking or serving them. If the mushrooms are very dirty, then it may be necessary to wash them briefly under cool running water, then pat them dry with paper towels.

Store mushrooms in a paper bag in the refrigerator. They will keep up to a week.

Nectarines: Not just fuzzless peaches, nectarines have a subtle, different taste and are a much sturdier fruit than peaches, which means that they will keep longer and not bruise quite as easily. Nectarines are a summer fruit. Look for heavy ones that are golden yellow with peachy, pink tones. Avoid small green fruit. When a nectarine "gives" a little under gentle pressure and smells sweet, it is ready to eat.

If you buy underripe, hard greenish nectarines, store them on the counter in a paper bag for a day or two to ripen. Then eat or refrigerate.

Nectarines will keep in the refrigerator for at least a week.

Onions: Use medium-sized yellow onions for cooking. They give the most flavor (and fumes and produce lots of tears). Try peeling them under cold running water. Large Spanish onions are easier for a novice cook to handle, but are not as flavorful. Use red (Bermuda) onions raw in salads and for garnishing. Look for shiny, papery skins free of soggy spots or wet, slimy bottoms. Avoid sprouted onions, any with green shoots, and those with black powdery rust spots.

Store the onions, unrefrigerated, in a paper bag in a cool, dry place. They will keep for a month or so.

Oranges: If you are picky about seeds, then you must wait for winter and the arrival of navel oranges. They are bright orange in color, with thick, finely grained skin. They can be peeled and sectioned and are juicy and wonderful tasting. Look for largish, heavy ones without soft spots. Juice oranges are thin skinned and full of seeds. If you are into making your own juice, it is delicious and worth the effort.

Keep oranges in the refrigerator for several weeks.

Peas: Spring and early summer are the best times for local farm-grown sweet peas. The most readily available kinds are English peas—the kind you "shell"—as well as Chinese snow peas and sugar snap peas. All three varieties should have crisp, bright green pods that are not oversized, which indicates toughness and tastelessness. Avoid limp or yellow peas. Peas should not be stored because the sugar in them starts turning to starch as soon as they are picked. Try to use them the day you buy them.

Peaches: Nothing says summer quicker than a perfectly ripe peach. Look for creamy golden/pink fruits that are uniformly shaped and feel heavy. A ripe peach should smell sweet and yield slightly to gentle pressure. Avoid green peaches as they will not ripen correctly and wrinkled, dried-out, bruised, or otherwise blemished ones.

Peaches don't keep a long time. If they are too hard to eat when you bring them home, let them ripen in a paper bag on the counter for a day or two. Then eat or refrigerate for up to 3 or 4 days. Peaches bruise easily, so be careful how you handle and store them.

Pears: No matter which variety you select, choose pears that are firm and let them ripen at home. (This doesn't necessarily mean the rock-hard ones, though.) Avoid pears with bruises, soft spots, rips in the

skin, and other blemishes. The thin-skinned yellow types will be more fragile than the brown and red-skinned varieties.

As with nectarines and peaches, pears will ripen faster when stored in a paper bag on the counter. A pear is ready to eat when the stem detaches easily and the fruit smells sweet.

Store ripened pears in the refrigerator for up to a week.

Peppers: Sweet or bell peppers come in a variety of colors—green, red, yellow, and purple. The green variety tends to be the best buy, but I think that red peppers have the most (and sweetest) flavor. The red, yellow, and purple varieties are imported from Holland during the off season and are outrageously expensive. Check the prices.

Also sweet and flavorful are the long green Italian peppers. Do not confuse these with the smaller set-your-mouth-on-fire variety, or the incinerate-your-mouth jalapeño peppers. These come both in red and green. Read the signs above the produce compartments carefully or ask the clerk for guidance. If you are using a recipe that calls for hot peppers, always use gloves when handling them.

With all peppers, look for firm, unblemished, glossy-skinned ones, avoiding those that have been waxed to prolong shelf life as well as those with bruises or soft spots. Store peppers in brown paper bags in the refrigerator for up to 2 weeks. Green peppers will keep longer than red peppers.

Pineapples: When I first started cooking, I established a "relation-ship" with my produce man and pineapples. I would ask him to pick them out for me (What did I know? All pineapples looked alike then.). He showed me a good trick for picking out a ripe one, although I can't see a large supermarket letting you do this. Grab the stem by the fruit end and twist it. If it comes off easily and the top emits a sweet, pineapple smell, then the fruit is ripe. Alternatively, press the fruit gently with your fingers; it should yield slightly. A ripe pineapple should smell deliciously sweet. Make sure the bottom is firm and not rotted or soft.

Pineapples will not get any riper at home, only softer, and they will attract fruit flies. Once they are picked from the plant, that's it; so, select a ripe one and either serve it immediately or store it in a plastic bag (to keep it from leaking) and refrigerate it for a few days. If you buy one with the top still attached, twist it off and discard it (why take up valuable space in the fridge?).

Plums: Like peaches, plums are summer and fall fruit, and, while imported varieties are available year round, the price and quality

aren't worth it. Choose firm, full-colored fruit with smooth, unblemished skin. It's better to buy plums a little on the underripe side, store them at home on the counter in a paper bag for a day of so until they ripen, and then either eat or refrigerate.

They will keep for several days. Don't wash them until you're ready to eat them.

Potatoes: These now come in a variety of shapes and sizes. For general baking and cooking, buy those labeled Idaho or "baking." For potato salad (and a change of pace) look for small red or new potatoes. Avoid potatoes that look wilted or are dried out. A greenish cast to the skin means the potatoes have been exposed to too much light and will be bitter in taste. It is best to avoid these and also potatoes that have sprouts (tiny leaves or shoots growing out of them).

Store potatoes in a brown paper bag in a cool, dry place, away from sunlight. Ideally they should not be stored above 50°F., where they will keep for several weeks. At warmer temperatures they will keep for only a week or so before sprouting. If this happens, just cut off the sprouts and use the potatoes. And, by the way, don't store potatoes in the refrigerator; the starch in them will turn to sugar, making the potatoes turn brown when cooked. To clean potatoes, scrub with a vegetable brush under running water just before using.

Spinach: Most folks don't learn to appreciate spinach until they are grown up. This is too bad, since it's a delicious, economical, nutritious, and wonderfully versatile vegetable. If you have the option of buying loose spinach, as opposed to that already in a sealed plastic bag, do so. This way you get to make sure the leaves aren't wilted, yellow, or slimy. Look for big leaves. They are easier to clean and stem. Avoid, however, the really huge ones. They will be tough.

Spinach is sandy. It's a fact of life, but try to select leaves with the least amount of grit, which will make rinsing them easier. Wash spinach very carefully (see page 219) just before using. Store spinach in a paper or plastic bag in the refrigerator for up to 2 days.

Chopped frozen spinach is a good and handy substitute for the fresh when you are making certain stuffings, casseroles, or spinach soup. After cooking it, squeeze out all the water with your clean hands.

Sprouts (bean, mung, alfafa, radish): These are a satisfyingly healthful addition to salads and sandwiches. The shorter the sprout, the tenderer. They should smell sweet and fresh. Look for crisp and moist

(but not soggy) ones. Check the bottoms and make sure there are no brown ends. Shake off any excess water, place the sprouts in a plastic bag or in a container, cover, and store in the refrigerator for up to a week.

Squash (summer): Zucchini and yellow squash are what your next-door neighbor with the garden will try to unload on you when the crops come in. Smile and say you're looking forward to tomato season. Just-picked summer squash is wonderful. It's what you would hope for from the supermarket. Look for bright green zucchini or yellow, smooth-skinned, firm, and unwilted ones without bruises, soft spots, or blemishes. Select small-to-medium squash, which will be tender and flavorful rather than the giant variety, which invariably are tough and woody.

Store summer squash in the refrigerator in a plastic bag for up to 5 days, taking care not to bruise its fragile outer skin.

Squash (winter): These are the hard squashes—acorn, butternut, Hubbard, spaghetti squash, and pumpkin. Their season is fall and winter. Select hard, heavy ones with a dull coating. Avoid those with gouges, soft spots, or blemishes. Whole squash will keep for about a week at room temperature. Many stores sell winter squash already cut and peeled; it looks like cut-up pumpkin. This saves time. Look for brightly colored pieces with no discoloration, mold or slime.

The only pumpkins suitable for cooking are sugar pumpkins, although the seeds from all varieties are fine for roasting. Ask the farm stand or grocery produce clerk to direct you to the sugar pumpkins. If he or she says there's no difference, go to another store.

Canned pumpkin-pie filling is fine for making pies.

Pumpkins will keep at room temperature for several weeks.

Tangerines: In season during the winter months, tangerines are a great snack food (easy to carry, peel, and eat). Look for bright orange fruit with moderately pebbled, glossy, loose-fitting skin and no bruises. The heavier ones will have the most juice. If you have a strong aversion to seeds, ask the produce clerk to make sure which are seedless.

Store tangerines in the refrigerator in a plastic bag. They will keep for several weeks.

Tomatoes: I am a tomato snob and buy them only in the summer when they come straight from the farm. Don't worry if the home-grown ones are slightly misshapen and have funny-looking cracks along the top. They don't have to be cosmetically perfect to be deli-

cious. Look for heavy, red tomatoes without bruises, mold, or soft spots.

Hothouse tomatoes, sold in cellophane packages, have all the look, flavor, and personality of a baseball. For cooking, I'd rather use tomato paste, which is always available in a small can or handy tube, and do without cardboard crescents in my salad. Plum tomatoes (sometimes available off season) are more flavorful than the hot-house variety for cooking.

Cherry tomatoes, usually ready to eat from the store, are most frequently used in salads but can make a delicious hot vegetable when tossed with a little butter or olive oil in a frying pan. Remove them from the heat before they explode.

It is better not to refrigerate tomatoes as they will lose their flavor. If you buy or pick them underripe and store them on a counter, they will ripen in a day or so. Slightly overripe plum tomatoes will have more flavor than those just ripe.

Choosing and Storing
Other Perishables: Will This
Fuzzy Green Stuff Kill Me?

It's relatively easy to pick a "good" can of tuna off the supermarket shelf. The rules go for any canned goods: If there is a bulge, hole (no matter how tiny), gouge, or dent in the can, then pass it up. Don't buy cans with missing labels, or labels that have been taped back on, no matter how much the prices might have been slashed.

When it comes to perishables there are, unfortunately, more rules to consider.

Poultry (including chicken, turkey, duck, geese, Cornish game hens, and anything else with feathers): The absolutely best place to buy poultry is a meat market or butcher store or shop that sells birds that are not prepackaged. Where I live on the East Coast we have a fabulous chain of health food stores that sell organically raised poultry. It is expensive but magnificently fresh and flavorful. In such stores you can see and smell exactly what you are getting. Usually the birds are displayed on a bed of ice in a nice clean case lit with bright lights. In other words, no one is trying to hide anything.

You have to be a smart consumer when you buy poultry in most large supermarkets. Short of ripping open the plastic wrapping, it's hard to tell if what you're getting is really fresh. Start by checking the date on the package. Don't be tempted to go for bargain chicken with today's date. Supermarkets extend the short shelf life of chickens with a process called "deep-chill," which is two degrees north of frozen in my book. They freeze and thaw chickens as well. Both processes leave chicken watery and diminish its flavor. It's difficult for a novice to tell when a bird has been processed this way. Sure signs: If the breast is rock solid or if there is ice clumped around the wings, neck, or back or if there is a puddle of pink liquid in the bottom of the package, chances are the bird has been processed in this way.

Choose poultry that looks bright and wholesome. Its skin color is irrelevant since it depends on the season and what the bird has been fed. However, avoid any bird with gray, pasty skin. Go for the plump birds, not the scrawny ones.

In some places it is impossible to purchase fresh ducks or turkeys. Before you buy the frozen variety, see below for defrosting tips.

Chicken-wise, you have lots of choices:

Broilers or fryers are smaller chickens and come either in parts or whole. A broiler or fryer weighing between 3 and 4 pounds will serve about 3 people.

Roasting chickens and capons come whole, weigh between 5 and 8 pounds, and will serve up to 6 people, depending on the weight of the bird. Capons have more breast (white) meat than regular roasting chickens.

Fowl is a more mature chicken used most often to make soup. The meat, if simmered slowly, is wonderful in salad.

Chicken breasts are available both with the bone in and out, skin on and skin off. Boned chicken breasts cost more than any other cut of chicken, but they are convenient, cook quickly, and adapt to all sorts of recipes.

"Economy packs" of chicken parts are ideal if you are cooking for a crowd. Consider the value in a large package of drumsticks or chicken wings.

Poultry is extremely perishable and a perfect breeding ground for bacteria that can cause serious food poisoning. Take it straight

home. Don't do fifty other errands while the chicken or duck reposes on the floor of your car (unless you had the forethought to bring a cooler and some ice). When you get home rip open the package and take a smell. There should be no smell whatsoever. Very occasionally a bird will have a slightly off smell, but then, once the bird has been rinsed off, it will be fine. If you have one of these borderline birds and are too busy to return it, then cook it right away. If the bird smells at all after you have rinsed it, then take it back to the store and raise hell. Do it *very loudly* with loads of self-righteous indignation. The store goes nuts when someone does this.

If you have purchased a whole chicken and plan to cook it the next day, reach into the body cavity between the drumsticks and pull out the little bag of giblets, which includes the heart, kidney, liver, and neck. These are even more perishable than the rest of the chicken. Immediately removing the giblets will save you the embarrassment of cooking the chicken with the giblets inside. Rewrap the poultry in clean plastic and place it on a plate so it doesn't drip onto anything else in the refrigerator. Store poultry in the coldest part of the refrigerator for not more than 2 days. To use frozen chicken defrost it in the refrigerator or in the microwave. If it is defrosted in the microwave, you must cook it immediately since parts of it have been heated during the defrosting process.

To avoid spoilage (another food-poisoning alert), you must defrost all previously frozen poultry in the refrigerator. Never defrost any poultry or meat at room temperature. Place the pieces or whole bird in a pan to catch any drips. If you have a package of frozen chicken parts and want to make soup, you don't have to defrost them first. Add the frozen parts to the water or broth (see page 126). Check carefully to ensure that all paper, tags, and plastic have been removed first.

Turkeys and ducks: Most turkeys and ducks are frozen before they reach the market, which creates more of a challenge for a novice cook, since you have to defrost the bird first. If you don't have access to fresh birds (try your local butcher, where you might have to place a special order, or look in the phone book under poultry farms), you have to plan ahead to give yourself time to defrost a turkey or duck before you can cook it. Again, you must defrost poultry in the refrigerator. A 12- to 14-pound turkey may take up to 3 days and a duck can take up to 2 days to defrost. Check to see if it is defrosted by pushing against the breast with your finger—it should feel spongy and give to pressure. You don't have to wait for all the ice crystals in the cavity to melt before cooking the bird.

Cook the giblets for your dog or cat by simmering them in 1 cup of water for 20 minutes (they will love the cooking liquid, too). Sauté the liver as a treat for yourself. Melt 1 tablespoon of butter or margarine in a small skillet. Add the liver and cook over moderate heat for 5 to 6 minutes on each side, or until the liver turns dark brown and has lost its limpness. It should remain medium-pink in the center. Sprinkle with salt and pepper and enjoy.

As with whole chickens, remember to remove the bag of giblets hidden inside the cavity of the bird.

Beef: Yes, yes, I know the choices are overwhelming enough to make you become a vegetarian. But I'm going to simplify things by dividing beef into (1) chopped (or ground), (2) steaks, (3) roasts, and (4) "other," which includes stew beef, brisket, and pot roast. Chopped looks as if it has been through a grinder. Steaks tend to be flat. Roasts are mound-like. And the others are sort of a combination of numbers 2 and 3.

The more tender cuts, those from the lightly used muscles with more marbling (which means more fat running through the meat), such as steaks, some roasts, and chops, should be cooked with dry heat: broiling, roasting, grilling, sautéing, and barbecuing. The less-tender cuts—brisket, pot roast, chuck roast—should be cooked with moist heat: braising, stewing, and so on. (Don't worry, I'll explain these terms later.) It's important to understand the relationship between the cut of meat and the cooking technique, so that you don't buy a brisket, throw it on the grill, and expect it to be edible. Conversely, I don't want you to spend a fortune on a Delmonico steak and place it in a pot with a bunch of vegetables for stew.

All the recipes for beef in this book specify a certain cut. To learn more about cooking with beef ask a butcher. Most butchers love to consult. Not only will they suggest cuts to match the occasion, but they will tell you how to cook them. For even more information read some of the recommended titles listed in the reference guide at the end of this book.

There are several grades of beef and the ones you're likely to be confronted with are prime and choice. Prime is more tender and more expensive than choice. One of the first things some people do when they get rich is buy a Cadillac and switch to prime beef. So, I

guess you could also say it's a status symbol. If you can afford prime steak, that's terrific.

As with poultry it is great if you can buy your meat from a butcher, but failing that you'll have to learn how to shop smart at the supermarket. You want to look for beef that is assertively deep red in color and accented with white fat. Avoid gray meat with yellow or off-white marbling. Check the bottom of the package. The meat should be red on the underside as well, not brown or gray. Make sure to check the date code on the package. Don't buy meat when the date expires that same day. Never select a ripped or opened package. Avoid meat that has dried out edges.

Before you refrigerate it, rewrap the cut airtight in new plastic wrap, then place it on a plate or in a pan to keep any juices from dripping on to the other food in the refrigerator. Keep the package in the coldest part of the refrigerator and use within 3 days. Use ground beef and stew meat the day of purchase or the next day.

Lamb: Lamb, whether chops, leg, or breast, should be light rosy pink in color with very little fat, and what fat there is should be very white. The darker the meat, the older and tougher the lamb. Check the date code for freshness and avoid any ripped or opened packages.

There are several varieties of lamb chops: shoulder, loin, and rib. The ribs are the most expensive, having the most meat and the least gristle and fat. The loin and shoulder are cheaper cuts. They have less meat and more fat. Mutton, rarely available in American supermarkets, has a very strong lamb taste.

Rewrap lamb airtight in clean plastic wrap and place on a plate or in a pan and store in the refrigerator. Use all cuts of lamb within 3 days, except ground lamb and lamb stew meat, both of which should be used the day of purchase or the next day.

Pork: Fresh pork is what bacon, ham, and sausage start from. Cuts of pork, including roasts and steaks, should be light pink with a firm and lightly marbled texture. As with beef and lamb, the fat should be bright white and firm. Don't buy pork if the package is torn or punctured. Also avoid any packages with an accumulation of liquid, which may mean that the pork has been frozen and thawed.

Refrigerate pork after replacing the store wrap with new plastic wrap (seal airtight) and use it within 3 days of purchase. Place the pork on a plate or in a pan to catch any drips.

Veal: Veal is the tender meat from a young calf that has been milk fed. The color of the meat should be very pale pink, almost white. Look for moist, glossy, firm, fine-textured cuts—ground, chops,

roasts, stew meat, and cutlets, which are smallish, flat pieces that look like flattened, skinless chicken breasts. Steer clear of ripped or punctured packages and packages in which liquid has accumulated, indicating that the veal may have been frozen.

Rewrap veal loosely in new plastic wrap, place on a plate or in a pan, and refrigerate. Use ground veal and veal stew meat within a day or two. Roasts and chops will keep for about 3 days.

Deli meats (cold cuts): When you buy bologna, sliced ham, salami, turkey, and so on, get only as much as you think you will need for a week. Cold cuts are perishable, but if they are kept refrigerated and wrapped tightly in plastic wrap, not that loose paper wrap from the store, they will keep for 5 to 7 days. Avoid any that look old or dried out, any with a faded color or obvious mold. Replace the deli-wrap with your own plastic wrap before you store the cuts in the refrigerator. Discard any cold cuts that have become moldy or develop unpleasant smells.

(As far as the salads in a deli case go, they are appealing because the work has been done for you. However, just wait until you see how much money you save and how easy it is to make your own coleslaw and potato salad.)

Packaged hot dogs will stay fresh if unopened and, of course, refrigerated, for one week after the store's expiration date. Once opened, rewrap in fresh plastic wrap and use the remaining dogs within one week. Or, wrap well in plastic wrap and freeze.

Fish: I never buy fish any other place but in a fish market. I'm spoiled. I live in Boston, where fish markets are as common as people who have a love-hate relationship with the Red Sox. If you don't have a fish market and are forced to buy fish in a grocery store or supermarket, then you have to have a dialogue with the clerk. It goes something like this:

You: "Hi, that looks like mighty nice flounder you have there. When did it come in?"

Clerk (worse-case scenario): "Beats me. I usually do produce."

Okay. Listen up. There is only one correct answer to your question "When did it come in?": *"Today."* Not yesterday, or last week, or I don't know, or it doesn't matter. If the clerk's mouth is saying "today" and his eyes look like Richard Nixon's, then ask to smell the fish. This takes a certain amount of panache to pull off and not look like a pervert. It helps to have a companion standing by, nodding with approval at your goings-on. The fish should have no smell.

None, zippo, *nada*. The only possible exception is scallops, which are shellfish. They may smell slightly sweet.

Your next question should be "Was it frozen?" With the exception of shrimp, which are usually only available "previously frozen," meaning the store brought them in frozen, then thawed them, it is always preferable to buy fresh (as opposed to previously frozen) fish. If the clerk doesn't know, don't buy it.

I know that some of you are reading this book in places where fresh fish is a rarity. Go out of your way to find it. The quality of the taste and texture are worth the extra effort. Look for firm, clean-looking cuts without any signs of dryness.

Refrigerate fish immediately and use on the day of purchase or the next day at the latest.

Shellfish is notoriously perishable. Make sure you buy items like lobster, clams, oysters, mussels, and shrimp from an absolutely reputable source. The lobster should be alert and lively, very lively, and should smell like the ocean—fresh and clean. Clams, oysters, and mussels should have tightly closed shells. Discard any that are opened or cracked. Wrap shellfish airtight in plastic wrap or paper, store in the coldest part of the refrigerator, and use within 24 hours.

Dairy products: Make sure to pay attention to the store expiration date on cartons of milk, cream, sour cream, cottage cheese, yogurt, and on the wrapping on cheeses. Select the items with the farthest-off expiration dates. Don't be shy about reaching behind and underneath to pick out newer items. Make sure the place you shop keeps its cases nice and cold.

Remember that skim milk has a shorter shelf life than 2% or whole milk and that even though a carton of cream can smell sour, if you empty the contents into a clean pitcher or glass, you will find that unless the cream is really old only the cream stuck around the sides of the carton has turned.

Packages of pre-shredded cheeses (Cheddar, Monterey Jack, mozzarella) are convenient, but if the cheese turns moldy, then the whole bag spoils. If you buy a chunk of Cheddar and grate it yourself, then you can always trim off mold that accumulates on the sides. (The mold won't hurt you. It's related to the stuff that makes blue cheese blue.)

Pre-grated cheeses (Parmesan, romano, pecorino) can be stored either in the refrigerator for several months, or, if well wrapped, indefinitely in the freezer. Use these grated cheeses directly from the freezer.

Before you put that carton of eggs in your basket, check the date, then move each egg around to make sure the shell is intact. This isn't just to save you money. Cracked eggs can be contaminated with salmonella bacteria and make you very sick.

I tend to buy extra-large eggs and have geared my recipes to that size. In everything *but baking recipes* you can substitute extra-large for large and jumbo eggs, and the only difference will be in the yield. The best place to store eggs is in their original carton in the refrigerator, not in the egg rack on the refrigerator door. In the carton they will stay fresher and be safer from breakage. They will keep for 4 to 5 weeks. By the way, you can tell if an egg is stale by placing it in a bowl of water. If it floats, it's stale. This is because a large pocket of air has formed while the egg was sitting around waiting for you to get the urge for an omelet. You can tell if an egg is hard-boiled by spinning it. If it wobbles, it's uncooked; if it spins nicely, it's hard-boiled.

Refrigerate all dairy products and eggs immediately and leave them refrigerated, which means don't leave the carton of milk on the table or on the counter during dinner as this will wildly reduce its shelf life.

Ice cream: Wait until you are ready to join the check-out line before selecting ice cream. The array is enormous and overwhelming. Do you want super-duper premium high-fat? Low-fat masquerading as high-fat? Frozen yogurt? Sherbet? Sorbet? Is sorbet really sherbet with a fancy name? Should you buy the store brand? Is $3 an unconscionable amount of money to spend on a pint of ice cream? You want me to answer all these questions?

Okay. I am an ice-cream freak and a colossal snob as well. I would rather eat premium ice cream than frozen flavored air. If you eat ice cream every day, can't live without it, and have a limited budget and don't care too much about taste, then by all means go for the cheapo stuff. If you only indulge once in a while and are fussy about the taste, texture, and butterfat content (that's what makes the high-priced ice cream so rich-tasting), then be my guest. If you really are into ice cream and have the time to be adventuresome, look into purchasing an ice-cream maker. Then you can make ice cream at home whenever you want.

Whatever brand of ice cream you select, get it home and into the freezer in a hurry since melted ice cream looses its overrun (the air that has been beaten into it to make it ice cream rather than simply flavored frozen cream). Stick it in a plastic freezer bag. This

will prevent a major mess should your freezer have a melt-down or if someone forgets to close the freezer door. It also protects the ice cream from picking up flavors of other foods in the refrigerator and freezer. Unopened containers of ice cream will remain in prime shape up to 2 months. Opened containers should be used within 2 weeks.

Breads: I suppose most new cooks don't think of bread as a perishable item until they look at the bottom of an English muffin that has been sitting on the counter for a week. While I don't love the taste of cold bread I store bread in the refrigerator, which almost doubles its shelf life. Items like fresh bagels and French bread, on the other hand, should be eaten on the day of purchase, or frozen. All bread and bread products can be frozen. It is best to thaw them still wrapped on the counter (yes, this can take longer than the time you have), or in the microwave or toaster oven. The toaster oven, however, tends to burn the top of rolls and bagels and the like before the inside gets thawed, and the microwave can turn frozen bagels into thawed fossils.

Storing food in cans, jars, bottles, and bags: *Don't store leftovers in tin cans.* This includes canned vegetables, sauces, tuna, Spam-like products, fruits, and prepared foods, such as canned soups, and meals in a can. This policy has more to do with taste than health issues. Also, one tends not to be as careful when wrapping the top of a can in plastic wrap (an impossible job if ever there was one), so food gets dried out or tipped over in the refrigerator. Transfer the food to a sealable plastic container or bag and refrigerate. Don't keep leftovers stored this way for more than 3 days.

If you are storing food in the bottle it came in, wipe off any food remaining on the inside of the lid with a clean, damp paper towel. Do not keep these leftovers more than 3 days. If there is an off odor, presence of mold, discoloration, or if the liquid is foamy or frothy, or if you have the slightest suspicion the food may have gone bad, dump the whole thing. Don't even taste it. A case of food poisoning is not worth the few pennies you might be saving.

Things like jams, jellies, store-bought mayonnaise, salad dressings, barbecue and dessert sauces have a very long shelf life once they have been opened. For these products the above rules, for the most part, don't apply.

Opened bags and boxes of chips, crackers, cereal, and cookies will get soggy and stale unless they are carefully resealed in either the bag they came in or transferred to another sealable container. A great way to store cereal and chips is in half-gallon–sized plastic containers with snap-on lids or Ziploc plastic bags. Crackers can be

"re-freshed" by placing them on a cookie sheet in a 250 °F. oven for about 10 minutes. Stale potato chips and crackers can be recycled into crumb toppings for baked chicken and casseroles. Bags and boxes of cookies can be slipped into a plastic bag to stay fresh.

Does the Catsup Go in the Refrigerator?

Okay, you're shopped out. No rest for the weary. You have to unload the stuff and put it away. The following guidelines are my suggestions for where it should go. Obviously, when you start cooking and cleaning up it may make sense to move things around.

Immediately refrigerate all cold-seeking food, and freeze the appropriate items. Really organized people might want to consider taping a list of the contents of the freezer to the wall near it. If you freeze items in packages other than the ones they came in, make sure to label them. I promise, you won't be able to tell the difference between bean soup and hot fudge sauce once permafrost has set in.

Sometimes the factor that decides if a thing can be stored on a shelf versus in the refrigerator hinges on how cool your cabinet or shelves are. If they are away from direct sunlight, not next to the stove or heat source, then you are golden. If you are crammed into a tiny space where everything is close to sunlight or heat, try to utilize a porch to store packaged and bottled goods (be sure they won't freeze) or a closet away from the heat. Odds are that your refrigerator won't be able to hold everything, so look around for some cool storage space.

If you have a canister set, empty the granulated sugar and flour into the appropriate containers. Place some sugar in a sugar bowl and some salt and pepper in the shakers. Store these either on a little-used counter or in a nearby cabinet. Place the surplus flour and sugar (still in the box or bag) in a plastic bag in the back of the cabinet. This will keep the sugar from getting lumpy and the flour from attracting meal bugs. Also in the cabinet place the rest of the items from the baking aisle. When you open the brown sugar, put the box in a sealed plastic bag to keep the sugar soft. If it gets hard, cut an apple in half and stick it in the bag with the sugar overnight, then remove the apple.

Store the spices and seasonings in a cool, dry place (not the refrigerator) away from heat and light, which can shorten their shelf

life. Don't buy spices and seasonings in bulk. They have a very short shelf life, just a few months, before they lose their potency. The worst way to store them is in clear glass jars. Best are dark, opaque, securely sealed small containers.

Store the oils, vinegar, and unopened jar of mayonnaise in a cabinet or on an open shelf. Opened cans of solid shortenings and all opened bottles of oils, vinegars, honey, syrups, and steak sauces (ketchup included) can be stored in cabinets or on shelves that are out of direct sunlight, but not above the stove, and away from other heat sources. Once opened, mustard, mayonnaise, and salad dressings must be refrigerated as must most jams and jellies. I keep grape jelly in the cabinet when I'm stretched for refrigerator space. Even though the label says refrigerate after opening, I've never lost one yet. I don't like the consistency of cold peanut butter, so I put that in the cabinet too. If you like your peanut butter hard and cold, then refrigerate it.

If you choose to refrigerate honey, which I don't, and it becomes crystallized, just set the opened jar in a pan of very hot water until the crystals dissolve.

Miscellaneous jars and cans can go in the cabinet until they are opened, then refrigerate them. Store rice, cereal, dried fruits, and all dry ingredients (cocoa, noodles, and so on) on a shelf. Tea bags and instant coffee can also go on the shelf. Refrigerate or freeze coffee beans or ground coffee. While I have friends who store unopened cans of tuna in the fridge, I wouldn't dream of it.

Keep on eye on opened packages of dried fruit—raisins, for example. If they begin to attract bugs, throw them out and store the new box in a plastic bag.

The contents of opened boxes of pretzels, chips, cereals, cookies, and crackers will get stale and soggy fast if you don't reseal the inner lining or repackage in plastic bags. Same with marshmallows, except they get stale and hard. Use a rubberband to close up the bag. Actually it is a really good idea to train yourself early on to reseal, refasten, and rewrap everything you use carefully. You will extend the shelf life and the ingredients will taste better.

Opened jars of tomato sauce, salsa, and the like need to be refrigerated. If they originally came in metal cans then transfer the contents to a plastic container.

Never refrigerate chocolate. It will accumulate moisture and get moldy and be difficult to work with. Place chocolate, well wrapped since it will quickly pick up the odors of anything stored near it, in a cool, dry place.

> **A**dd a slice of apple to a bag of brown sugar to keep it from hardening. Seal the bag tightly, and remove the apple slice after one day.

Unripened fruit can be stored on the counter until ready to eat. Refrigerate when ripe. Potatoes, onions, and garlic should be stored in paper bags (not plastic—they need air!) in a cool, dry place. Do not refrigerate. If you have run out of room, think about buying an inexpensive plastic storage bin from an office-supply place; the put-together kind with wheels is super for potatoes and onion and storage.

Paper products can go in those harder to get to storage places, except for the items that you'll need every day, such as paper towels, which should be hung from the paper towel holder it will take you 3 minutes to install on the inside of the cabinet door under the sink. Place plastic wrap, foil, and waxed paper near your work area to have handy when putting food away.

Designate a place and containers to store recyclables. Remember to rinse out every can, bottle, and jar so that you're not inviting the roach brothers and their families to a tasty buffet. A bottle brush is good for this job. If you live in a state where bottles and soda cans are redeemables, throw them in one bag and the cans and jars in another.

Get in the good ecological habit of reusing grocery store plastic or brown paper bags for produce, deli-food containers, and rubber bands from home-delivered newspapers. Don't use a paper towel when a sponge will do. Earth-wise, it's kinder to ask for recycled brown paper bags to lug your groceries home in. It's easy to cut down on the number of plastic bags you take when picking out fruit in the market; 4 oranges or 2 lemons and a grapefruit or two can just as easily go loose in your cart or go in a small paper bag.

3

Getting Ready to Cook

How to

How to Measure

Use only standard measuring cups and use the U.S. ounces scale (as opposed to the metric system).

Dry ingredients (like flour, sugar, and rice) and solid fats (vegetable shortening, butter, and margarine) are measured in measuring cups that are usually made of plastic or metal. They have flat edges, no spouts, and can be used as scoops. They come in the following sizes: ¼ cup, ⅓ cup, ½ cup, 1 cup. The best set I ever used was by Tupperware and it also included a ⅔ cup. It's a good idea to have a full set plus an extra 1-cup measure. Measuring spoons are used to measure small amounts of both liquid and dry ingredients. They come in ¼ teaspoon, ½ teaspoon, 1 teaspoon, and 1 tablespoon.

When measuring a dry ingredient, heap or scoop the cup from the canister or flour bag to overflowing; then level off the top with the straight edge of a knife or spatula. If you are measuring fats, it will make the job easier if they are at room temperature. Use a small rubber scraper to pack the fat into the measuring cup, and level off the top with the flat side of a knife or metal spatula.

If a recipe calls for flour sifted before measuring, then scoop out the amount, level it off, and sift it into a bowl or onto a large piece of waxed paper. Carefully spoon the sifted flour back into the cup, taking care not to pack it down. Level off the top.

Never hold the measuring cup or spoon while you are measuring something directly over the mixture you are cooking. In other words, say you want to add a teaspoon of salt to your soup. Don't hold the teaspoon over the soup and pour the salt into the spoon.

To measure baking powder, baking soda, yeast, dried seasonings, and so on, dip a clean, dry measuring spoon into the box or package and level off the top. A "heaping" spoonful means that you should pile as much of the ingredient into the spoon as possible.

Sometimes it is far more accurate to weigh ingredients using a kitchen scale instead of measuring them. The best example is chocolate. Say you have half a chocolate bar or part of a bag of chocolate chips left over from the last time you made brownies. The recipe calls for 3 ounces. The only way to figure out what 3 ounces looks like is to pull out your trusty kitchen scale (although in this case, a postage scale would work as well).

When a recipe says to season "to taste," start with the smallest pinch, shake, or squirt. You can always add more. It's hard as hell to take away.

Before measuring brown sugar, carefully mash out any lumps, then pack the measuring cup full and level off the top.

Liquids should always be measured in a glass measuring cup. Pyrex makes good ones. It's a good idea to own a 1-cup, 2-cup, and 4- or 6-cup measure. To measure liquids place the measuring cup on a flat surface and slowly pour the liquid in, bending so that you are at eye level with the marker. If you are measuring egg whites, pour the entire white into the measuring cup and if you have too much, use a small spoon to remove some. If you are measuring milk or juice that has bubbles on the surface, wait for them to subside before taking the final reading.

It is easier to measure honey when it is in liquid form. Run the container under very hot water before pouring.

Here is a list of equivalent measures:

a pinch = slightly less than ⅛ teaspoon

3 teaspoons = 1 tablespoon

2 tablespoons = 1 ounce liquid

4 tablespoons = ½ cup or 4 ounces liquid

1 cup (liquid) = 8 fluid ounces

2 cups (liquid) = 1 pint = ½ quart

4 quarts (liquid) = 1 gallon

1 tablespoon butter = ⅛ stick, ½ ounce

2 tablespoons butter = ¼ stick, 1 ounce

4 tablespoons butter = ¼ cup, ½ stick, 2 ounces

8 tablespoons butter = ½ cup, 1 stick, 4 ounces

32 tablespoons butter = 4 sticks, 16 ounces, 1 pound

margarine = same as butter

1 pound brown sugar = 2¼ cups firmly packed

1 pound confectioners' (powdered) sugar = 3½ cups sifted

1 pound granulated sugar = 2 cups

1 pound white flour = 4 cups

1 pound whole-wheat flour = 4½ cups

1 cup uncooked rice plus 2 cups liquid = 3 cups cooked rice

2 slices bread = 1 cup bread crumbs

12 graham crackers = 1 cup cracker crumbs

1 pound cheese = 2 cups grated

4 ounces nuts = ¾ cup chopped nuts

1 large egg white = 2 tablespoons

8 large egg whites = 1 cup

1 large egg yolk = 1 tablespoon

16 large egg yolks = 1 cup

apples, sliced raw, 1 pound = 3 cups

carrots, sliced, 1 pound = 3 cups

onions, chopped or sliced, 1 pound = 3 cups

Square cake pans

8 × 8 × 2 inches = 6 cups

9 × 9 × 1½ inches = 8 cups

9 × 9 × 2 inches = 10 cups

Round cake pans

8 × 1½ inches = 4 cups

9 × 1½ = 6 cups

Pie plates

8 × 1¼ inches = 3 level cups

9 × 1½ = 4 level cups

Loaf pans

8½ × 4 × 1¼ inches = 6 cups

9 × 5 × 3 inches = 8 cups

How to Read a Recipe

A good recipe works. It is a precise formula. It is not a loose suggestion for things you might do to ingredients, nor is it an invitation for experimentation. A few recipes in this book will invite you to experiment with ingredients or add more of less of something to change the consistency more to your liking. However, for the most part, the basic premise here is that if you want the same dish I got when I finished cooking, you should follow the recipe exactly and in the order it was written.

Don't be put off because a recipe has more than a few ingredients. It's the number and kind of steps that can make a recipe easy or more challenging or downright difficult. I tend to be very specific when writing recipes, so sometimes they can appear long. That's because I spend a lot of time explaining what to do. Don't judge the recipe by its length. Judge it by the number and complexity of the steps.

Your first job is to read the recipe thoroughly and through to the end. Complete this step before you even think about cooking, since there is a great chance you won't have all the ingredients on hand. Pay close attention to tablespoons versus teaspoons.

So, you've decided to make applesauce. Good for you. Wait till you see how much more delicious it is than the store-bought kind. You can make extra (by doubling or tripling the recipe if you have a large enough pot) and freeze some for later. The recipe follows.

Applesauce

Preparation time: about 40 minutes
Cooking time: 20 to 30 minutes
Yield: 8 to 10 servings, about 5 cups
Can be made ahead? Yes. Up to 1 week. Keep refrigerated.
Can be frozen? Yes. Up to 6 months.
Can be doubled and tripled? Yes.
Good for leftovers? Yes. Applesauce will keep for 1 week refrigerated in a
 sealed container.

*8 to 10 large Cortland or
 McIntosh apples
1½ cups water or apple
 cider*

*¾ to 1 cup sugar
½ teaspoon cinnamon
Lemon juice to taste*

Quarter the apples and remove the cores and seeds (leave the skins
on). Place the apples and cider or water in a deep, heavy-bottomed
pot. Cover, and cook over low heat until the apples are very tender,
about 20 to 30 minutes.

Use a slotted spoon to remove the apples from the pan and
reserve the cooking liquid. Purée the apples in a food processor or
blender (if you use a blender, put in only a very small amount of the
apples at a time, adding liquid to the blender as necessary to make a
purée). Add the remaining ingredients, including about ½ to ⅔ cup
of the cooking liquid. Purée until smooth. Add more lemon juice, if
desired.

Have you read it completely? Good. Then get your shopping list and
jot down the things you'll need to buy. You should already have sugar
and cinnamon on hand, perhaps even lemons as well. You'll need one
of the specific kinds of apples mentioned in the recipe. Note the
number or weight you'll need. Do you want to make the applesauce
with water or cider? If you want cider, then chances are you'll have
to buy that as well. If cider isn't available, how about using apple
juice? I think that's fine.

Now you have all the ingredients. Do you have the time? The
recipe says it will take about 40 minutes to make applesauce. This
means 40 consecutive minutes. You might speed things up a bit by
chopping faster. Then again you may also slash your finger, require
a trip to the emergency room for stitches, and as a result completely
abandon your idea of making applesauce. If you are a brand-new

cook, add a generous amount of time to the suggested time, until you are really comfortable slinging those pots and pans.

Next, take out all the ingredients you'll need, then all the utensils. This recipe calls for liquid measures (for the water or cider and the lemon juice) and for dry measures (the sugar and the cinnamon). This means you will need a 1-cup dry measure (that's the kind without the spout) and a 1- or 2-cup liquid measure (that's the glass one with a spout). Don't forget the measuring spoon for the cinnamon.

It also calls for a sharp knife large enough to quarter apples (don't use a tiny paring knife—it will take all day), and you'll need a cutting surface. You'll need a pot large enough to hold all the ingredients (without their boiling all over the stove) and a pot cover. You'll need a timer to remind you that you have something cooking (although your kitchen will take on a heavenly smell), and a large slotted spoon to transfer the cooked apples into the blender or food processor and purée the apples. Oops, what's purée? Quick, look under Cooking Terms (pages 90 to 96) in this book to find out.

You'll need a small spoon to taste the applesauce. It's a very good idea to wash the spoon between tastes with hot water and soap. Don't use your finger. It's bad form and you'll get burned.

What are you going to store the applesauce in? Something with a tight-fitting top is in order, like a heavy glass jar with a wide mouth, or a plastic container with a snap-on lid. Are you going to freeze part of it? Remember to label the container with the date as well as the contents.

How to Substitute

I have to say right off the bat that I am not enthusiastic about the idea of substitutions. It's far better to use exactly what the recipe calls for. I do understand, however, that people get caught in situations where they can't have exactly the right ingredient. There's a howling blizzard outside and you can't live without brownies and you don't have baking chocolate. Just remember, the results won't be the same. So, here goes:

- **baking powder, 1 teaspoon** = ¼ teaspoon baking soda plus ½ teaspoon cream of tartar
- **beef broth or stock, 1 cup** = 1 beef bouillon cube dissolved in 1 cup boiling water
- **butter** = margarine in the same amount
- **buttermilk, 1 cup** = 1 cup yogurt, or 1 cup warm milk plus 1 tablespoon vinegar or lemon juice

To remove the smell of garlic or onion from your fingers, try running your fingers under cold water or rubbing them with fresh lemon juice or parsley.

- cake flour, 1 cup = 1 cup less 2 tablespoons white flour plus 2 tablespoons cornstarch
- chicken broth or stock, 1 cup = 1 chicken bouillon cube dissolved in 1 cup boiling water
- chocolate, unsweetened, 1 ounce (1 square) = 3 tablespoons cocoa plus 1 tablespoon shortening (butter, margarine, or vegetable shortening)
- chocolate, semisweet, 1 ounce = 3 tablespoons cocoa plus 2 tablespoons shortening (butter, margarine, or vegetable shortening) plus 3 tablespoons sugar
- cracker crumbs, ¾ cup = 1 cup dry bread crumbs
- cream, 1 cup = ⅓ cup melted butter plus ¾ cup milk (this will not whip to make whipped cream)
- flour, white, 1 cup = 1⅛ cups cake flour, or 1⅛ cups whole-wheat flour
- garlic, 1 clove = ⅛ teaspoon garlic powder
- herbs, dried, 1 teaspoon = 1 tablespoon fresh herbs
- milk, whole, 1 cup = ½ cup condensed milk plus ½ cup water, or ⅓ cup powdered milk plus 1 cup water, or 1 cup buttermilk plus ½ teaspoon baking soda
- milk, skim, 1 cup = 1 cup water plus 4 tablespoons nonfat powdered milk, or ½ cup evaporated skim milk plus ½ cup water
- mustard, 1 tablespoon prepared = 1 teaspoon dried
- nuts, chopped or ground, such as almonds, walnuts, and pecans can be substituted for one another
- sour cream, 1 cup = 1 cup yogurt
- sugar, 1 cup = 1 cup molasses plus ½ teaspoon baking soda, or 1 cup honey plus ½ teaspoon baking soda
- tomatoes, canned, 2 cups = 2½ cups peeled fresh tomatoes cooked for 10 minutes
- vanilla bean, 1-inch piece = 1 teaspoon pure vanilla extract

How to Decipher Abbreviations

When I write a recipe I don't use abbreviations because I think it's much too easy to confuse tsp. with tbl., or T. with t. However, many cookbooks do use abbreviations. Here's what they stand for:

t., tsp. = teaspoon oz. = ounce

T., Tbl., Tblsp. = tablespoon lb. = pound

C., c. = cup min. = minute

pt. = pint hr. = hour

spk. = speck (same as a pinch)

How to Prepare a Pan

This important step will save you time, money, and aggravation. It's easier to get food out of a pan that's been properly prepped. You won't waste the stuff that's baked onto the sides and bottom, and cleanup is much faster.

An aerosol oil spray is a godsend. I use it on the racks and the floor of my oven (*apply it only in a turned-off oven*) so I can just wipe off spills and burned-on food. Before roasting, spray your pans or coat them with a very fine film of solid vegetable shortening or vegetable oil. Spray a frying pan for low-fat sautéing, and a soup pot before adding the ingredients. Use it on casserole dishes as well.

Baking is a different matter. I find that cooking spray burns too easily and makes hard-to-remove marks on things like cookie sheets. I always line my cookie sheets with foil, unless the recipe says specifically not to do so. The cookies usually can be peeled right off. Another choice for lining cookie sheets is parchment paper, which is sold by the roll or by the sheet in gourmet cookware shops. A third choice is to line the cookie sheet with waxed paper, use a paper towel to coat the paper with a thin film of soft butter or shortening, and sprinkle on a fine dusting of flour. Knock off the excess flour.

To prepare cake pans (both round, square, and oblong, glass and metal), apply a thin coating of soft butter or shortening, line the pan with a piece of waxed paper or parchment paper measured to fit the bottom, and grease the paper. Dust with flour, knocking out the excess. I know this sounds like a lot of bother, but you will get the cake out of the pan instead of serving the cake in the pan—very tacky, indeed.

Most things will freeze. The big exceptions are salads containing raw vegetables, things with mayonnaise or other like dressings, marshmallows, gelatin-based foods, and meringue (egg whites whipped with sugar). Whipped cream will lose a lot of its personality, but still tastes good.

The things to watch out for are freezer burn (when the food gets dried out from not being wrapped properly); odor contamination (when everything in the freezer starts to smell and taste like your famous garlic bread); and general identity crises (what the hell is this?).

The first two problems are easily solved by using only heavy-duty plastic bags or plastic containers with tight-fitting snap-on lids. The third is solved by scrupulously labeling everything that goes into the freezer even though you'll swear you'll remember what it is next time you run across it. Trust me. Everything looks the same after a week in the freezer. Label. It helps to keep an inventory taped to the freezer door so you'll know what's inside without having to spend hours searching for those veal chops that you forgot you ate last Friday.

If you are freezing garlic bread, wrap it in heavy-duty foil first, then in plastic wrap, which will keep the garlic to itself. You only have to remove the plastic wrap and pop the foil-wrapped bread into the oven to heat it.

It's always a good idea to store ice cream in a plastic bag or wrap the container in plastic. This keeps the flavor fresh and prevents a catastrophe in case of a melt-down.

Nuts, grains, coffee, flour, and things like shredded coconut, bread crumbs, and grated cheese should be stored in Ziploc freezer bags or plastic containers. Just make sure that you're not taking up lots of space with half- or quarter-filled containers.

Uncooked meat, poultry, and fish should be rewrapped before freezing. Discard the store packaging, rewrap in clear plastic, then

Carefully squeeze out all the air from plastic bags before storing them in the freezer. This will prevent ice crystals from forming on the food, and preserve the flavor and texture of the contents.

put in a freezer bag. Freeze meat in one layer to shorten defrosting time, or insert layers of plastic wrap between things like hamburger patties and chops so that you can pry them apart if you want only one or two while the rest remain frozen.

When you make extra to freeze—soup, stews, applesauce, breads—wrap them carefully and *label! label! label!* Otherwise, I can guarantee that you won't be able to differentiate between last month's vegetable curry and last week's beef stew.

Lastly, try not to look at the freezer as your trust fund. Not only is it okay to dip into the principle, it's expected. Rotate that stock. Use it up and replenish it. Frozen food isn't like fine Burgundy. After a year or so frozen peas take on the personality of buckshot. Eat 'em while they're fresh-frozen.

How to Defrost

Healthwise it's imperative to let meat, chicken, fish, egg-based dishes, and casseroles with any of these ingredients defrost in the refrigerator. This will take between 24 and 36 hours, depending on whether you're defrosting a 1-inch swordfish steak or a 6-pound roast beef. If you plan to defrost a turkey give it at least 2 full days in the refrigerator (may even be longer if it's very large). Always set the defrosting item, loosely wrapped in plastic to keep it from drying out, in a shallow tray or on a plate so that any drips don't get on other food in the refrigerator.

If you choose to use the microwave to defrost meat, fish, poultry, or dishes containing these items, you should proceed to cook them right away since the microwave defrosting process tends to cook parts of the food as well.

Baked products—bread, cake, cookies—can defrost on a counter. Make sure to leave them in their wrappers so the moisture can accumulate on the outside of the package.

Wrap lettuce in paper towels before you put it in a plastic bag. This will prevent the leaves from browning by absorbing any excess moisture.

Frozen vegetables should be cooked frozen. Do not defrost first.

You can quickly defrost either store-bought or home-frozen plastic bags of fruits like raspberries, blueberries, strawberries, and peaches, by dipping the still-sealed plastic bag they are stored in into hot water.

How to Wash Lettuce

Lettuce should be washed only a few hours before you plan to eat it, although if you're careful about removing the excess moisture, you can do it the day before.

If you want something other than iceberg lettuce in your salad, like red leaf, Boston, or Romaine, you'll have to wash it. Don't make the mistake of assuming that if you can't see dirt, there isn't any there. One gritty bite says it all, and when the dressing's on, it's too late.

Snap, twist, or cut the stem part off the bottom of the lettuce. This is a little hard to do with Boston lettuce because the stem tends to be small. Separate the leaves and wash each one under cold running water. Run your fingers over the stem end to wash away any remaining dirt. Cut off any fibrous or tough-looking ends (they are the ones wearing the white undershirts with a pack of unfiltered Camels tucked into the rolled-up sleeve).

Shake the lettuce to get rid of as much water as possible and then either pat dry with a *clean* dish towel or paper towels, or dry in a salad spinner. A salad spinner is a handy gadget you will start out being sure you can live without and then have a quick change of heart next time you go on a salad diet.

Place the lettuce in a plastic bag until time to serve.

How to Tell When It's "Done"

This takes practice. Pay close attention to the cooking times in the recipes. With a cake, the sides will begin to pull away from the pan and a cake tester (a thin wire that you push into the center of the cake) or a wooden toothpick will come out clean and dry. You can tell this by wiping the inserted part with your thumb and forefinger. The top of the cake will spring back when lightly pressed.

Cookies generally will have a golden brown color and the edges will appear crisp when done. If in doubt, lift one with a spatula and check the underside. It should be golden brown. If it's chocolate, this rule doesn't apply.

Bread will sound hollow when the bottom is tapped. It's fine to take the bread out of the pan and let it finish baking right on the rack for the last 10 minutes. This will give it a beautiful crust. Baking powder breads will have begun to pull away from the sides of the pan, and a cake tester or wooden toothpick should come out clean and dry.

Vegetables that you bake in the oven—whole potatoes and some kinds of squash—will yield easily to a sharp knife. Vegetables that you boil take far less time and should be tested after the first 3 to 4 minutes of cooking. Carrots and other root vegetables take longer. Spear a piece with a fork or sharp knife. It should cut easily, but not look wilted.

Dried beans, peas, and other legumes are done when they are tender and have absorbed most of the cooking liquid.

Casseroles are done when the top is well browned, any liquid is bubbling, and a knife inserted in the center comes out very hot.

Rice is cooked when all the liquid is absorbed and the grains no longer are crunchy.

Pancakes are ready to turn when the top starts to bubble all over and the edges puff up. Flip them over and cook for an additional 1½ to 2 minutes until the bottoms are dry. The flip sides won't get as brown as the others.

Waffles are done when the steam stops and the sides are golden brown.

Milk-based soups are done *before* they come to a rolling boil. Watch for tiny bubbles forming around the edge of the pan.

A soft-boiled egg is done after 2 to 3 minutes of active boiling; a hard-boiled egg after 12 minutes. Remove the egg from the water and immediately run cold water over it to stop the cooking.

Pasta and noodles: Try one to know if it's done. If it's still crunchy or chewy, it is not done. I have a friend who swears by the throwing-at-the-ceiling method, where you fling a strand of pasta heavenward and if it sticks it's done. (Or is it if it falls down it's done? I forget.) But her ceiling looks like hell, so I don't recommend it.

Jell-O and puddings are set when you can tip the bowl and nothing moves. You can speed the setting of gelatin by adding half the volume of liquid in the form of ice cubes or shaved ice. Add the

boiling water first, dissolve the gelatin, then add the ice, stirring until it melts completely. Refrigerate until firm.

Fish will flake easily when it's done. Use a knife or fork to cut into the middle (in the thickest place). It should cut as easily as butter and have lost that translucent raw look.

It's best to use a meat thermometer when cooking a whole chicken (see chart, page 86). For chicken parts, cut into the leg at the joint. The juices should run clear and the meat should be very tender and separate easily. The breast should have no traces of pink.

Expert cooks learn to gauge a steak's doneness by touch. The more resistance, the more well done it is. Rare will feel almost squishy. The easiest way for new cooks is to pay attention to suggested cooking times and then cut into the meat to make sure. Remember, the thicker the meat is, the longer it will take to cook, and the closer it is to the element or heat source, the faster it will cook.

How to Use a Meat Thermometer

Of all the foods you will be preparing meat will probably be among the most expensive. It is well worth the small expense to purchase a meat thermometer and use it. I'm not just talking beef here. Use it for any kind of roast from pork to veal. Use it when roasting a turkey or large chicken. There are two kinds of thermometers: one kind you insert and leave in for the entire cooking process, and the other is an "instant read," which you use to take the temperature, then remove. I prefer the first kind for a new cook, since it usually comes attached to a handy chart that lists cooking temperatures.

Insert the point of the meat thermometer in the center (thickest part) of the meat, away from any bones and fat. On a turkey this would be the neck end of the breast slanting downward toward the tail. On a roast beef it would be in the center.

To keep green beans, fresh spinach, asparagus, and peas green, add a pinch of baking soda to the cooking water.

85

Meat Temperature Guide

Ground Meat and Meat Mixtures

turkey, chicken 170°F. veal, beef, lamb, pork 160°F.

Beef

rare 140°F. well done 170°F.
medium 160°F.

Veal

medium 160°F. well done 170°F.

Lamb

rare 140°F. well done 170°F.
medium 160°F.

Pork

medium 160°F. well done 170°F.

Poultry

chicken, whole 180°F. poultry breasts, thighs,
turkey, whole 180°F. wings 170°F.

Ham

fresh, raw 170°F. precooked (to reheat) 140°F.

The cooking time will vary with the oven temperature, so your thermometer is the very best indicator of what's going on inside the beast. Remember all fresh (uncured) pork and pork products must be cooked to over 140°F to eliminate the danger of trichinosis—a parasitic disease that (believe me) you don't want.

How to Set the Table

Even when you are eating a simple meal alone, creating a pleasant space is a nice thing to do for yourself. It gets you into the habit of setting the table so that when you have company, you'll know just what to do.

Start by clearing everything off the table or counter (or at least piling it an arm's length away). Wipe down the surface. Set out a place mat or tablecloth (if you love doing laundry). Actually some

people keep a tablecloth on their table all the time and use place mats as well, extending the shelf life of the tablecloth.

If you are serving food onto a plate in the kitchen, then put the plate near the stove. If not, set the plate on the place mat. On the left of the plate place a napkin, folded in half. The fork goes on top of the napkin. If you're being really fancy and using one fork for dinner and one for dessert, then place the dinner fork (the bigger one) to the left of the smaller one. The knife goes on the right side of the plate, blade facing toward the plate. Next to that goes the teaspoon, if you need one. If you are having soup, then the soup spoon goes on the right of the knife. The water or wineglass goes above the spoon or knife, and if you want to be really fancy and use a small bread-and-butter or salad plate, that goes above the fork. The general rule of thumb is that the utensils are laid out in the order in which they are to be used. So, if you go to someone's house for dinner and see a small fork on the left of the dinner fork, you should assume that there will be an appetizer served. If there is another small fork, this one on the right of the dinner fork, you can assume that these folks are well endowed in the silver department and are serving a dessert, too.

Don't let the lack of a lot of knives and forks prevent you from serving more than one course. You can always wash silverware between courses, or simply instruct your guests to L and R (lick and retain).

How to Make Great Coffee

You're a grown-up now. Throw away that instant coffee. There is nothing in the world like a great cup of coffee, and anyone with half a mind can make one.

Some rules. Oy, more rules?

- Great coffee starts with fresh grounds, which come from fresh beans. It's terrific if you can grind your own, but don't lose sleep if you can't. You can have the supermarket grind the beans for you. Or, buy cans of already ground coffee. Store your beans or ground coffee in the freezer at all times. Write on the package whether it's decaf or regular and place in a freezer bag. Your Aunt Sophie will thank you for not keeping her up all night and your freezer will be blissfully free of little brown grinds.

- Use the right grind for your pot. Drip, percolator, and espresso pots call for different grinds. Specify which you want when you buy it.
- Be generous when measuring. Use 2 level tablespoons to one 8-ounce cup of coffee, or 1 heaping coffee measure for each cup. If you like it stronger, add a little more. Don't be tempted to pour coffee through the grounds more than once—it makes the coffee bitter.
- Don't ever let coffee boil, and don't let it sit around too long. It will get bitter and taste burned. Don't reheat it.
- Make sure your coffee pot and all its parts are as clean as possible. Run some coffee pot cleaner (available in the supermarket) or a weak solution of water and vinegar through the system every month or so.

To make iced coffee, use double the amount of ground coffee, cool the coffee, and add ice. You can also used leftover coffee to make ice cubes to add to hot coffee.

If you like steamed milk but don't have one of those fancy cappuccino machines, simply pour about a cup of milk into a small saucepan. Set it over medium heat. Using either a wire whisk or an egg beater, beat the milk while it heats. The easiest way to do this with a whisk is to hold the end of the whisk straight up between your palms and rub your hands briskly back and forth, twirling the whisk around. Don't let the milk boil! It will overflow the pan and cause a gross mess. This is enough steamed milk for two cups of coffee. Top with a dusting of cocoa or cinnamon.

How to Make Tea

Our friends, the health food nuts, have rediscovered the joys of tea. The varieties are endless, from spiced apple cinnamon without caffeine to Earl Grey in individual foil-covered packets to keep it fresh. Remember that before tea bags were invented, tea came loose and was made in a teapot.

Tea bags are a great invention, but there's more to making great tea than dunking a bag into a cup of hot water. First of all, you need to heat the cup. Since you're already boiling water for the tea, this isn't hard to do. Start with fresh water (not the water that's been sitting in the pot for a week). Bring it to a rolling boil. Fill the mug or cup and let the hot water sit there for a minute. Empty the cup,

add the tea bag, and refill with boiling water. Steep until it's as strong as you like.

To make tea in a teapot: Bring fresh water to a boil. Rinse the teapot out with boiling water and pour the water out. Refill with boiling water. Add either 1 teaspoon of loose tea for every cup of hot water or 1 tea bag for every 2 cups. Let the tea steep until it is the desired strength and serve. Pass lemon wedges, sugar, and milk separately. Don't use milk and lemon together. The acid will make the milk curdle.

What About Wine?

The best place to learn about wine is in a reputable wine store. Many have a resident wine expert who will happily produce a bottle in your price range to go with your menu. You don't have to spend a fortune to get a decent bottle of wine. If you pick something out you like especially well, soak off the label and save it to remind yourself to buy it another time.

There used to be a simple rule about serving dry white wine with fish and chicken, and red wine with meat and cheese. For the most part, that rule still applies, although many people drink white wine with veal and red wine with duck, it being more like red meat than chicken or turkey.

Rosés or blush wines (pale pink in color) are often served with light, cold summer dishes and are also fine with fish and chicken. Champagne is great as a before-dinner drink or with dessert. It tends to be too sweet to be served with an entrée. There are sweet dessert wines for you to explore as well. A full-bodied red wine is great with a hearty casserole or thick soup or stew as well as with a roast or steak.

White wines, champagnes, and rosés are served chilled, but not freezing cold, as this would rob them of all their flavor.

Red wines are served at room temperature. Ask the wine merchant if you should open your red wine ahead of time to let it breathe.

Alcohol has lots of calories and little nutritional value. Try diluting wines with seltzer, or drink fruit juice that is cut with flavored carbonated water.

Cooking Terms and What They Mean

You will find many of these terms used in the recipes in this book, and most of them when you venture into other cookbooks.

Al dente: This Italian term literally means "to the tooth" and describes the texture of food, primarily pasta, when it is cooked still on the firm side.

Au gratin: This French term means "to a thin crust" and is a dish with a crispy cheese, crumb, and butter topping.

Au lait: This French phrase refers to food prepared with milk, as in *café au lait*, hot coffee with hot milk.

Bain-marie: A waterbath—a pan of hot water into which another dish of food is placed. Both pans are put in the oven, where the *bain-marie* creates a moist cooking environment for certain foods such as custards. Used on top of the stove a *bain-marie* is exactly the same as a double boiler: one pot of gently simmering water holding another pot of food to be cooked or kept warm by gentle heat.

Bake: To cook with dry heat, either covered or uncovered, in an oven. Cakes, cookies, pies, casseroles, and many other similar preparations are baked.

Barbecue: To cook on a charcoal or gas grill over high heat.

Baste: To moisten a preparation with liquid while it cooks to keep it from drying out.

Batter: A mixture usually made of flour, water, and eggs that is thin enough to pour.

Beat: To mix by machine or by hand with a spoon or whisk. The object of beating is to incorporate air into the mixture being beaten.

Blanch: To boil rapidly and for a very short time in a large quantity of water. Blanching removes the brown skins from almonds and loosens the skins of tomatoes for peeling. It is a way of cooking vegetables so they remain crunchy.

Blend: To combine two or more ingredients until they are incorporated.

Boil: To heat a liquid to a temperature of 212°F. at sea level until bubbles break continually on the surface. For each 2,000 feet above sea level, the boiling point of water drops 2°F. Because the liquid boils at a lower temperature, food cooked at high altitudes must be cooked a little longer than food cooked at sea level.

With a full boil, bubbles consistently form across the surface of the liquid. When the liquid is boiling so rapidly it cannot be stirred down, it is called a rolling boil.

Bouquet garni: An assortment of fresh and dried herbs and spices tied in a piece of cheesecloth. Think of it as an herbed tea bag. Used in stews, stocks, spiced wines, and punches.

Braise: To cook food slowly, usually covered, in a small amount of fat or liquid, either in the oven or on top of the stove.

Bread: To coat food with bread, cracker, or cereal crumbs as a preparation for baking or frying.

Broil: To cook under and close to the direct source of intense heat.

Brown: To cook the outside of food quickly, usually over high heat, to seal in the juices and flavor.

Calorie: The amount of heat needed to raise the temperature of 1 gram of water from 14.5 to 15.5 degrees Celsius.

Caramelize: To heat sugar and a small amount of water until it melts and turns a golden brown. Also the process of sprinkling a dish with sugar and holding it under the broiler until the sugar melts and begins to darken.

Casserole: This word refers to both a container and the food that goes in it. Usually a combination of meat, chicken, or fish and vegetables, or vegetables with a starch like rice or pasta, or a combination of all of the above combined with a sauce.

Clarify: To make a liquid completely clear by removing all traces of fat and food particles. To clarify soup, for example.

Clarified (drawn) butter: The result of separating out the milk solids and residual liquid from butter. This is done by either melting the butter and pouring off the milky white solids, or carefully heating the butter to a boil and boiling off the milk solids. Best done with sweet (unsalted) butter.

Chop: To cut food into small pieces.

Cream: To mix one or more ingredients together until smooth, soft, and completely blended. Butter and sugar are creamed together to make cake batter.

Crudités: Assorted raw vegetable sticks, usually served with a dipping sauce.

Cut in: To incorporate cold shortening (fat) into flour until it resembles coarse crumbs. It is a step in making pie pastry and crumb toppings and can be done with a pastry blender or with 2 knives and a crisscross cutting action.

Degrease: To remove fat by lifting it off the surface of a cold dish or skimming it off the surface of a hot dish such as a soup, stew, or sauces.

Dice: To cut food into a uniformly small size.

Dough: A stiff mixture of flour, liquid, and other ingredients. The mixture will take on a different personality depending on its ingredients; pie dough and bread doughs are examples.

Dredge: To cover the outside of food, such as meat, with a dry ingredient, such as flour. The food is then cooked in hot fat. Dredging keeps the flavor in and gives the food a nice appearance.

Drippings: The accumulated bits of cooked matter and liquid left in a roasting pan after meat, poultry, or fish has been cooked. Used to make pan gravy (page 261).

Dust: To sprinkle food lightly with dry ingredients, such as a dusting of cocoa on the top of a cake.

Fillet: The verb: To remove the bones from a piece of beef, chicken, or fish. The noun: the food after the bones have been removed; fillet of sole, fillet mignon.

Flambé: To flame a dish that has been doused with warmed alcohol to impart a specific flavor and drama. Cherries jubilee is an example.

Fold in: A delicate scooping motion to combine a lighter mixture into a heavier one without deflating the final combination. Stiffly beaten egg whites are folded into a yolk base to make a soufflé. The air bubbles expand and the soufflé rises.

Fondue: A dish wherein small pieces of food are cooked or dipped in hot broth, oil, or melted cheese. Also served as a dessert with fruits and pieces of cake dipped into warm chocolate sauce.

92

Fricassee: To cook slowly, covered, over low heat until the resulting combination is extremely tender.

Fry: To cook in hot fat in a pan or kettle over moderate-to-high heat. Or, to submerge food completely in hot fat until crisp. Doughnuts and fried chicken are examples.

Garnish: To embellish a dish as a way of finishing it and making it look appealing and pretty. Parsley and lemon wedges surrounding fish, or sprigs of watercress on a platter of roast beef are examples.

Glaze: To apply a coating on the surface of certain foods to give them a shiny or smooth appearance.

Grate: To reduce food into small pieces by means of a metal utensil with sharp holes on it called a grater; grated lemon or orange rind, horseradish.

Grill: To cook food on a rack directly over an intense heat source such as a barbecue.

Grind: To reduce food to tiny particles either by hand (chopping) or in a food grinder or food processor.

Julienne: To cut food into very thin matchstick strips.

Knead: To manipulate dough (usually a yeasted one) by hand or machine for a period of time until it is smooth and elastic.

Lukewarm: Approximately body temperature.

Marinate: To cover food, such as meat, fish, and chicken, with a seasoned liquid and allow it to remain for several hours or overnight (refrigerated) to render it more flavorful and tender. Always refrigerate foods that are being marinated and do not reuse marinades from meat, fish, poultry, or other like foods.

Mince: To chop food into very fine pieces.

Mix: To combine two or more ingredients until well blended.

Mousse: A light and airy dish, sweet or savory, stabilized with gelatin and whipped cream and/or egg whites. Salmon mousse and chocolate mousse are examples.

Parboil: To precook food in boiling water for a very short time.

Pare: To remove the outer skin of fruits and vegetables.

Pipe: To force a stiff mixture through a pastry bag fitted with a metal tip to make a decorative border or filling.

Pinch: The amount of an herb, spice, or seasoning that can be picked up between the thumb and forefinger.

Pith: The white fibrous skin immediately under the outer skin on certain fruits and vegetables, notably citrus fruits. The pith of lemons, limes, grapefruits, and oranges contain high amounts of bitter and unpleasant-tasting oil.

Poach: To simmer food very slowly over low heat in hot liquid. Examples include poached eggs and chicken breasts.

Proof: To test yeast for potency to ensure that it is still active. This is done by adding liquid and a pinch of sugar to yeast, mixing well, and then waiting several minutes to make sure bubbles form and the mixture begins to get foamy.

Purée: To mash and blend to a completely smooth consistency. Baby food and applesauce are good examples of puréed foods.

Reduce: To boil down a liquid to decrease its volume and increase its flavor. When you reduce heavy cream by boiling it, it gets thicker because the water is reduced, leaving butterfat.

Render: To make solid fat liquid by heating it slowly.

Roast: To cook, uncovered, with dry heat in an oven.

Roux: A cooked mixture of fat and flour used as a thickener in sauces.

Sauté: To cook food quickly in a shallow pan in a small amount of hot butter or oil until wilted, transparent, or colored. Done at a lower temperature and for a shorter time than frying.

Scald: To cook liquid over moderate heat until tiny bubbles form around the edge of the pan. This is the stage just before boiling starts. Also, to scald food can mean to drop it into boiling water briefly, or pour boiling water over it.

Score: To make steam holes or vents in pastry so that the steam will escape and keep the inside from being soggy. Or, to make shallow cuts in meat before cooking to retain its shape while cooking. Scoring also helps meat stay tender.

Sear: To cook meat rapidly over high heat to seal in its juices and flavor.

Season: To add flavoring in the form of herbs, spices, and salt and pepper.

Shell: To remove the hard, inedible outer coverings on certain foods.

Shred: To cut or grate food into long, slim pieces. The cabbage in coleslaw is shredded.

Sift: To eliminate any lumps or foreign matter from a dry ingredient by passing it through a sieve or strainer. Also a way to blend dry ingredients.

Simmer: To cook liquid or food in liquid very gently over low heat just below the boiling point. Food cooked this way will remain more tender than if it is boiled vigorously.

Slice: To cut into uniform pieces.

Steam: To cook food over, but not in, boiling water or stock in a covered pot.

Steep: To pour boiling water or other liquid over food and let it sit in the liquid.

Stew: To simmer food slowly and for a long time in a small amount of liquid in a covered pot.

Stir: To mix ingredients together with a spoon or like utensil. To move ingredients in a pan around over heat to prevent burning.

Stir-fry: A Chinese technique of quickly cooking small slices of meats, fish, or vegetables in a small amount of oil or soy sauce over high heat, in a slope-sided pan called a wok.

Stock: The aromatic liquid left over from cooking either meat, poultry, or fish and herbs and vegetables. This is the basis for almost all sauces and soups.

Toss: To mix ingredients gently together using a light upward motion of the hand when combining.

Truss: To tie a chicken, turkey, or roast with string so that it keeps its shape during cooking.

Unmold: To turn the contents of a cake pan or other container out onto a plate or serving platter.

Whip: To beat air rapidly into a food to lighten and increase its volume. Whipped cream and meringue are examples.

Whisk: To beat with a whisk or whip until well mixed or frothy.

Zest: The outermost colored rind of citrus fruit. This is the thinnest layer possible, devoid of the white pith underneath.

Cooking Basics This Mother Thinks
You Should Know
❧

Cooking is like science in many regards. In order for things to turn out right (edible), you have to follow certain rules. These rules should get stored some place in your head so you don't have to think about them too much while you're preparing dinner. Some are handy tips more than rules that will make cooking simpler and more efficient.

A classic case in point concerns *preheating the oven*. If you are making a lasagna, baking a potato, or reheating last night's casserole, sticking the pan in a cold oven and then setting the thermostat won't result in the demise of the dish. However, if you stick a roast beef or turkey in a cold oven, all the juices will run out as the oven warms up, and you will be left with a dry, tough dinner. You will see in my recipes that the very first thing I mention is the oven temperature. I put it first because if you do it first the oven will be at the right temperature by the time you finish preparing the dish.

Choosing the right-sized pan for the job is important. If you are baking a loaf of bread and you use a pan that is too small the dough will overflow the sides, burn, and not get cooked in the middle. If the pan is too big, then you will end up with a flat loaf that has cooked too much in the middle. Where it makes a difference in the outcome of the dish, I give specific pan sizes in each recipe.

Set a timer. Even though you think you will know when fifteen minutes is up, there is always the chance that the phone will ring or something else will engage your attention, and you will forget about those chocolate chip cookies fossilizing in the oven. If you plan to stay in the kitchen, then set the oven timer. Get a good loud timer and set it right after you put the dish in the oven or over a flame on top of the stove. If you have to leave the room, stick the timer in your pocket.

Most recipes come with a cooking time, usually toward the end. I hope you don't have to learn the hard way to *respect the given cooking time*. A raw or undercooked meal is almost as unpleasant as

an overcooked or burned one. Give yourself enough time to complete the job you have started and this won't happen.

How much does this serve? The yield is given at the beginning of the recipe. If you live alone and find yourself craving turkey, you should note that a roast turkey will feed upward of 12 people. You had better really like turkey a lot if you are contemplating fixing a whole bird for just yourself. It would make more sense to roast a turkey breast instead. On the other hand, if you invite 8 of your best friends to dinner, make sure that the recipe makes enough for 8. A good rule of thumb to remember is that for every adult you are feeding, you'll need about 8 ounces of raw protein—fish, chicken, beef, and so on. This does not include the weight of bones and waste—fat, gristle, and shells.

Remember, many recipes are easy to double. I have been specific about which can be doubled or even tripled and which cannot.

Planning ahead makes the job easier. Before you go food shopping take a few minutes to do some meal planning. Think about what you would like to eat during the week, how much time you can budget for cooking, how many people you have to feed, and how you feel about left-overs. Thumb through this book until you find some dishes that you would like to try. Note how long the dishes will take (I tell you at the beginning of each recipe), and write down on your shopping list the ingredients you will need to buy to make those dishes.

How much time will this take? You have just worked a 10-hour day in the coal mines or in the library. You are starving. You want to eat now. This is not the time to think about making a recipe with 10 ingredients and 12 steps. Chicken pot pie is not fast food. At the beginning of each recipe I give the approximate time it will take for you to prepare the dish (if you have all the ingredients on hand). This time will decrease as you get more kitchen experience.

Where does this cook? Some dishes can be cooked on top of the stove as well as in the oven; pot roast and brisket, for example. These are both cooked slowly, covered, over low even heat in plenty of liquid. So in this case the choice is up to you. Other dishes must be cooked in specific places—either on top or inside the stove. Where you place a pan in the oven is important. Cakes, pastries, and breads should be positioned on the center rack, while roasts and casseroles and angel food cakes should go on a lower rack. Soufflés go on the higher rack. The reason for this is that since heat rises, the top part of the oven is much hotter than the rest. Dishes needing the most intense heat go in at a higher level. In my recipes I provide oven positioning.

Keep notes. Next to each recipe you have tried, write down some notes about whether or not you want to make it again. The !!! system is helpful. Which pot did you use? What did you serve this with? How long did it take you to make it? (The time it takes you to make something may well be different from my projections.) Jot down if the dish would be good for entertaining. This makes for easy reference when you are menu planning in the future.

Follow the directions of a recipe in sequence. Don't get creative and start skipping around. Don't make any innovative changes in a recipe unless you have made it the way it is written at least once. This way you have a reference point. You can see how it's supposed to be before you start changing it.

A note about *substitutions*: Margarine is a fine substitute for butter in many (but not all) dishes, and no one will ever know or care if you use Monterey Jack cheese instead of Cheddar. It's fine to use tofu in place of beef, fish, or chicken in most casseroles. However, some things can't be substituted for: eggs, for instance. They perform a unique function in cooking. A soufflé won't rise without them, a cake will be flat, dry, and heavy. There is a list of substitutions on pages 78 to 79. In the recipes I try to suggest as many ingredient substitutions as possible.

Some recipes call for *sifting dry ingredients before measuring*. Lay a large piece of waxed paper on the counter or set out a metal bowl that is under the opening of your sifter. Use the measuring cup or spoon to scoop out an amount approximate to what you'll need. Set the sifter over the waxed paper or metal bowl and sift the dry ingredient. Use a spoon to transfer the sifted ingredient gently back into the measuring cup, taking care not to pack it in. Remember to sift only one ingredient at a time since you'll have to remeasure it before adding it to a mixture.

When measuring butter, it's fine to use the tablespoon markers on the paper wrapping if they line up accurately with the end of the stick of butter. Other solid shortenings should be spooned into a dry measuring cup, pressed down firmly, and leveled off. Measure brown sugar in the same way.

On my Wish List for general cooking equipment and gadgets, I mentioned a kitchen scale. It comes in particularly handy when measuring items like chocolate chips, nuts, and the like, especially if the recipe calls for 4 ounces and all you have is part of a previously opened bag. If you don't have a scale, refer to the equivalency charts for the measured volume of an ounce amount. Keep in mind that 8 ounces weighed dry ingredients are not the same as 8 ounces mea-

sured. A good recipe should read: 8 ounces crushed graham cracker crumbs, or 1⅓ cups.

Taste as you go along, waiting to the very end to add salt and potent flavorings like Tabasco sauce, chili pepper, or hot sesame oil. Add these very slowly, tasting with each addition. More often than not, once you overdo it, you're stuck with a mouth-on-fire-please-pass-the-ice-cubes dish.

There are two remedies for oversalting: Add some lemon juice and/or add a couple of chunks of raw, peeled potato. Cover the pot and let the oversalted liquid simmer a bit so that the potato absorbs some of the salt. Don't forget to remove the potato. Be very careful in these instances not to let the liquid reduce as that will only intensify the saltiness.

Help! This is raw (and it's not *sushi*). Some things like tenderloin and duck breast are perfectly delicious rare. However, the sight of pink juice running out of a chicken leg or the uncooked center of a flounder steak doesn't do it for me. Undercooked can be downright dangerous in the case of pork, which should be heated to 160°F. to 185°F., depending on the cut (see chart in reference section) to prevent trichinosis, a nasty disease you don't want. It's a good idea to cut into the food when you remove it from the oven but before you put it on the table.

If it gets to the table and it is raw, then you have to regroup. The simplest thing to do with undercooked meat, fish, or poultry is to cut it up into serving pieces, spread it out in the pan (this will make it cook faster), stick it back in the oven on the highest rack, and jack up the thermostat to 400°F. Or nuke it in the microwave, if you have one. This also works well with items like baked potatoes. If rice is undercooked, add a little more water and simmer it a few minutes more, stirring occasionally, until done. Pasta is almost impossible to salvage unless you add the sauce, pour the whole thing into a casserole, and bake it in the oven. This is why it's important to test pasta by eating a strand of it before you drain off the cooking water.

Burned popcorn is still edible; burned chocolate is not. As long as folks fix food over fire, things will occasionally get burned. I love the taste of burned popcorn and lamb chops, and hot dogs can't be cooked too black for me. If you burn the crumb and cheese topping of a casserole, you can always scrape it off, start again, or simply bag the topping entirely. If the corners of the lasagna get too hard, just cut them off. The problem with burning other things—the bottom of the pot with the mashed potatoes or the chocolate pudding in it—

is that the unpleasant burned taste pervades the rest of the food as well. While burned onions are tolerable, burned or even browned garlic should be dumped. It tastes terribly bitter and will wreck the dish. Same with burned chocolate.

My final tip will save you time and energy; when you are tackling a big job *consider doubling the recipe and freezing half of it.* If you like homemade muffins in the morning and have budgeted a Sunday afternoon to bake a week's worth of them, it isn't very much more work to double the recipe and end up with two week's worth of breakfasts. Let the second batch cool completely, store it in an airtight plastic bag, and freeze it. If you only have one muffin tin, you could bake the second batch of batter in a loaf pan or a 9-inch square pan, since it's not a good idea to activate baking soda (mix it with liquid), then wait to cook it. Making lasagna, some soups, and many stews are big enough jobs to warrant making twice the amount and freezing half. It will be worth the effort when you don't want to cook and can actually pull something out of the freezer one morning to enjoy that evening.

4

Fueling the System

Feeding Yourself
♥

Do you think your mother yelled at you for eighteen years to eat your breakfast and finish those vegetables for her health? Wake up, darling. It is a sober fact of life that the food you put in your mouth is what your body lives on, works on, plays on, sleeps on, and grows on. Would you scrimp and save for ten years to buy a Maserati and then fill the tank with low-grade sludge? I think not. The Maserati wouldn't make it to the next block with cheap fuel in its system, but you can get away with poor eating habits for an amazingly long time. However, the speed with which the years of sloth catch up with you will blow your mind. Suddenly, your tennis game only looks good when you play doubles. Your nails, teeth, and hair suddenly look used and abused. Love handles attach themselves to your waist practically overnight. You can't see your belt when you are sitting down. You

can jog, swim, do aerobics for hours every day, but unless you feed yourself in a nutritionally sound way, all the exercise in the world won't do the trick. You need both. If you are a couch potato with a high metabolism and think you can stay thin while living on chips, dip, and Häagen-Dazs, just wait till you turn forty.

You don't have to turn into a home economist or nutritionist to get smart about eating right, but it does help to get the facts straight, then you can be as creative as you want. Jane Brody, nutrition and health columnist of *The New York Times* and one of the smartest and most sensible women I know, once told me she fed her teenage sons homemade pizza and last night's spaghetti for breakfast. Traditional? No. Nutritional? Absolutely.

If you are still chafing against mornings of Mom's forced oatmeal, or find no joy in corn flakes, then wake up and smell the coffee, dear. What you eat for breakfast, lunch, dinner, and in-between is now up to you. The goal is to get some good fuel into your body that will last at least until the next meal. It goes without saying that it should taste good, as well. The nutritional issues you need to address are:

Protein: Protein builds your body, fuels the hemoglobin that carries oxygen to your tissues and carbon dioxide away from them, and is a source of energy. A lack of protein can show up in exhaustion, dull hair, teeth problems, and anemia. If you aren't a heavy protein eater to begin with, there is good news for you; Americans tend to eat too much anyway. Two servings a day, totaling from four to six ounces (depending on your weight), should do it. Spreading these servings out over the course of the day will keep your diet more interesting and your body fueled more efficiently.

There are conventional sources of protein in the form of eggs, dairy products, and red meat. However, when eaten as a steady diet, these foods add lots of calories and don't do great things for your cholesterol levels. Unconventional sources of protein include tofu, lean meat, fish, poultry, and peanut butter as well as certain foods in combinations—beans and rice, and whole grains and nuts, as examples.

I'm not suggesting you jump out of bed every morning, dash to the kitchen, and cook a chicken or hamburger. There is nothing wrong, however, with reheating last night's leftover stir-fry or pouring low-fat milk over a bowl of granola (your whole grains and nuts combination above) or making a high-protein blender shake.

Dairy products are still essential even though you're not a kid

anymore. They are especially essential for women since the calcium found in these foods decreases the chances of osteoporosis in later years. Most adults need two servings each day from this food group. If the naturally high fat content of some dairy products is an issue, then eat it in the form of low-fat skim milk, low-fat yogurt (frozen or regular), low-fat cottage cheese, farmer cheese, or reduced-fat semisoft cheese.

Carbohydrates: In a healthy diet, carbohydrates will be the principal source of energy. The starches and sugars found in carbohydrates are metabolized into glucose, which charges your body's batteries. A baked potato is an example of a complex carbohydrate (i.e., one that is good for you, nutritionally speaking; a Twinkie is not). It's the complex carbohydrates you should be eating, whole-grain products that combine carbohydrates with fiber and take longer to digest than the simple carbohydrates in which the sugar is immediately turned to energy. A candy bar may give you an immediate jolt of energy, but a half hour later, when your blood sugar has dropped to below where it was when you were feeling the need for a jolt, you will be even more depleted, hungry, and cranky. A peanut butter and banana sandwich on whole-grain bread and a handful of raisins will fill you up and keep you going for a good long time.

Foods high in complex carbohydrates like whole grains, beans, nuts, and many vegetables and fruits add fiber to your diet. Think of fiber as a giant scrub brush that keeps your innards sparkling-clean and healthy. Fiber keeps the system moving along. I'm talking about the other thing you thought you'd never have to worry about— regularity. When we were kids we used to snicker at Uncle Milt's daily routine of stewed prunes and a couple of tablespoons of bran. Well, good old Uncle Milt is still playing golf in his nineties while his two brothers died of colon cancer in their sixties. Yes, the luck of the genetic draw plays a major role, but weighting the odds won't kill you, literally.

The recommended daily allowance for carbohydrates is at least four servings—the amount will depend upon your age and weight— plus four or more servings of fruits and vegetables. I know this seems like a lot of individual items to worry about, but in the morning if you eat a bowl of multigrain cereal topped with half a cut-up banana, some raisins, and a tablespoon of bran and some low-fat or skim milk splashed on top, you've satisfied at least four or five of the daily requirements for carbohydrates as well as a couple for fruit, iron, protein, and calcium.

Fats: Here's where you can get into trouble if you're not careful. Everybody needs a certain amount of fat in his or her diet because this is where stored energy is. If you get sick or engage in a prolonged physically intense activity (cycling around France or cleaning your kitchen), fat is where your energy to do this will come from. Fat also forms a protective cushion around vital organs and transports fat-soluble vitamins around the body.

It's the kind and amount of fat you have to pay attention to. Current wisdom (with which I tend to agree) is that saturated fats—the ones that raise your cholesterol level and can ultimately lead to heart disease—that come from animals and certain plants are the "bad" fats. This means you should select leaner (less fatty) cuts of meat. Bacon is an example of a fatty meat, while a slice of roast turkey without the skin is an example of a lean meat. Trim off any visible fat remaining after cooking, leave the chicken skin on the plate, cut way back on hard cheeses, ice cream, and butter, cut down on the number of eggs and egg-based dishes you eat, and stay away from hydrogentated fats that come from palm kernel oil or coconut oil.

Here is where label reading becomes crucial. I used to eat loads of crackers but not the cheese spread and feel virtuous. Then, why was my cholesterol level sky high? My doctor made me go eyeball to eyeball with the ingredients panel on the side of a box of my favorite crackers. Yes indeed, there was the culprit—coconut oil. Now many cracker producers are getting smart and substituting healthier oils, but you still have to be careful. Don't be fooled. Read labels! I laugh at health food freaks who avoid chocolate like the plague and settle for carob bars, which not only taste disgusting (in my humble opinion), but are made with palm kernel oil as opposed to cocoa butter, which does not raise the body's blood serum cholesterol level. Cook with polyunsaturated fats—olive oil, canola oil, or peanut oil. Repeat: Take the time to trim off as much visible fat as possible, including draining off what is in the pan after you cook hamburgers. *And read the labels* so you can be sure of what you are eating.

The twofold good news about eating sensibly is that nutritious food can taste even more delicious than the not-so-nutritious stuff, and you should feel perfectly free to cut loose every once in a while and dig into that hot fudge sundae or the bag of chips.

Vitamins: Vitamins are chemical compounds that allow your body to utilize all the food you eat. Think of using a computer without a keyboard or modem; that's what eating without paying some attention to vitamins is like. You can pop pills. Actually a multivitamin

(with iron if you are a woman) is a good idea. But you can save money on all those other pills if you eat the right foods.

The following is the short list of essential vitamins. There are at least a dozen or so others, just as there are other minerals besides calcium and iron that you need for good health. Since I have to cover lots of things in this book, not just nutrition, I have selected the most common and familiar vitamins to discuss here. It would be a good idea, however, for you to pick up a book about nutrition and get all the information you can. You get only one body in life and if you feed it well, you should get to enjoy it for a long time.

Vitamin A is necessary for new cell growth, good vision, and healthy skin and hair. It is found in yellow and dark green vegetables (summer squash, sweet potatoes, broccoli, and so on) and in eggs, dairy products, and liver. Adult females need about 800 milligrams a day and adult males need 1,000 milligrams.

Vitamin B_1 (thiamine) is needed for good digestion, growth, fertility, functioning of the nervous system, and carbohydrate metabolism. Since it is a water-soluble vitamin and not stored in the body, it needs to be consumed on a regular basis. You will find it in pork, soy beans, peas, nuts, whole-grain products, brewer's yeast, and blackstrap molasses. Adult females need 1.0 milligram a day and adult males 1.2 milligrams.

Vitamin B_2 (riboflavin) is another water-soluble B complex vitamin. It aids in digestion and is essential for the metabolism of carbohydrates and proteins. It is found in green leafy vegetables—spinach, kale, broccoli—whole-grain products, liver, dairy products, eggs, lean meats, and blackstrap molasses. Adult males need 1.6 milligrams a day and adult females need 1.2 milligrams.

Vitamin B_3 (niacin) is another water-soluble vitamin and is used by the body to maintain healthy tissue cells. It is found in liver, meats, peas, beans, whole-grain products, and fish. Adult males need about 19 milligrams a day and adult females need 13 milligrams.

Vitamin B_6, also water soluble, comes in three forms, and is necessary for proper growth and the maintenance of body functions, as well as the metabolism of proteins. All three types of B_6 are found in liver, whole-grain products, grains, potatoes, lean meats, green vegetables, and corn. Adult males should have 2.2 milligrams a day and adult females 2.0 milligrams.

Folic acid, found in liver, beans, green vegetables, oranges, nuts, and brewer's yeast, is necessary for the body's conversion of food into energy. It is also important in the manufacturing of red blood cells. Both women and men need 400 micrograms daily.

Vitamin B_{12} is important for the proper functioning of all cells and is involved in the normal development of red blood cells. It is found in milk, eggs, shellfish, organ meats, and lean red meat. If you are a vegetarian, it is important to take a vitamin B_{12} supplement since this vitamin is not found in vegetables. Both adult men and women need 3 micrograms a day.

Vitamin C, abundant in citrus fruits, green peppers, many dark green vegetables, and strawberries, is essential for tissue growth and repair. It is necessary for good tooth and bone formation, and many authorities believe that it plays an important role in helping the body protect itself from infection. Vitamin C is the least stable of the vitamins and is destroyed both by heat and exposure to the air. Cooking and prolonged storage will rob many vitamin C rich foods of their nutritional benefits. Adult women and men both need 60 milligrams of vitamin C every day.

Calcium, as mentioned previously, is (along with phosphorus) essential for the hardness of bones and teeth. Women, especially, have to be careful to watch their calcium intake in the attempt to avoid bone problems later on in life. A calcium supplement should be considered if one's diet is calcium deficient. Milk (skim is fine) and other dairy products, such as yogurt, cheeses, and milk-based dishes, are great sources of calcium. One good source is orange juice with calcium added. Dark leafy green vegetables are another source of calcium, as are sardines, due to their soft edible bones. Women under fifty years of should have 800 milligrams of calcium a day; over fifty, they should have 1,000 milligrams. Men need 800 milligrams a day.

Iron aids the body in producing hemoglobin, which carries oxygen from the lungs to the cells and carbon dioxide back to the lungs to be exhaled. When you don't get enough iron, you become anemic and, if you get too anemic, you become completely exhausted. Since iron is found in meat (organ meat in particular), egg yolks, blackstrap molasses, dried beans, and dried fruits, it is something that vegetarians, picky eaters, and dieters can be in danger of not getting enough of. Women who don't get enough iron are in danger of losing their hair. If you know you're not getting enough iron, then consider a supplement. Make sure you pick one that has some colace (stool softener) in it so you won't become constipated.

The daily recommended iron allowance for both men and woman under fifty is 18 milligrams; over fifty, it is 10 milligrams.

Salt (Sodium): I am not a great lover of fast food, but this has nothing to do with the amount of fat or the usual negative nutritional

impact of it. Nor has it anything to do with the taste. On the contrary, I love the taste of McDonald's french fries and could easily wolf down a fish sandwich. My problem is with the incredibly high salt content of those foods. As a kid, I never thought about salt as anything but essential. I would grab the shaker and sprinkle my plate even before I tasted anything. Today I don't even have a salt shaker on my table. The first thing I learned was that it is really lousy manners and a great insult to the cook to doctor the flavor of the food until you have tasted it. Second, as I got older and took a look in the mirror at my puffy eyelids the morning after a dinner at the Chinese restaurant, I began to think that salt might not be so good for me after all. I started to read labels and was appalled to find that not only is salt added to every kind of prepared food, it's usually added in massive quantities. The final insult turned out to be that if you wanted something salt free you had to pay extra! I have a misguided friend who tried to lose weight by eating frozen diet dinners and drinking incredible quantities of diet soda. Why did she gain weight instead? Each dinner had almost 1,500 milligrams of salt; each soda had 25. The recommended daily allowance is between 1,100 and 3,300 depending on how much strenuous physical activity you do. She was eating most of the salt she needed for one day in one meal! By the end of each day she had consumed more than three times as much salt as she needed, and it was causing her body to retain all fluid that she was drinking.

Excessive sodium intake is one of the most important reasons why to train yourself to read labels. Crackers, cereal, snack foods like chips and popcorn, canned soups, and vegetables are extremely high in sodium. A little is fine, but too much can lead to high blood pressure and a general feeling of bloating—stiff, swollen fingers, ankles, and feet. One teaspoon of salt (remember salt is found naturally in all foods) is all you need each day. If you work out excessively and perspire heavily, you might need to replenish the sodium you lose. A doctor is the best judge of how much you need to replace.

Water: After reading in the newspapers about the condition of our natural resources, it might scare you to drink tap water. This is not an excuse for eliminating water from your diet. You need water to live. It is essential for digestion, for moving the nutrients through the blood stream to the body's organs. Water regulates your body temperature through evaporation; it keeps your skin hydrated and young looking; it carries waste products out of the body. You need six to eight 8-ounce glasses of water a day. While this can come in

the form of juice or soda, you won't find many nutrients in these fluids (except for vitamins in the juice). Drink water instead and you'll save money, unless you go for the imported Italian brands. Try to get into the habit of drinking water every day. It will make you feel great.

A final word to vegetarians: The diet you have selected brings with it certain responsibilities. Eating the way you do can certainly be healthful. However, it is harder for you to be sure that you are getting all the proper nutrition you need than it is for someone who eats meat, poultry, fish, and dairy products. There are a few things you can do to make sure you are making wise food choices: Get a good book about nutrition for vegetarians, read it cover to cover, and follow its advice. Take vitamin supplements, brewer's yeast, and iron. Make sure you pay attention to the combinations of foods like beans and rice, since these are a valuable source of protein. Learn to love tofu. Buy high-quality fruits and vegetables, nuts and grains. If you are a female vegetarian, give very serious thought to drinking milk or consuming other dairy products, as well as a calcium supplement. The course you chart now will be the one you travel by come middle age and beyond. You want to make sure your bones are as good and strong as they possibly can be.

Women also need to consider the time when they may chose to have children. Starting out pregnant with a poorly nourished body and poor eating habits can be dangerous to a developing fetus. Now that you are feeding yourself, it is time to make a commitment to doing it well.

The same goes for you athletes. To get superior output, you need superior input. It wouldn't hurt to start taking into account every thing you put in your mouth. You'll be amazed at how you'll have to stretch to justify too many items. Healthy food can be just as delicious—ultimately even more so—as junk food. Try some of my recipes and see what you think.

Feeding Your Guests
❦

There are some simple basic rules for being a good dinner, lunch, or breakfast guest. If you have special dietary needs, then you should let your host or hostess know when the invitation is issued. In other words, the time to inform Paula that you're a strict vegetarian is not

the moment she proudly sets down a sizzling sirloin steak on which she spent half of her last week's paycheck.

If you do have special needs that an ordinary host cannot easily meet, then you should offer to bring your own food or ingredients. Say you have strange food allergies and eat only a certain kind of tofu from a certain health food store that's miles across town. Let the host know well ahead of time that you'd love to come for the company, but will bring your own food.

As far as food fetishes and phobias go ("The very thought of liver makes me puke," or "I was traumatized by a giant eggplant when I was an infant and the thought of eating one would push me over the brink"), we're all adults here. First of all, a host shouldn't be serving something like liver unless he or she knows for sure that the guests are organ fans. However, it's time you gave eggplant another chance. If, in your capacity as a guest, you run across something you really can't get down, then quietly push it to the side of your plate and get on with the rest of the meal. A good host should never point out to the rest of the table, "Oh look, Harold hasn't touched his deviled fish burgers. Don't you like them?" A perfectly acceptable response from Harold would be, "I'm allergic," and quickly change the subject.

If you plan to invite someone who keeps kosher to dinner, there are some simple things you should keep in mind. First of all, if this person is really strictly kosher, he or she won't eat at your house, unless, of course, you are strictly kosher as well. Don't serve any kind of pork or pork products and don't use them in cooking. That includes lard—why would you be using lard in the first place?—bacon, ham, and so on. Don't serve any kind of shellfish: no lobster, shrimp, crab, scallops, oysters, clams, mussels. Don't mix milk (or any dairy products like butter or cheese) and meat or poultry in the same dish or even in the same meal: no lamb in curried cream sauce or chicken sautéed in butter. The simplest thing to serve is fish, which is sort of a neutral food that can be prepared with dairy products. A vegetarian meal is a great idea as well.

Speaking of vegetarians, there are as many different kinds as there are snowflakes, from the very strictest, who don't even eat milk products or eggs, to the most laid-back who simply eschew red meat. Here it's really up to the guest to let the host know what the limitations are. If the list gets too long, I would suggest letting the vegetarian bring his or her own food. Or everybody go out to eat.

I previously mentioned food allergies. Remember, some people are violently and dangerously allergic to certain foods. It is their job to let you know ahead of time or to ask the contents of a dish before

they eat it. If you are feeding a person with a food allergy and he or she asks if any nuts are in the meal, don't just give an off-hand "no." What about the hazelnut or almond oil you used in the salad dressing? The anchovy paste that you used in the Caesar salad dressing could be as lethal to someone with an allergy to fish as a piece of flounder.

Some people, for one reason or another, don't consume alcohol. Have club soda (and ice cubes) on hand to offer them. Don't make a big deal about their not drinking and don't ask why. They know what they want to drink. If you know ahead of time that a guest does not consume alcohol, don't use any alcohol in the preparation of the meal. Yes, most of the alcohol does cook off, but the taste remains. That's why you used it. If a guest passes up a drink before dinner and you suspect he/she might also like the option of passing up your chicken in wine sauce, quietly and privately tell him there is wine in the preparation. Is that a problem? If it is, then offer to serve him or her a plain piece, if possible; if not, serve this person lots of salad and vegetables. Just remember that for all you know, your guest has been dealing with this issue far longer than you have been entertaining, so for them it's not a big deal. It shouldn't be for you either.

Finally, if someone comes to dinner and brings a child, cut the kid some slack and offer her or him some options. (Remember, not so long ago you hated adult food too.) The child can have the fancy spaghetti Mommy and Daddy and Uncle Bob are eating, plain spaghetti, a peanut butter sandwich, or a bowl of cereal. Don't let your ego be crushed by a six-year-old's rejection of your culinary masterpiece. What did you know when you were six?

T W O

130 RECIPES TO
GET YOU STARTED

Appetizers and Snacks

Yogurt Dill Dip

Preparation time: 10 to 15 minutes
Yield: 2⅔ cups
Can be made ahead? Yes, the day before. Store in a covered container in the refrigerator.
Can be frozen? No.
Can be doubled and tripled? Yes.
Good for leftovers? Yes. Will keep refrigerated up to one week.

*1 pint plain yogurt, regular
or low- or nonfat
½ cup fresh dill, rinsed,
dried, and finely chopped*

*1 tablespoon Dijon mustard
1 tablespoon soy sauce*

With a fork mix all the ingredients together in a bowl. Spoon into a serving bowl and pass with the vegetables.

Appetizers

You might think of appetizers as company food. It's a fancy name for something that if you were all by yourself, you'd eat like a small snack before a meal, to take the edge off your hunger. Maybe the tradition was started by the first dieter who figured that eating six radishes before dinner would mean she'd be able to pass on the buttered noodles. Don't ask me how six radishes turned into chips and dip.

Appetizers, eaten before you sit down to dinner, give guests a chance to get to know each other. They also provide an opportunity for folks to catch up, sort of like company bonding. By the time everybody gets to the table, the mood is copacetic.

If you are running on a tight budget, serving lots of starchy things (like chips, bread, and crackers) to scoop up lots of filling food (like cheese, dips, and spreads) will lull the hunger pangs of your company so you won't have to feed them quite so much at the table. Of course, then you always have to worry about the people who pass on the appetizers to save themselves for dinner.

Generally speaking, appetizers fall into two categories, the ones you eat standing around before you actually sit down at the table and those that serve as a first course. As a rule of thumb, I suggest you figure on serving those things that need individual plates and forks or knives at the table. Anything that can be passed on a serving plate or in a bowl, then transported on a napkin to your mouth by your fingers, is fine for eating before you get to the table. Some people call these hors d'oeuvres. Not me, since I'd have to stop to look up the spelling every time I write it. I prefer to call them "pick-ups."

Pick-up appetizers don't have to be constructed masterpieces. Basically, they should be one- (or two-) bite tidbits that you can pop into your mouth with one hand. Generally they don't require a plate; a sturdy paper napkin should suffice.

Cheese and crackers can do some damage to the budget, but most everyone loves cheese. I'd stick to two or three kinds that you personally like, since you might be eating the leftovers. A nice Cheddar, a wedge of Brie, and some goat cheese, or a small wheel of Camembert, a wedge of Stilton (an English blue cheese), and a mild fontina (Italian). It's time to give up saltines and Wheat Thins. Try Carr's Biscuits—the wheat ones are especially wonderful—also sesame crackers that come in rectangular shapes. If they are on the

large size, just break them in half. Sliced French bread is also great to serve with cheese.

Another big hit is string cheese, a Middle Eastern product that comes in a braid. You cut off the plastic wrap and strip off ribbons of cheese. Place them in a bowl. It's lots of fun to eat and tastes really good, although it is salty. You will need lots of liquid refreshment on hand.

Cocktail Sauce

Prepared horseradish comes red, which has been colored with red juice, or white. Either is fine for this recipe.

Preparation time: 5 to 10 minutes
Yield: 1⅓ cups
Can be made ahead? Yes, up to 1 week. Store in a covered container.
Can be frozen? No.
Can be doubled and tripled? Yes.
Good for leftovers? The sauce will keep for several weeks, although the horseradish will lose its potency.

1 cup catsup
1 tablespoon soy sauce
¼ to ⅓ cup prepared
 horseradish (in the dairy
 section of the
 supermarket)

In a bowl mix the catsup and soy sauce together. Add as much horseradish as desired. Use a fork to blend so no red or white streaks appear. Spoon the sauce into a serving bowl and pass with the vegetables.

Easy Pesto Dip

Preparation time: 5 minutes
Yield: 1½ cups
Can be made ahead? Yes, up to 3 days before.
Can be frozen? No.
Can be doubled and tripled? Yes.
Good for leftovers? Yes. Will keep for 1 week in a covered container in the refrigerator.

One 4-ounce container 1 cup mayonnaise
pesto sauce (in the
refrigerated sauce section
of the supermarket)

Mix both ingredients together in a bowl and spoon into a small serving bowl. Pass with the vegetables.

Chutney Dip

This dip is a little more exotic than the previous ones. Chutney is a sort of spicy jam often made with mangoes. You can buy it in a jar in the grocery store. Look near the catsup or in the fancy foods section.

Preparation time: 10 minutes.
Yield: 2½ cups.
Can be made ahead? Yes, up to 1 week. Store in a covered dish in the refrigerator.
Can be frozen? No.
Can be doubled and tripled? Yes.
Good for leftovers? Yes, will keep for 2 weeks in a covered container in the refrigerator.

One 16-ounce container ½ teaspoon chili powder
whipped cream cheese 1 tablespoon soy sauce
4 tablespoons Major Grey's ½ cup currants (optional)
chutney, or more to (currants are like tiny
taste raisins)

In a bowl mix all the ingredients together until smooth. Add more chutney, if desired. Spoon into a serving bowl and pass with the vegetables.

Parmesan Pita Wedges

Preparation time: 10 minutes
Cooking time: approximately 1 to 2 minutes
Yield: 16 wedges per small loaf of bread or 48 wedges from this recipe
Can be made ahead? Yes, up to point of cooking. Cover with plastic wrap and
keep at room temperature for up to 3 hours.
Can be frozen? No.
Can be doubled and tripled? Yes. Cook in batches.
Good for leftovers? If you don't mind soggy bread.

> *3 small (pocket-sized)*
> *loaves pita bread*
> *2 tablespoons butter or*
> *margarine, melted*
>
> *½ cup grated Parmesan*
> *cheese*

To cook the wedges right after you prepare them, preheat the broiler
to high with the rack in the upper part of the oven.

Line 1 or 2 baking sheets with foil. (This will save on cleanup.)
If you only have 1 sheet, you can reuse the foil to make another batch
of wedges. Use a clean pair of scissors to cut each loaf into 8 wedges.
Open each wedge to form a diamond. Cut in short-ways through the
middle, so you have 2 triangles. Lay the triangles rough sides up on
the baking sheet(s).

If you have a baking brush, use it to brush some melted butter
onto each triangle. If you don't have a brush, use a teaspoon to
dribble the butter over the wedge. Use enough butter so that the
wedge is moistened but not soggy. Use another teaspoon or your
fingers to sprinkle about ½ teaspoon of grated Parmesan evenly over
each triangle. Don't worry if some of the cheese gets on the foil. You
can brush it up and reuse it. Just do it before you cook.

Use a potholder to slide the baking sheet under the broiler.
Count to 20. Check to see what's happening. The cheese should have
just started to melt. Slide the tray back in and count to 20 again.
Check again. *These suckers burn very easily.* Don't take your eyes
off them for a second. You want the cheese to be melted and the pita
just beginning to get brown on the edges. Nothing will be uniform,
neither the melting or browning, because the surface is uneven. Aim
for browned and melted, but not burned. You'll probably have to do
a few trial batches before you get the hang of it.

Use a spatula to transfer the wedges to a serving tray and serve
immediately. While these are best served straight from the oven when
they are crisp, they're pretty decent at room temperature as well.

Baked Salami

Crispy chunks of sizzling salami skewered on a toothpick, then dipped into mustard on the way to your mouth. You won't believe how easy this is to make and how delicious it is. Choose a small (8-inch) salami for a few friends and a bigger one (or even a huge one) for a crowd.

You must use a whole kosher salami. Check the kosher section or deli of your supermarket or a Jewish-style delicatessen. The other "unusual" ingredient is something called ham glaze, which I have located in major supermarkets. Check in the condiment section as well as in the Chinese food section or in specialty foods. Look for a thick, iridescent red mixture that turns spareribs that unearthly hue. My local brand is Ah So sauce. If you can find that, great. If not, use any ham or sweet-and-sour meat glaze that's available.

I serve the salami with either a Dijon-style mustard for an up-scale effect, or Gulden's for a down-home taste. The choice of mustard is yours.

Only three ingredients; not bad, huh? The only other thing I'd suggest is that you invest in a cheap, throw-away 1-inch paint brush to paint the sauce on the salami.

Preparation time: 10 minutes
Baking time: 1 hour
Yield: 6 to 8 servings for a small salami; 12 to 15 for a medium; up to 30 for a very large one
Can be made ahead? Yes, up to 12 hours before baking; refrigerate, uncovered, until then.
Can be frozen? No.
Can be doubled or tripled? Yes
Good for leftovers? Yes. But it won't be as crispy. Try reheating in a 350°F. oven for 20 minutes.

1 whole kosher salami, small, medium, or large, depending upon how many people you are serving	*One 8-ounce jar ham glaze (Ah So brand, if available)* *Mustard of your choice*

If you are going to cook the salami right after preparing it, then preheat the oven to 350°F. with the rack in the center position.

Line a baking pan that is at least one-third longer and wider than the salami with foil. (The salami will expand during baking.)

Use a sharp knife to slit the plastic casing as well as any additional casing (some brands have a double layer) and peel it off. Then use

118

the knife to cut a series of 2-inch crisscrosses about ¼ inch deep over the surface of the salami. This makes it look pretty and keeps it from exploding in the oven. Place the salami on the prepared pan.

Use a small *new* paint brush (or one that you use only for this job and wash well between usings) to generously coat the top and sides of the salami with the glaze. Roll the salami over and coat the underside as well.

Bake for 1 hour. Remove the pan from the oven and allow the salami to cool in the pan for 15 minutes. It will be very hot, so be careful. Use tongs or 2 forks to transfer the salami to a cutting board and use a serrated knife to first cut it into approximately 1½-inch slices. Cut each slice into quarters.

Place the pieces of salami in a serving bowl or on a tray. Serve with the mustard of your choice. Don't forget the toothpicks!

Crudité is a fancy French name for a cut-up vegetable—a good thing to present if you and your company aren't interested in bulking up on more fattening foods. You can make a selection of crudités at least 4 hours in advance. Cut the vegetables into bite-sized pieces, place them in a bowl with a few ice cubes, and cover tightly with plastic wrap. Store in the refrigerator. Use sturdy vegetables—strips of red and green bell peppers, cauliflower and broccoli flowerettes, cherry tomatoes, strips of zucchini and summer squash, cucumber rounds, celery and carrot sticks, individual endive leaves, slices of mushrooms (coat with a little lemon juice so they stay fresh looking), radishes, and daikon, an Oriental long white radish that has a deliciously mild taste and refreshing texture. You may love spinach and watercress, but they make lousy dippers. When ready to serve, arrange the vegetables on a large plate. Don't forget the napkins.

If you want to serve a dip to dunk the vegetables in, consider those on pages 113 and 116, which you can make the day before and store in a covered container in the refrigerator. Other ideas for dips include any of the blue cheese dressings (page 140), Honey Mustard Dressing (page 143), or store-bought salsa or hummus.

If you serve crudités with a dipping sauce, figure on ¼ cup of dip for each person.

Stuffed Mushrooms

You can serve stuffed mushrooms as a pick-up appetizer, or place several on a plate for a hot first course. The great thing about this dish is the endless possibilities of stuffings. Try some of the suggested stuffings, then get creative using leftovers or items from your pantry.

What will make your job infinitely easier is to select the very largest, freshest, cleanest mushrooms available. Then all you have to do is snap off the stems, brush off any of the growing medium (it looks like small pieces of peat moss), and prepare the stuffing. You're all set.

My friend Liz Rose suggested the creative stuffings that follow the basic recipe.

Preparation time: 20 to 30 minutes
Cooking time: approximately 20 minutes, depending on the size of the mush-
rooms
Yield: 4 servings
Can be made ahead? Yes. Can be stuffed but not cooked up to 24 hours ahead.
Cover tightly with plastic wrap and refrigerate.
Can be frozen? No.
Can be doubled and tripled? Yes.
Good for leftovers? Yes. Either cold or reheated.

*12 large fresh mushrooms
(count on 3 or 4
mushrooms per person)*

*1 tablespoon vegetable oil
½ cup seasoned bread
crumbs
½ cup grated Parmesan
cheese*

Preheat the oven to 350°F. with the rack in the center position. Select a pan or ovenproof skillet just large enough to hold all the mushroom caps.

Use your fingers or a small sharp knife to separate the stems from the mushrooms as close to the caps as possible. If the mushrooms are very dirty, rinse them briefly under cold running water, then gently pat dry. If they are fairly clean, then just brush away any visible growing medium.

Clean the stems and chop them into very small bits. Heat the oil in a small skillet and cook the mushrooms for 5 minutes over moderate heat, stirring very frequently.

Combine the cooked mushrooms with the bread crumbs and the cheese and mix well. It's easiest to use your hands for the next step,

so if you haven't washed them yet, do it now. Eyeball the amount of stuffing and then eyeball the mushrooms. The trick is to divide the former among the latter. It's better to have a little left over than to run out. I have given fairly generous proportions, so unless you're using Three Mile Island mushrooms, you should be okay. Scoop up about 2 tablespoons of filling and gently fill each mushroom cap so that the filling is twice as high as the cap. Cup your hands around the cap and gently push the stuffing in to make a neat, round mound. Repeat with the remaining mushrooms, placing each cap, stuffing side up, in the baking pan. It's fine if they touch.

Bake for 20 to 30 minutes, or just until the stuffing turns light brown and the mushrooms begin to give up some of their liquid. Serve hot either as a pick-up, or as a plated first course.

Variations Other ideas for stuffing mushrooms (always include the chopped stems that have been sautéed in oil):

- 1 small package of Boursin cheese plus ½ cup plain cream cheese
- One 4-ounce package cream cheese with chives plus ½ cup plain or seasoned bread crumbs
- 1 cup crumbled feta cheese mixed with 1 egg, ½ cup seasoned or plain bread crumbs, and 1 tablespoon fresh or dried chives. Do not make this filling in advance. It should be cooked as soon as it is made.
- Very finely flaked canned tuna mixed with a little mayonnaise
- Canned or fresh crab meat (make sure to pick out any pieces of cartilage) mixed with a little mayonnaise
- 1 package cooked creamed spinach (use the frozen kind), plus ½ cup plain or seasoned bread crumbs (optional: add ¼ cup Parmesan cheese)
- One 8-ounce container whipped cream cheese mixed with 2 table-spoons capers and 1 teaspoon anchovy paste

Store-bought pâtés and cheese spreads are fine, but they are expensive. If money isn't a problem and you need to save time, then go ahead. Serve with a loaf of French bread.

Garlic Bread

You can serve garlic bread as an appetizer with almost any kind of meal, and it's all you need to compliment a hearty soup or dish of pasta. It's so easy to make and it freezes beautifully. It can go right from the freezer to the oven.

If you can find the small jars of chopped garlic in oil sold in some supermarkets, your work here will be cut to practically zip.

Preparation time: 20 minutes
Cooking time: approximately 10 to 15 minutes
Yield: 6 to 8 servings
Can be made ahead? Yes. Up to 6 hours. Wrap in foil and refrigerate for up to 12 hours.
Can be frozen? Yes. Up to 3 weeks. Wrap in foil and freeze. Heat right from the freezer, following the cooking instructions below.
Can be doubled and tripled? Yes.
Good for leftovers? Stale garlic bread makes great croutons that can be added to soup or a salad.

1 large loaf soft Italian bread
¼ cup vegetable oil
1 stick (4 ounces) butter, cut in pieces

3 large cloves garlic, peeled and finely chopped, or 1½ tablespoons store-bought chopped garlic in oil
⅓ to ½ cup grated Parmesan cheese (optional)

Preheat the oven to 400°F. with the rack in the center position. Place the bread on 2 large overlapping pieces of foil, shiny side up.

Use a serrated knife to cut the loaf into 1-inch slices, but cut only ¾ of the way down. Try not to cut completely through the slices.

Place the oil, the butter, and the garlic in a small saucepan over low heat. Stir until the butter melts. Cook over low heat for another minute or so, but don't let the garlic brown. Use a tablespoon or pastry brush to coat each side of each slice of bread with the garlic butter, including the chopped garlic. Sprinkle some of the cheese between the slices, if you wish.

Spread any remaining garlic butter and cheese on top of the bread and wrap in the foil, twisting the ends to close securely. Bake in the preheated oven for 10 minutes. If you are preparing frozen bread, bake for 15 minutes.

To brown the crust, open up the foil and bake 5 minutes more.

Spiced Pecans

Be sure to make lots of these as they will disappear fast.

Preparation time: 15 minutes
Baking time: 20 minutes
Yield: 6 to 8 servings
Can be made ahead? Yes. Store in an airtight container for up to 1 week.
Can be frozen? No.
Can be doubled and tripled? Yes.
Good for leftovers? Yes, if there are any left over.

*1 cup dark brown sugar,
 firmly packed
¼ cup soy sauce
¼ cup Dijon mustard
10 drops Tabasco sauce
 (fewer if you want it less
 spicy)*

*12 ounces (approximately
 2½ cups) shelled pecan
 halves*

Preheat the oven to 400°F. with the rack in the center position. Line a shallow baking pan with foil (to make cleanup easier).

In a medium mixing bowl combine all the ingredients, except the pecans, in the order they are listed. Mix well to combine, then mix in the pecans. Distribute the pecans and the sauce evenly over the bottom of the prepared pan. Bake for 20 minutes. Then cool 15 minutes in the pan.

Pass the pecans while still warm in a bowl or on a plate. Or store in a covered container at room temperature until ready to serve.

A great treat before an informal dinner is Garlic Bread (page 122). Cut the slices completely through before serving, place them on a cookie sheet, sprinkle each slice with 1 teaspoon grated Parmesan cheese, and run under the broiler for a minute, until the cheese melts and the tops have just started to turn brown. Serve with lots of napkins.

Bread sticks, a variety of olives, and bowls of popcorn and nuts (above) are easy appetizers. For the olives, look in the gourmet section of the supermarket or in a Greek or Italian market.

Appetizers at the Table

So, you want to get right to the table. No dilly dallying in the other room. Here's where the appetizer can also be called a first course. Again, *keep it simple*. My personal rule of thumb here is to serve something I can make well ahead of time and will only have to reheat, spoon up, or place on a plate at the last minute. Soups, both cold and hot, are perfect. Any of the soups listed in the next chapter can be served as a first course.

Salads are also great starters. A beautiful dish of greens mixed with some interesting vegetables is always appreciated. You can really get creative by adding pieces of sun-dried tomatoes (reconstitute them first by soaking them in warm water until soft), or slices of goat cheese, feta cheese, canned chick peas, roasted red peppers, marinated artichoke hearts or mushrooms (they come in jars), slices of orange or pears, or nuts like pecans, walnuts, pine nuts, toasted hazelnuts. You can add croutons, grated cheese, toasted coconut, or raisins. Salads and dressings need never be boring. See the recipes beginning on page 133.

This last first course idea is a classic, and one that you have to wait for perfectly ripe melons to make. Ask your produce person (remember the one I told you to cultivate for this very moment?) to pick you out a perfectly ripe Persian or honeydew melon. Pick out four limes as well.

Then go to either an Italian or German deli and buy three slices of Black Forest ham or prosciutto per person. Make sure that the ham isn't too fatty. Have it cut paper-thin.

About one hour before dinner, place the plates on which you plan to serve this dish in the refrigerator. Use a long, very sharp knife to slice the melon into eighths. Use a spoon to carefully scoop out the seeds. Place the slices on a tray or cookie sheet, cover them with plastic wrap, and refrigerate. Cut the limes into quarters and place in a plastic bag in the refrigerator.

When ready to serve, place a slice of melon on each plate. Use a sharp knife to sever the fruit at the bottom near the rind. Cut the melon into five or six sections, but leave the sections in place. Drape the slices of ham over the melon and place two wedges of lime on each plate.

Soups

Fast "Homemade" Chicken Soup

If you like the chicken part as much as the soup, here's the recipe for you. This is great if you're coming down with a cold or flu and need some quick comfort.

Preparation time: 20 minutes
Cooking time: 20 to 30 minutes
Yield: 4 to 6 servings
Can be made ahead? Yes. Up to 4 days. Keep refrigerated and covered.
Can be frozen? Yes.
Can be doubled and tripled? Yes. Use a very large pot.
Good for leftovers? Wonderful. Will keep up to 5 days, covered and refrigerated. Reheat and enjoy.

Continued

2 whole skinned and boned
 chicken breasts
4 cups canned chicken
 broth plus 2 cups water,
 or 2 chicken bouillon
 cubes dissolved in 6 cups
 hot water

2 large carrots, peeled and
 thinly sliced
1 onion, thinly sliced
Black pepper to taste

Rinse the chicken well and pat it dry with paper towels. With a sharp knife cut the chicken into 1½-inch pieces.

Place the liquid in a large pot and bring it to a simmer. Add the chicken, carrots, and onion. Cover and simmer gently for 20 to 30 minutes, or until the vegetables are very tender. It is important not to let this soup boil or the chicken will become tough.

Add pepper to taste. This soup gets better with each reheating.

Variations Add any of the following during the last half hour of cooking:

- 3 to 4 sprigs chopped parsley or coriander
- 2 teaspoons slivered gingerroot, thinly sliced peeled parsnip, celery, or mushrooms, or 2 cloves garlic, minced

After cooking, add:

- Cooked white rice
- Cooked pasta or noodles

Chicken Soup

This is something you need to know how to make. You may not need to make it today, or tomorrow, or even next week. But one day, someone you love will be under the weather or really sick or depressed and you'll want to do something special for that person. There is nothing better than homemade chicken soup to convey a message of love and caring.

The very best thing to use to make chicken soup is an older chicken, called a fowl. Its meat has the most flavor. A fowl is readily available in a kosher butcher shop, or you can ask your supermarket to get you one. It's fine if it's frozen. You don't even have to thaw it before making the soup. If you can't get your hands on a fowl, then use a roasting chicken and go heavy on the onions.

Preparation time: 25 minutes
Cooking time: 2 hours
Yield: 8 servings making about 3 quarts
Can be made ahead? Yes. Up to 2 days. Chill well after cooking and keep
refrigerated until ready to reheat. Skim off fat first.
Can be frozen? Yes. Cool completely in the refrigerator, skim off all visible
fat, store in plastic containers, and freeze for up to 6 months. Defrost
in the refrigerator or microwave.
Can be doubled and tripled? Yes. You'll have to use a very large pot, or 2 pots.
Good for leftovers? Yes. Keep covered and refrigerated for up to 4 days.

*1 large fowl, fresh or
frozen, or 1 large
roasting chicken, discard
the organs but reserve
the neck
2 Knorr chicken bouillon
cubes
3 large onions, peeled and
sliced
4 carrots, cut into 2-inch
chunks
3 parsnips, cut into 2-inch
chunks
4 stalks celery, cut into 2-
inch slices*

*1 bunch parsley, well
rinsed
2 teaspoons black
peppercorns
5 cloves garlic, peeled
Approximately 3 to 4
quarts cold water
Additional chunks of
carrots, celery, and
parsnips and more sliced
onions
Salt and freshly ground
black pepper to taste*

Rinse the chicken and neck well and place them in a very large pot
or kettle. If you are using a frozen fowl, don't bother defrosting it.
Add the bouillon cubes and the cut-up vegetables, parsley, pepper-
corns, and garlic. Cover completely with cold water and bring to a
simmer.

Cover the pot, leaving the lid off center so that some steam
escapes. Cook for 2 hours over very low heat. The soup should be
just barely simmering. Let the soup cool with the chicken in it for
an additional half-hour at room temperature, and then strain off the
liquid. You should have about 3 quarts liquid.

Refrigerate the soup until very cold and then scrape off the fat
that has solidified on top and discard it. You can use the cooked
chicken for chicken salad or add it back to the soup before serving.
(It won't have much taste.) Discard the cooked vegetables (or eat
them out of the bottom of the pot the way I do).

Reheat the soup and taste before adding any additional vegetables

or seasoning. If the soup is very undersalted, I like to add another bouillon cube rather than straight salt; try adding one-half a cube at a time to avoid oversalting. I like lots of pepper in my soup. Add the remaining vegetables and cook only until they are tender.

Creamy Carrot Soup

Serve this cold or hot. Puréed potatoes give this soup a creamy texture.

Preparation time: 20 minutes
Cooking time: 30 minutes
Yield: 6 servings, about 3 quarts
Can be made ahead? Yes. The day before. Cover and refrigerate until serving or reheating.
Can be frozen? Yes.
Can be doubled and tripled? Yes.
Good for leftovers? Will keep, covered and refrigerated, up to 1 week.

6 large carrots, peeled and sliced
2 medium onions, peeled and diced
2 large Idaho potatoes, peeled and sliced
4 cups canned chicken broth, or 4 cups water and 2 chicken or vegetable bouillon cubes
1 tablespoon soy sauce
Dash of Tabasco sauce
⅓ cup honey or brown sugar, firmly packed
½ teaspoon gingerroot, peeled and finely chopped (optional)
Salt and pepper to taste
Yogurt or sour cream for garnish

Place the vegetables and the broth or the water and bouillon cubes in a large pot and bring the liquid to a gentle simmer. Cover and cook until the vegetables are very tender, about 30 minutes. Purée the vegetables and liquid in 2-cup batches in a food processor or blender until very smooth. Return soup to the pot. If a thinner consistency is desired, add a little milk.

Add the remaining ingredients and serve hot, or cool and chill to serve cold. Garnish each serving with a tablespoon of yogurt or sour cream.

Bean Soup

This economical and hearty dish is a great meal in itself when served with a salad. The recipe calls for soaking the beans overnight; so, you have to start this soup a day ahead of when you plan to serve it.

You can make this vegetarian by using vegetable bouillon cubes instead of beef or chicken ones.

Preparation time: 30 minutes, plus 8 to 9 hours for soaking the beans
Cooking time: 2 hours and 20 minutes
Yield: 8 servings
Can be made ahead? Yes. Covered and refrigerated up to 3 days.
Can be frozen? Yes. Consider freezing individual servings in 1-pint or ½-pint plastic containers to make defrosting faster.
Can be doubled and tripled? Yes.
Good for leftovers? Yes. Will keep up to 1 week, covered and refrigerated. Can be eaten hot or cold. Makes a great breakfast.

1 pound dry red kidney beans
4 quarts cold water
6 cups canned chicken or beef broth, or 6 cups water and 3 beef, vegetable, or chicken bouillon cubes

½ cup olive oil
5 cloves garlic, finely chopped
3 large onions, diced
⅓ cup wine vinegar
Salt and pepper to taste
Sour cream or plain yogurt for garnish

Rinse the beans carefully, and pick out any pebbles. Place the beans in a very large bowl or pot, cover with the cold water, and let sit overnight in a cool place. (No need to refrigerate unless it's very hot out.)

Drain the beans and place in a large pot. Add the 6 cups of broth or the water and bouillon cubes and bring to a gentle simmer.

Meanwhile, heat the oil in a skillet and sauté the garlic and onions until translucent, taking care not to brown the garlic. Add the contents of the skillet to the beans, cover, and cook over low heat for about 2 hours, checking to make sure the level of liquid is just above the beans. Add more if necessary. Add the vinegar and salt and pepper. Remember that canned broth and bouillon cubes are very salty.

If you want a smooth texture to the soup, purée it, 2 cups at a time, in a blender or food processor.

Serve each portion garnished with a tablespoon of sour cream or yogurt.

Gazpacho

This traditional Mediterranean soup is served cold. It can be made well ahead of time and will keep for 1 week, refrigerated. It's a great starter for a summer supper or before a hearty main course. You can use it as a low-cal snack, too.

Preparation time: 20 minutes
Yield: 4 servings
Can be made ahead? Must be made ahead, up to 2 days ahead. Refrigerate in a covered container.
Can be frozen? No.
Can be doubled and tripled? Yes.
Good for leftovers? Yes. Will keep refrigerated in a tightly covered container (glass or plastic is best) for up to 1 week.

3 ripe tomatoes, chopped, or one 10-ounce can whole tomatoes, chopped, undrained.
2 large cucumbers, peeled and diced
1 green bell pepper, diced
1 red bell pepper, diced
1 stalk celery, diced
4 cups (32 ounces) tomato juice or V8 vegetable juice or spicy V8 vegetable juice, if you like a kick

¼ cup tomato paste
1 teaspoon Worcestershire sauce
Juice of 1 lemon, or *¼ cup red wine vinegar*
Salt and pepper to taste
Tabasco sauce to taste

In a glass or plastic container with a lid combine all the ingredients and taste for seasoning, adding as much salt and pepper and Tabasco as desired. Chill for at least 4 hours or overnight and serve cold.

Tomatoes, avocados, peaches, and nectarines ripen faster when enclosed in a brown paper bag and kept at room temperature for 2 to 3 days.

Tomato Soup

When you get tired of store-bought, try this.

Preparation time: 25 minutes
Cooking time: about 40 minutes
Yield: 6 to 8 servings
Can be made ahead? Yes. Up to 3 days. Cool at room temperature for 20 minutes, then refrigerate in a covered container. Reheat over low heat, stirring frequently.
Can be frozen? Yes. But it may separate, so you'll have to blend it or put it in a food processor for a few minutes before heating as directed above.
Can be doubled and tripled? Yes.
Good for leftovers? Yes. Reheat as above.

2 tablespoons butter, margarine, or vegetable oil
1 medium onion, chopped
2 stalks celery with leaves, diced
2 cloves garlic, finely chopped
1 large (28-ounce) can whole or crushed tomatoes

2 tablespoons tomato paste
1 teaspoon dried oregano
1 teaspoon dried basil
1 carrot, peeled and thinly sliced
6 cups canned chicken or beef broth
2 teaspoons sugar
Salt and pepper to taste

In the bottom of a large pot set over moderate heat, melt the butter and sauté the onion and celery until wilted, stirring frequently (about 4 minutes). Add the garlic and cook for an additional 2 minutes, without letting the garlic brown.

Add the tomatoes, tomato paste, herbs, carrot, broth, and the sugar. Increase the heat until the broth starts to simmer and then reduce it so that the soup just bubbles. Cover and simmer for 30 minutes.

If you want a chunky soup and have used whole tomatoes, mash them with a wooden soup against the sides of the pot. If you want a smooth soup, then purée the mixture, 2 cups at a time, in a food processor or blender. Season with salt and pepper.

Zucchini Velvet Soup

Smooth and soothing. Sprinkle with grated Parmesan cheese or some garlic croutons.

Preparation time: 25 minutes
Cooking time: approximately 30 minutes
Yield: 6 servings
Can be made ahead? Yes. Up to 3 days. Refrigerate in a a covered container. Either reheat or serve cold.
Can be frozen? Yes. Defrost partially in the refrigerator, then at room temperature for up to 2 hours. Or microwave.
Can be doubled and tripled? Yes
Good for leftovers? Yes. Store for up to 1 week in a covered container in the refrigerator. Serve hot or cold.

¼ cup olive or vegetable oil
3 cloves garlic, peeled and chopped
1 large onion, peeled and diced
2 large carrots, peeled and sliced
2 stalks celery, chopped
One 10-ounce package frozen peas
5 medium-large zucchini, scrubbed and sliced

4 cups canned chicken broth, or 4 cups water and 2 chicken or vegetable bouillon cubes
½ teaspoon curry powder
1 tablespoon soy sauce
Pepper to taste
Garlic-flavored croutons or grated Parmesan cheese

Heat the oil in a large pot. Sauté the garlic and onion over moderate heat until they are translucent. Be very careful not to let the garlic brown. Add the other vegetables, the broth or the water and bouillon cubes, and the seasonings except the pepper.

Cover the pot and simmer over low heat until the vegetables are very tender, 20 to 30 minutes. Purée the soup in 2-cup batches in a blender or food processor or until smooth. Serve hot with the croutons, or sprinkle with the Parmesan cheese.

Salads and Dressings

Lora's Diet Salad

This recipe title is actually misleading because usually a diet means you're depriving yourself of something good. But this is good—and so easy to make—especially if you have a microwave in which you can nuke the potato.

Preparation time: 15 minutes
Cooking time: 1 hour to bake the potato in a conventional oven; or 12 to 14 minutes in a microwave oven
Yield 1 serving
Can be made ahead? No.
Can be frozen? No.
Can be doubled and tripled? Yes.
Good for leftovers? Not unless you're into soggy salad.

Continued

133

1 hot baked potato
One 3-ounce can tuna,
 packed in water
1 small Bermuda (red)
 onion, thinly sliced
Lettuce and greens of your
 choice (I like iceberg
 lettuce mixed with
 endive, which has a
 slightly bitter taste)

1 tablespoon bottled
 dressing, or oil and
 vinegar

Cut the potato (include the skin—it tastes great and is very nutritious) into chunks (kitchen scissors are good for this), and place in a large mixing bowl. Drain the tuna, flake it, and add it to the potato. Add the onion and as much lettuce or greens as you wish. Add the dressing and mix well. Eat immediately, while the potato is hot.

Three-Bean Salad

This inexpensive dish takes only a few minutes to whip together and it will keep for a couple of weeks in the refrigerator.

Preparation time: 15 to 20 minutes
Yield: 10 servings
Can be made ahead? Yes. Up to 3 days. Store in a covered container in the refrigerator.
Can be frozen? No.
Can be doubled and tripled? Yes.
Good for leftovers? Yes. Will keep for 2 weeks in a covered container in the refrigerator.

3 cans (1 pound each)
 beans, such as green
 beans, yellow beans, red
 kidney beans, or other
 beans of choice
²/₃ cup sugar
1 cup red wine vinegar or
 cider vinegar

½ cup vegetable oil
1 teaspoon salt
½ teaspoon pepper
1 large Bermuda (red)
 onion, chopped

Drain the liquid from the beans and discard it. Combine the remaining ingredients in a jar and shake well. Combine the beans and the dressing. Store in a covered plastic container in the refrigerator.

Cucumbers with Yogurt

Think of this as sort of a salad/soup concoction. If you go heavy on the yogurt, you'll have soup; less yogurt and it's more salad. Either way, this is a refreshing dish that can be had as a first course or as a side dish with spicy foods such as chili or curry.

You can make this a super low-cal dish by using nonfat yogurt.

Preparation time: 20 minutes
Yield: 6 servings
Can be made ahead? Yes. The day before. Store in a covered glass or plastic container in the refrigerator.
Can be frozen? No.
Can be doubled and tripled? Yes.
Good for leftovers? Yes. Will keep refrigerated in a covered container for 3 to 4 days.

4 medium cucumbers
1 bunch scallions
½ teaspoon salt
1 to 1½ cups plain yogurt (regular, low-fat, or nonfat)

⅓ cup minced fresh dill
1 large clove garlic, finely minced
Juice of 1 lemon
¼ teaspoon black pepper

Peel the cucumbers, slice them, and cut the slices into quarters. Cut the ends off the bulb (white) part of the scallions, peel off the very outer layers, and slice the scallions, using both the green part and the remaining bulb part, about ¼ inch thick.

Mix the remaining ingredients together in a bowl, adding just 1 cup of yogurt at first so you can adjust the consistency. Add more, if desired. Add the cucumbers and scallions and mix to distribute the dressing. Chill for at least 1 hour before serving.

When mincing garlic, shallots, or onions, sprinkle a pinch of salt over them. This will keep the pieces from sticking to the knife and cutting board.

Greek Salad

Preparation time: 20 minutes
Yield: 4 servings
Can be made ahead? Up to 4 hours, without the dressing. Store in a covered bowl in the refrigerator.
Can be frozen? No.
Can be doubled and tripled? Yes.
Good for leftovers? Any salad that has dressing on it will be soggy. However, I happen to like soggy salad. Undressed salad will keep for one more day, covered and refrigerated.

1 head lettuce of your choice, such as iceberg, Romaine, Boston, or red leaf
2 ripe tomatoes, sliced
1 cucumber, sliced
1 green bell pepper, sliced
½ cup black olives (such as Kalamata)

½ pound feta cheese, crumbled
¼ cup red wine vinegar
½ cup olive oil
1 teaspoon dried oregano
1 teaspoon dried basil
½ teaspoon salt
Pepper to taste

Wash and dry the lettuce, tear it into small pieces, and place it in a serving bowl. Add the other vegetables and top with the olives and the feta cheese.

Combine the vinegar, oil, herbs, salt, and pepper in a jar and shake well. Dress and toss the salad just before serving.

Coleslaw

You'll turn your nose up at store-bought coleslaw after tasting this.

Preparation time: 25 minutes
Yield: 6 to 8 servings
Can be made ahead? Yes. Up to 4 days. Refrigerate in a covered container.
Can be frozen? No.
Can be doubled and tripled? Yes.
Good for leftovers? Yes. Will keep for 1 week in a covered container in the refrigerator.

1 medium head purple or
 green cabbage
1 large Bermuda (red)
 onion, chopped
1 green bell pepper,
 chopped
1 red bell pepper, chopped
2 teaspoons salt, or to taste

½ cup red wine vinegar
⅓ cup soy sauce
2 tablespoons sugar
2 tablespoons caraway
 seeds (optional)
1½ cups mayonnaise
Salt and pepper to taste

Remove the outer leaves of the cabbage and discard. Cut off the bottom/woody stem section, discard it, and quarter the cabbage. Shred the cabbage either by hand using a metal grater, or in the food processor using the shredding blade. You can also use a large chef's knife to chop the cabbage. Place all the ingredients in a large salad bowl and toss well. Season with salt and pepper. Serve chilled.

Orange Streamer Salad

Tastier than coleslaw and healthier, too. Double or triple the recipe to feed a crowd.

Preparation time: 20 minutes
Yield: 6 servings
Can be made ahead? Yes. The day before. Cover and refrigerate.
Can be frozen? No.
Can be doubled and tripled? Yes.
Good for leftovers? Yes. Covered and refrigerated, it will keep 4 to 5 days.

Juice of 1 lemon, or 2
 tablespoons red wine
 vinegar or cider vinegar
2 tablespoons honey
1 tablespoon soy sauce

⅓ cup vegetable oil
4 large carrots or 6
 medium, peeled
1 cup raisins
⅔ cup sunflower seeds

Place the lemon juice or vinegar, honey, soy sauce, and oil in a large mixing bowl. Stir until blended. Grate the carrots into the bowl. Add the raisins and sunflower seeds and mix well. Store in a covered container.

Potato Salad

Preparation time: 20 minutes
Cooking time: about 20 minutes
Yield: 6 servings
Can be made ahead? Yes. The day before. Store in a covered container in the refrigerator.
Can be frozen? No.
Can be doubled and tripled? Yes.
Good for leftovers? Yes. Will keep refrigerated in a covered container for up to 5 days.

*3 pounds potatoes,
preferably Idaho*
1 onion, finely chopped
*2 stalks celery, plus the
leaves*
*2 tablespoons chopped fresh
parsley, or 2 teaspoons
dried parsley*

*1 tablespoon fresh dill,
chopped, or 2 teaspoons
dried dill*
*2 tablespoons red or white
vinegar or lemon juice*
1 teaspoon salt
½ teaspoon pepper
1 tablespoon Dijon mustard
1 cup mayonnaise

Peel the potatoes, and cut them into quarters. Boil the potatoes in enough salted water to cover for about 20 minutes, or until they are tender. Drain and let the potatoes cool while you chop the vegetables.

Combine all the ingredients in a large bowl. Toss to mix well and chill before serving.

Peel onions under cold running water, then freeze them for 5 minutes before chopping or slicing them. This will keep you from crying while working with them.

Macaroni Salad

Preparation time: 20 minutes
Cooking time: according to noodle package instructions
Yield: 6 servings
Can be made ahead? Yes, the day before.
Can be frozen? No.
Can be doubled and tripled? Yes.
Good for leftovers? Yes. Will keep covered and refrigerated up to 5 days.

*2 cups cooked elbow
 macaroni, well drained
2 stalks celery, finely
 minced*

*1 small Bermuda (red)
 onion, finely chopped
1 red bell pepper, chopped
1 cup mayonnaise
Salt and pepper to taste*

Combine all the ingredients in a bowl and toss until combined. Season to taste.

Basic Vinaigrette

Think of vinaigrette as a fancy name for good homemade salad dressing.

Preparation time: 5 to 10 minutes
Yield: 1⅓ cups
Can be made ahead? Yes. Will keep in a glass jar in the refrigerator for 1 month.
Can be frozen? No.
Can be doubled and tripled? Yes.

*½ cup olive oil
½ cup vegetable oil
⅓ cup red wine vinegar*

*1 clove garlic, minced
1 teaspoon salt
½ teaspoon pepper*

Place all the ingredients in a jar, cover tightly, and shake very well. Shake again before using.

Variations　Add ¼ cup of any of the following fresh herbs or 2 teaspoons dried: tarragon, dill, thyme, basil, oregano, chervil, sage, or parsley.

Blue Cheese Dressing:
Variations on a Theme

The secret to good blue cheese dressing is to use good-quality blue cheese. You may use Roquefort cheese in place of the blue; it will be more expensive, however.

Some folks like their blue cheese dressing with lumps of cheese in it, while others like it smooth. Control the texture when you mash the ingredients together.

Preparation time for all variations: 10 to 15 minutes
Yield: 1½ cups
Can be made ahead? Yes. Up to 1 week. Store in a covered glass jar or plastic container in the refrigerator.
Can be frozen? No.
Can be doubled and tripled? Yes.
Good for leftovers? Yes. Will keep 2 weeks in a covered container in the refrigerator.

Basic Blue Cheese Dressing

1 cup mayonnaise
½ cup crumbled blue
cheese

Place both ingredients in a bowl and mash together with a fork until well combined.

Yogurt Blue Cheese Dressing

Yield: 1½ cups

1 cup (8 ounces) plain *4 ounces crumbled blue*
yogurt *cheese*

Place both ingredients in a bowl and mash together with a fork until well combined.

Creamy Blue Cheese Dressing

Yield: 1⅓ cups

4 ounces cream cheese at
 room temperature
4 ounces crumbled blue
 cheese
¼ cup grated Parmesan
 cheese

3 drops Tabasco sauce
3 to 4 tablespoons cream or
 milk

Place all the ingredients except the cream or milk in a bowl and mash together with a fork. Add enough cream or milk to achieve the desired consistency.

Non-Creamy Blue Cheese Dressing

Yield: about 1⅔ cups

1 recipe Basic Vinaigrette
 (page 139)

3 tablespoons crumbled
 blue cheese

Mix the crumbled blue cheese into the vinaigrette, leaving small lumps.

Fast Russian Dressing

Preparation time: 5 minutes
Yield: 1 cup
Can be made ahead? Yes. Up to 3 days. Cover and refrigerate.
Can be frozen? No.
Can be doubled and tripled? Yes.
Good for leftovers? Yes. Will keep for 3 weeks, covered and refrigerated.

½ cup mayonnaise

½ cup catsup

Place both ingredients in a small bowl and stir together until blended. Keep refrigerated.

Easy Thousand Island Dressing

Preparation time: 10 minutes
Yield: 1⅓ cups
Can be made ahead? Yes. Up to 3 days. Cover and refrigerate.
Can be frozen? No.
Can be doubled and tripled? Yes.
Good for leftovers? Yes. Will keep for 3 weeks, covered and refrigerated.

> *1 recipe Fast Russian
> Dressing (page 141)*
> *⅓ cup chopped sweet
> pickles*
>
> *2 teaspoons Worcestershire
> sauce*

Place all the ingredients in a bowl and stir until combined.

Yogurt Dill Dressing

This is great served over sliced cucumbers.

Preparation time: 15 minutes
Yield: 1¼ cups
Can be made ahead? Yes. Up to 3 days. Cover and refrigerate.
Can be frozen? No.
Can be doubled and tripled? Yes.
Good for leftovers? Yes. Will keep for 3 weeks, covered and refrigerated.

> *1 cup plain yogurt,
> (regular, low-fat or
> nonfat)*
> *3 tablespoons vinegar or
> lemon juice*
> *1 teaspoon Dijon mustard*
> *2 tablespoons chopped fresh
> dill, or 2 teaspoons dried
> dill*
>
> *2 tablespoons chopped fresh
> parsley, or 2 teaspoons
> dried parsley*
> *Salt and pepper to taste*

Place all the ingredients but the salt and pepper in a bowl and mix until incorporated. Season to taste.

Honey Mustard Salad Dressing

This is easy and mighty tasty.

Preparation time: 15 minutes
Yield: about 2 cups
Can be made ahead? Yes. Up to 1 week. Cover and refrigerate.
Can be frozen? No.
Can be doubled and tripled? Yes.
Good for leftovers? Yes. Will keep for 3 weeks, covered and refrigerated.

1 cup mayonnaise
Juice of 1 lemon
½ teaspoon powdered
ginger
3 tablespoons Dijon
mustard

3 tablespoons dark brown
sugar
3 tablespoons honey
3 tablespoons soy sauce

Place all the ingredients in a bowl and mix to blend.

Tartar Sauce

This can turn a plain piece of broiled or sautéed fish into a tastier meal.

Preparation time: 15 minutes
Yield: 1½ cups
Can be made ahead? Yes. 1 week. Keep in a covered container in the refrigerator.
Can be frozen? No.
Can be doubled, and tripled? Yes.
Good for leftovers? Yes. Will keep for 2 weeks in the refrigerator.

1 cup mayonnaise
⅓ cup sweet pickle relish
1 small onion, finely
chopped

2 tablespoons chopped fresh
parsley, or 1 tablespoon
dried parsley

Place all the ingredients in a small bowl and mix until blended.

Sandwiches, Tacos, and Pizzas

Tuna Fish Salad

A note about tuna in cans: I suppose some people choose the solid white meat tuna over the darker chunk kind because the former has practically no taste when compared with the latter. Let's face it, this stuff *is* fish even though your mother may have tried to pass it off as chicken in her chicken chow mein. If you like boring, go for the white meat; if you want taste, get the chunk, dark meat.

Tuna packed in oil is tastier than tuna packed in water. Hang the calories. And the Italian canned tuna is the most delicious of all. I wouldn't use the Italian tuna to make salad, however. Just eat it straight from the can (oops, I mean straight off a plate), sprinkled with a little lemon juice and a few capers.

Continued

145

Preparation time: 15 minutes
Yield: 1½ cups tuna fish, enough for 4 sandwiches
Can be made ahead? The tuna salad can, but the sandwich might get soggy.
Can be frozen? No.
Can be doubled and tripled? Yes.
Good for leftovers? Only the salad part, unless you're a fan of soggy bread.

One 6½-ounce can tuna fish, either solid or chunk, dark or light, packed in water or oil
Several large tablespoons mayonnaise

2 large stalks celery, finely minced
1 small sweet (Spanish) onion, finely chopped (optional)

Drain most of the liquid from the tuna fish and discard. Place the tuna fish in a medium-sized mixing bowl and mash it with a fork or a metal chopper. Stir in the mayonnaise and then the celery and onion, if desired.

Tuna Fish Sandwich

Preparation time: 10 minutes
Yield: 4 sandwiches

1 recipe Tuna Fish Salad (preceding recipe)
4 slices bread, or 2 rolls, toasted

2 tablespoons mayonnaise
Iceberg lettuce (optional)

Spread the toasted bread with some mayonnaise, mound a generous amount of tuna salad on 2 slices of the toast, cover with lettuce, and top with the remaining slices. Serve with pickles and potato chips.

Tuna Melt After spreading the tuna on the bread, top it with a slice of American, Swiss, or Cheddar cheese. Place under the broiler or in the toaster oven set on top brown for about 40 seconds, or until the cheese melts. Top with the other slice of bread. You can do this in the microwave, but the bread will get soggy.

Egg Salad

Please see page 153 about cooking hard-boiled eggs.

I'm a purist when it comes to egg salad. But I'm willing to give you some options if you want to jazz it up.

Preparation time: 20 minutes
Cooking time: 12 minutes to cook the eggs
Yield: Plan on two eggs per person per serving.
Can be made ahead? Yes. The day before. Store in a covered container and refrigerate in the coldest part of the refrigerator.
Can be frozen? No.
Can be doubled and tripled? Yes.
Good for leftovers? Yes. Will keep refrigerated in a covered container for 3 days.

4 hard-boiled eggs, shelled
2 to 3 tablespoons mayonnaise
1 tablespoon Dijon mustard
Salt and pepper to taste
1 stalk celery, finely chopped (optional)
6 pitted green olives, chopped (optional)
1 tablespoon chopped pimento (optional)
½ teaspoon curry powder (optional)

Place the eggs in a medium-sized bowl and use two knives in a crisscrossing motion to break them into small pieces. Stir in the other ingredients, including any of the optional ingredients, and mix to blend.

Egg Salad Sandwich

Preparation time: 5 minutes, if the egg salad is already made
Yield: 2 sandwiches
Can be made ahead? No. Not only will the bread get soggy, the eggs, unless very well refrigerated, can give you food poisoning.
Can be doubled and tripled? Yes.

4 slices bread (I like pumpernickel or whole wheat)
Mayonnaise
Egg Salad (preceding recipe)
Iceberg lettuce (optional)

You can toast the bread if you like. Spread with the desired amount of mayonnaise. Divide the egg salad between 2 slices of the bread and top with lettuce and the remaining bread.

147

Curried Chicken
(or Turkey) Salad

This wonderful cold dish is the mainstay of many gourmet take-out shops. You can pay sixteen dollars a pound for theirs, or you can make your own and save a bundle. The main ingredient is leftover turkey or chicken. If you're craving this salad and ate all the leftover turkey or chicken, then go to the deli and buy some turkey breast. Smoked turkey breast would also be wonderful. Ask the clerk to slice it on the thick (½-inch) side.

Preparation time: 20 minutes
Yield: 6 servings
Can be made ahead? Yes. Up to 1 day before.
Can be frozen? No.
Can be doubled and tripled? Yes.
Good for leftovers? Yes. Store in a covered plastic container and refrigerate
 for up to 3 days.

*⅔ cup plain yogurt
(regular, low-fat, or
nonfat), or mayonnaise
1 teaspoon curry powder
2 cups (approximately 8
ounces) cubed chicken or
turkey breast
2 Granny Smith apples,
cubed*

*1 small can pineapple
chunks, drained
½ cup raisins
2 stalks celery, thinly sliced
½ cup pecans, or slivered
almonds*

Mix the yogurt or mayonnaise together with the curry powder in a large mixing bowl. Add all of the remaining ingredients and toss gently to cover with the dressing. Refrigerate until ready to serve.

To create your own cookbook, purchase a photo album with clear plastic pages. File recipes clipped from the newspaper or magazines as well as your own creations written on index cards.

Vegetarian Tacos

Preparation time: 20 minutes
Cooking time: 10 minutes
Yield: 6 servings
Can be made ahead? Just the fillings.
Can be frozen? No.
Can be doubled and tripled? Yes.
Good for leftovers? The tacos get kind of soggy. If you don't mind that, go
 ahead. Eat them cold or reheated.

*Two 19-ounce cans kidney
 beans
1 teaspoon chili powder
1 large sweet (Spanish)
 onion, chopped
8 taco shells
1 cup shredded Cheddar or
 Monterey Jack cheese*

*2 cups chopped ripe
 tomatoes
1 cup sour cream, or plain
 yogurt
One 16-ounce jar salsa
2 cups sprouts of your
 choice*

Preheat the oven to 375°F. with the rack in the upper third.

Drain the kidney beans and place them in a small saucepan. Mash with a fork. Stir in the chili powder and the chopped onion and heat thoroughly.

Divide the bean mixture among the taco shells and place the shells in an ovenproof pan just large enough to hold them upright. Sprinkle the cheese on top and bake for 15 minutes, or until the cheese melts.

Place the remaining ingredients in small bowls and serve with the tacos.

Meat Tacos Follow the above recipe, adding 1 pound lean ground beef. Brown the ground beef in a skillet. Drain off the fat and add the beans, chili powder, and onion. Cook an additional few minutes, until the mixture is hot. Proceed as with Vegetarian Tacos.

French Bread Pizza

When making your own pizza from scratch was all the rage, I tried it a few times and got frustrated that I couldn't throw the dough up in the air, spin it around, and have it land some place other than the floor, just like Joe the Greek at the House of Pizza down the street. The hell with that. This is much simpler and faster, and, just like real pizza, you get to pick your own toppings.

Preparation time: 15 to 20 minutes
Cooking time: 7 to 10 minutes
Yield: 2 to 3 servings
Can be made ahead? No. It will get soggy.
Can be frozen? No.
Can be doubled and tripled? Yes.
Good for leftovers? Not for longer than 1 hour.

1 large loaf French or Italian bread (depends on whether you like your crust hard and chewy—French—or soft and chewy—Italian)
2 tablespoons olive oil
One 15-ounce jar pizza sauce
Any of these optional ingredients: cooked pepperoni, crumbled cooked hamburger, sautéed onions, green or red peppers, anchovies, pitted sliced olives, sautéed mushrooms, tuna, capers, or anything else that comes to mind

1 to 1½ cups grated mozzarella cheese, or any other kind of semisoft cheese such as Cheddar, feta, goat cheese, Brie, Camembert, or blue

Preheat the broiler to medium-high and position the rack in the upper third of the oven. Cover a sturdy baking sheet with foil, shiny side down.

Cut the bread in half, top to bottom, and then slice each half, end to end. You will have four longish pieces.

Drizzle some olive oil over the cut side of each piece. Spread with pizza sauce and any of the optional ingredients. Sprinkle generously with cheese and place on the prepared sheet. Broil for 7 to 10 minutes, or until the cheese is bubbling and has started to brown. Serve immediately.

Pita Pizza

This is a fast and easy, no-mess breakfast, lunch, snack, or supper. You can use up leftovers on it, in addition to the suggested ingredients.

Preparation time: 10 minutes
Cooking time: 10 minutes
Yield: 1 serving per pita loaf
Can be made ahead? No.
Can be frozen? No.
Can be doubled and tripled? Yes.
Good for leftovers? No.

1 small whole-wheat or regular pita loaf
3 tablespoons pizza or tomato sauce, or any other sauce such as pesto, white or red clam, meat, or mushroom sauce

½ cup grated mozzarella cheese, or ⅓ cup grated Parmesan cheese

Preheat the oven or toaster oven to 400°F. Place the rack in the middle position. Line a baking sheet with foil. Slit open the pita loaf to make 2 halves. Spread each piece with sauce and top with cheese. Bake the pizzas on the baking sheet until the cheese melts.

Eggs

Hard-Boiled Eggs

Cooking time: 15 minutes
Can be made ahead? Yes. Shell the eggs while they are still hot and store in a covered glass or plastic container in the refrigerator for up to 4 days.
Can be frozen? No.
Can be doubled and tripled? Yes. Make as many as you'd like. Just make sure you use a big enough pot to cook them.
Good for leftovers? Yes. Refrigerate for up to 4 days until ready to use.

It's best to use a Teflon-coated pan for boiling eggs, since a metal pan will become discolored unless you add a pinch of cream of tartar to the water.

Fill a saucepan two thirds full with cold water. Add as many eggs as you wish to cook (they should not be crowded) and 1 tablespoon salt. Bring to a rolling boil. Cover the pan, turn off the heat, and let the eggs sit in the hot water for 15 minutes.

Drain off the hot water and immediately run the eggs under cold water. Peel at once (it gets harder if you wait).

Eggs

- Raw eggs in any form are considered to be a health hazard since they are can carry the bacteria salmonella, which causes a very nasty form of food poisoning. This means that you should think twice about using recipes that call for uncooked eggs and look askance at that big bowl of chocolate mousse that has been sitting out on the dessert table for several hours.
- Always store eggs in the refrigerator.
- It's not safe to use eggs that have cracks in them. Before buying eggs in the store, open the box and remove each one to make sure it has no cracks (a cracked one will usually stick to the carton).
- Eggs keep longer when stored in the carton in the refrigerator, not on the egg rack on the door.
- To tell if an egg is stale, place it in a bowl of water. If it floats, it's old.
- It's easier to peel older eggs than new ones.
- To tell if an egg has been hard-boiled without cracking it, spin it around on the counter. If it spins, it's boiled. If not, it's still raw.
- Don't put eggs in the shell in the microwave.
- If you do decide to cook eggs in the microwave, pierce the yolk first to keep it from exploding and making a nasty mess.
- When you are making dishes like custard or sauces that call for eggs (without the addition of flour or other thickeners), it is important not to let the eggs cook or the mixture boil since the eggs will curdle. It's a good idea to cook such combinations in a double boiler, over hot water rather than directly over the heat source. You can improvise a double boiler by placing a metal bowl over a pan of gently simmering water. The water should not actually touch the bottom of the bowl. You must stir or whisk constantly. As soon as the dish starts to thicken, or coats the back of a spoon, remove it from the heat.

Scrambled Eggs

Halve the recipe if you are cooking for one person. If you have a nonstick frying pan, this is the time to use it.

Preparation time: 5 minutes
Cooking time: 5 minutes
Yield: 2 servings
Can be made ahead? No.
Can be frozen? No.
Can be doubled and tripled? Yes. Use a bigger pan.
Good for leftovers? Yes. Store in the refrigerator in a covered plastic container for 2 days and serve on top of a hot baked potato.

> *1 tablespoon butter or margarine*
> *4 eggs*
> *¼ cup milk or light cream*
> *½ teaspoon salt*
> *Pinch of pepper*

Put the butter or margarine in a frying pan and place it over moderate heat until melted and just beginning to sizzle. Be careful that it doesn't get brown or burn. Meanwhile, whisk (or whip with a fork) all the other ingredients in a small bowl until blended.

Pour the egg mixture into the pan and cook for 15 seconds, without stirring. Lower the heat slightly and continue to cook, stirring gently with a fork to break up the eggs, another few minutes until just set. Serve immediately.

Variations Add one or more of the following when you mix the eggs before cooking:

- 2 teaspoons chopped fresh herbs, such as chervil, dill, thyme, oregano, or parsley
- 1 teaspoon dried herbs (see the above selection)
- ⅓ cup grated Parmesan cheese
- ⅓ cubed Brie or other soft cheese
- 1 small onion, chopped and sautéed briefly in 2 tablespoons butter, margarine, or olive oil
- ¼ pound lox (smoked salmon), finely chopped
- 2 tablespoons finely chopped green or red bell peppers

Fried Eggs

Preparation time: 3 minutes
Cooking time: 3 to 5 minutes
Yield: 1 serving
Can be made ahead? No.
Can be frozen? No.
Can be doubled? Yes. But it's much easier to cook 2 eggs at one time.
Good for leftovers? No.

2 eggs
1 tablespoon butter or
 margarine

Salt and pepper to taste

Crack the eggs into a measuring cup with a small spout. Until you get really good at cracking eggs cleanly without chipping off pieces of shell, don't crack them into your pan or bowl. Place the butter or margarine in a small skillet or frying pan over moderate heat until melted and just beginning to sizzle. Add the eggs and cook until the whites set. *For sunny-side up:* Cook for another minute or so, then run a spatula under the eggs to loosen them. Transfer to a plate. *For eggs over:* When the whites have set, separate the egg whites with a spatula and then run the spatula underneath the eggs to loosen them. Gently turn each one over. (This takes practice; don't flip out if the yolks break the first few times you try. They taste the same.) Cook another 30 seconds for "over easy" to 1 minute for "over medium." Use the spatula to transfer to a plate. Season with salt and pepper. Serve immediately.

Variation Slightly undercook the eggs. Place 1 slice of cheese such as American, Velveeta, or Cheddar on top of each egg. Run under a preheated broiler on high for 30 seconds until the cheese bubbles.

Uptown Eggs

These taste fancy-schmantzy. Who'd know they were so easy to make? And you don't need to add salt because the lox is salty.

Preparation time: 15 minutes
Cooking time: 10 minutes
Yield: 2 servings
Can be made ahead? No.
Can be frozen? No.
Can be doubled? Yes. Use a larger pan.
Good for leftovers? Yes. Store for 1 day in a plastic container in the refrigerator. Serve on top of a baked potato.

> *1 tablespoon butter or*
> *margarine*
> *1 small onion, diced*
> *1 small green bell pepper,*
> *diced*
>
> *4 eggs*
> *¼ pound lox (smoked*
> *salmon), cut into small*
> *pieces*
> *Pepper to taste*

Heat the butter or margarine in an omelet pan or skillet until it is very hot, but don't let it brown. Add the onion and bell pepper and cook over moderate heat for about 5 minutes, stirring occasionally so the vegetables don't stick.

Crack the eggs into a bowl, whisk briefly, and then stir in the lox. Pour the egg mixture over the vegetables and cook, stirring with a fork, until the eggs are scrambled but still wet. Season with pepper and serve immediately.

When making scrambled eggs, use the yolks from only half the eggs.

Downtown Eggs

And on the other hand . . .

Preparation time: 10 minutes
Cooking time: 15 minutes
Yield: 2 servings
Can be made ahead? No.
Can be frozen? No.
Can be doubled or tripled? Yes, if you have a very large pan.
Good for leftovers? No.

*8 thin slices salami (I like
 kosher style, myself)*
5 eggs

Pepper to taste

Place the salami in an omelet pan or skillet and cook over moderate heat, draining off the fat often, until the salami starts to get brown and crisp.

Meanwhile, crack the eggs into a bowl and beat with a fork. Add pepper to taste. Drain the fat off the salami one more time and pour the eggs over it. Do not stir, but rather shake the pan to move the eggs around; lift up the edges of the eggs so that the uncooked part can run underneath. When the eggs are set, slide the "pancake" of eggs on a plate and serve.

Poached Eggs

Preparation time: 6 minutes
Cooking time: 2 to 4 minutes
Yield: 1 serving
Can be made ahead? No.
Can be frozen? No.
Can be doubled? Yes. Use a bigger pan. Until you're good at this, stick to cooking 2 eggs at a time.
Good for leftovers? No.

*Cold water
1 teaspoon salt
2 teaspoons white vinegar
 or lemon juice*

2 eggs

Fold a paper towel into thirds the long way and lay it on the work surface near the stove.

Fill a shallow pan or small saucepan two thirds full of cold water. Add the salt and vinegar or lemon juice and bring the water to a rolling boil. Lower the heat to a simmer.

Carefully break the eggs, 1 at a time, into a small spouted measuring cup. Take care not to break the yolks. Use a spoon to stir the water vigorously around in the pan to create a minor whirlpool. Stop stirring. Quickly drop the eggs in and let them simmer until the white becomes firm, about 2 minutes for very soft and closer to 4 minutes for medium. Use a slotted spoon to lift the eggs out and place them on the paper towel to drain. Transfer to a plate.

Egg in the Nest

Preparation time: 10 minutes
Cooking time: 2 to 4 minutes
Yield: 1 serving
Can be made ahead? No.
Can be frozen? No.
Can be doubled? Yes.
Good for leftovers? No.

2 slices bread of your choice
2 Poached Eggs (preceding recipe)
Butter

Salt and pepper to taste
2 tablespoons grated Cheddar or Parmesan cheese (optional)

Toast the bread and spread with butter. Place 1 egg on top of each slice of toast. Season with salt and pepper and top with the cheese, if desired.

Omelet

If you want to make an omelet that slides out of the pan in one piece, you might consider investing in a nonstick Teflon- or SilverStone-coated omelet pan. The one I use costs about twenty dollars, and I picked it up in the supermarket. Try never to use any metal utensils with it as they will scratch the surface and food will begin to stick.

There are three tricks to making a good omelet: Use lots of butter (make sure it's good and hot); shake the pan; and practice. If you are planning to make more than one omelet, crack the eggs into a spouted pitcher ahead of time. Then you can just pour the eggs into the bowl and mix. If you plan to make filled omelets, have all your ingredients chopped and at room temperature before you start making the omelets. And have the serving plates right next to the stove.

Preparation time: plain omelets, 5 minutes; filled omelets, 15 minutes
Cooking time: 5 minutes
Yield: 1 serving
Can be made ahead? No.
Can be frozen? No.
Can be doubled? No.
Good for leftovers? No.

*1½ tablespoons butter
(margarine will also
work, but not as well)
3 eggs*

*2 tablespoons water
¼ teaspoon salt
Pepper to taste*

Place the butter in a 6- or 7-inch slope-sided skillet or omelet pan set over high heat. As the butter melts, in a small bowl with a fork or whisk mix the eggs together with the water, the salt, and pepper.

When the butter has melted and is sizzling (be careful not to let it brown), pour in the egg mixture and let the pan sit undisturbed for 15 seconds. Then, use a fork to gently stir the eggs once or twice around with one hand while using the other hand to jerk the pan back and forth over the heat. The object is to move the eggs around in the pan so that they don't stick. Let the eggs continue to cook without stirring until a "pancake" forms.

When a "pancake" has formed and the top is no longer runny, the omelet is ready to fold. If a little bit of runny egg mixture remains, tilt the pan as you lift the edge of the omelet to allow the egg mixture to run underneath, where it will cook.

Technique #1: Fold the two edges of the omelet over to meet in the center and flip it over, seam side down, onto a plate. This will take lots of practice.

Technique #2: Slide half the omelet onto the plate and use the pan to help flip the other half over. This will make an omelet in the shape of a half moon. This technique takes less practice then #1. With both techniques I suggest rehearsing several dozen "private" omelets before you go public. If folding is too difficult, then serve the omelet pancake style.

To fill an omelet: Have ready a total of 2 generous tablespoons per omelet of any of the following ingredients, or combinations thereof. When you get better at folding an omelet and sliding it out of the pan, you can use more than the suggested amount of filling:

- sour cream
- cream cheese, plain or with chives or any other flavoring
- grated cheese, such as Parmesan, mozzarella, Cheddar, or Monterey Jack
- soft cheese, such as Brie, cubed
- salsa
- cooked sausage, crumbled
- cooked bacon, crumbled
- blue cheese, crumbled
- cottage cheese, plain or flavored
- onions, chopped, either raw or cooked; if using raw, stick to the Bermuda (red) variety
- chives or scallions, chopped
- leftover cooked vegetables, such as asparagus, beans, peas, corn, potatoes, broccoli, cauliflower, mushrooms, spinach, or carrots
- raspberry or strawberry jam (and combined with cream cheese is great)
- tofu, chopped
- leftover Chinese food
- the tomato, cheese, and pepperoni topping from leftover pizza, or anything else that you can think of

Continued

Place about 2 tablespoons of filling on one half of the omelet and use the back of a spoon to spread it around a little. Don't spread the filling too close to the edges. Slide the filled side of the omelet onto a plate, then use the pan to help flip the other side over it to form a half moon. Serve immediately.

Crustless Quiche

If I called this bread pudding, chances are, like eggplant for the uninitiated, you wouldn't try it. Quiche is a mixture of eggs, cream or milk, cheese, and, if you wish, vegetables, fish, or meat, all baked together in a pie crust. Now, pie crusts are a challenge even for seasoned cooks (not that *you* couldn't ever make one—you just need a tad more seasoning).

Something is needed, though, under the custard to absorb some of the liquid during the baking. This something will also enable you to get the quiche out of the pan when it is finished. This "crust" also offers a nice contrast to the custardy texture of the quiche. For this recipe, instead of pie crust, we're going to use bread, which makes it, strictly speaking, more like bread pudding than quiche. But if I called it bread pudding you wouldn't . . . Oh, the hell with it. Make this. You'll like it.

The cream/milk combination you choose will determine how creamy and rich the quiche is. If you are watching calories, go with the milk.

Preparation time: 30 minutes
Cooking time: 45 minutes
Yield: 6 servings
Can be *assembled* ahead of time? Yes. Up to 12 hours, but not less than 2 hours. Note baking instructions. Cover with plastic wrap and refrigerate until ready to bake.
Can be frozen? No.
Can be doubled? Make 2 quiches instead.
Good for leftovers? Yes. Eat cold. Or reheat in the microwave or wrap in foil and bake in a 350°F. oven for 15 minutes, or rewarm in the toaster oven.

1 to 2 tablespoons butter or margarine, softened

12 slices stale bread of your choice, such as challah, rye, whole wheat, croissants (halved horizontally), or onion rolls (halved horizontally)

2 medium onions, peeled and chopped

½ pound grated cheese of your choice, such as Swiss, Cheddar, Monterey Jack, or Cheshire

6 slices bacon, cooked and crumbled (optional)

1 cup cubed ham, chicken, or smoked turkey (optional)

1 cup sliced mushrooms (optional)

One 16-ounce can salmon, drained, flaked, and free of bones (optional)

6 eggs

2 cups heavy cream, or 1 cup heavy cream and 1 cup whole milk, or 2 cups whole milk

½ teaspoon salt

½ teaspoon pepper

1 tablespoon Dijon mustard, or 1 teaspoon dry mustard

Note that this dish stands for 1 hour before baking, so don't preheat the oven quite yet. Use the butter or margarine to generously coat a large ovenproof baking dish.

Place 6 slices of the bread or rolls in a single layer on the bottom of the dish. On top of these layer the onions, the cheese, and any of the optional ingredients. Place the remaining bread on top.

In a mixing bowl combine the eggs, the cream or milk, the salt, pepper, and mustard. Mix well and pour over the bread. *Let the dish stand for 1 hour, refrigerated.*

Preheat the oven to 325°F. with the rack in the center position. Place the baking dish in the oven and bake for 45 minutes. Serve hot or warm with the quiche cut into squares.

Breakfast and Brunch

Simple Granola

Preparation time: 10 minutes
Cooking time: 15 to 20 minutes
Yield: 5 cups, roughly 8 servings
Can be made ahead?: Yes. Up to 4 months in a tightly covered container in
the refrigerator.
Can be frozen? No need.
Can be doubled and tripled? Yes.

> 3 ½ cups quick-cooking,
> not instant, oatmeal
> ¼ cup vegetable oil
> ¼ cup honey

> 1 teaspoon vanilla extract
> ½ cup raisins
> ½ cup chopped nuts

Preheat the oven to 300°F. with the rack in the highest position.
Combine all the ingredients in a mixing bowl and spread on a cookie
sheet or on a shallow roasting pan. (Do in 2 batches if your pan is
too small.) Bake for 15 to 20 minutes, just until the mixture starts
to smell good. Take care not to burn it. Cool completely. Store in a
covered container in the refrigerator.

Granola

When you make your own granola, not only do you save money and know exactly how fresh it is, but, best of all, you also custom blend it. If any of the following ingredients aren't personal favorites or if you have a hard time locating them, then don't bother. It won't matter a bit. Make sure to store the granola in the refrigerator where it will keep for several months.

Many of the ingredients can be found in a health food store.

Preparation time: 25 minutes
Cooking time: 30 minutes
Yield: approximately 20 servings, about 12½ cups
Can be made ahead? Yes. Store in a covered container in the refrigerator for 2 to 3 months.
Can be frozen? No.
Can be doubled? Aren't you making enough already?
Good for leftovers? Great as a snack, with yogurt on top.

2 cups rolled oats
1 cup sesame seeds
1 cup sunflower seeds
½ cup wheat germ
¼ cup bran flakes
1 cup Grape-Nuts cereal
½ cup slivered almonds
½ cup cashews
1 cup raisins
1 cup coarsely chopped
 dried apples

½ cup coarsely chopped
 dried apricots
½ cup maple syrup
¼ cup molasses
½ cup brown sugar
⅓ cup safflower, corn, or
 canola oil
½ cup water

Preheat the oven to 325°F. with the rack in the center position. Place all the ingredients in a large mixing bowl and with your hands or 2 large spoons mix them well. Spread the granola in a large, shallow baking pan; the layer should not be deeper than 1 inch. You may have to bake the granola in several batches. Bake for 30 minutes, stirring occasionally. Let the granola cool completely before storing it in a closed container.

Oatmeal from Scratch

If your palate has been corroded by instant hot cereals, it's time to renew the system. There are few things more delicious than home-made hot cereals. I happen to be a Cream of Wheat freak, and Wheat-ena is high up on my list as well. Both those cereals have their instant counterparts, but if you are willing to take the few extra minutes—and I do mean few—to make the "real" thing, you'll be happy you did. Just follow the directions on the back of the box and feel free to add a pat of butter (or margarine), some brown sugar, and hot milk.

Preparation time: 10 minutes
Cooking time: 10 to 15 minutes
Yield: 2 servings
Can be made ahead? No. It will get lumpy and congeal.
Can be frozen? No.
Can be doubled? Yes. Take extra care scraping the sides and bottom of the pan while you are cooking the oatmeal.
Good for leftovers? No.

2 cups milk (whole, low-fat, or skim), or 1 cup milk and 1 cup water
1 cup oats (not instant)—you'll find them in the cereal section
½ teaspoon salt
½ cup raisins (optional)
Butter, cinnamon, brown sugar, and hot milk (optional)

Mix the liquid, oats, salt, and raisins together in a saucepan (if you have a nonstick one this is the time to use it). Bring the mixture to a boil and then lower the heat. Cover and simmer for about 10 minutes, stirring often and taking care to scrape the bottom and sides of the pan, until the mixture is thick.

Top each serving with a pat of butter or margarine, sprinkle with cinnamon and brown sugar, and add hot milk, if desired.

A Few Words in Support
of Breakfast

This isn't your mother telling you that breakfast is a good idea, so relax and listen up. This is me talking, a victorious veteran of the meal wars. I've seen more than four decades of hand-to-mouth combat on three fronts: as a food-loathing child; as a diet-driven adolescent; and as a mother of three kids who made my own childhood food finickiness look like a mild quirk. So here's some tried-and-true advice from an old hand: Skip lunch, forget an occasional dinner, but don't go without breakfast. Your body will thank you.

The way I look at it there are basically two kinds of breakfasts: the first kind you eat by yourself (usually) early in the morning with only the newspaper or Bryant Gumbel for company. You want food, not fuss. You want it easy and you want it fast. There may be another person or people sharing the kitchen, but basically it's every man/woman and child for him- or herself. This is the jump-start school of breakfast. It's the school that teaches a cup or two of really strong coffee can make almost anything the day may bring bearable. The mottos of the jump-start school are ingrained early and some of them are not so good: two cups of coffee now and a doughnut at the office when I get hungry; this cereal only *tastes* as if its main ingredient is sugar (the TV says it's full of vitamins: why does it have that stupid name?); and, worst of all: I'm still full from last night, so I'll just have Bryant for breakfast.

The other kind of breakfast doesn't happen nearly as often and rarely on a weekday morning. It's the kind of breakfast where friends or family get together to share a morning meal (perhaps—gasp —more than one course), some company, and some conversation. Usually it doesn't happen at the crack of dawn, either. So people gave it another name—brunch.

Let me suggest a third scenario. You get so good at whipping up pancakes, omelets, or two eggs over easy that you are inspired to get up a little earlier every once in a while on the weekdays and make a real breakfast—without waiting for company as an excuse. Start slowly here. Try the really simple recipes, the ones that don't take more than 5 minutes and don't involve more than 3 steps. Slowly gravitate to the next section. Before you know it, you'll be a breakfast

maven, serving up platters of hotcakes and bacon, oatmeal from scratch, and, even (can it be?) a quiche.

To make life really simple you have to plan ahead. This means shopping for items that you can keep on hand to make your quickie breakfast. I'm not talking Pop-Tarts here. Essential appliances are a toaster and a blender. If you want to drink your breakfast, check out the breakfast shakes. A microwave could make the earth move.

The following is a list of suggested staples you can use to throw together any number of fast, nutritional, and delicious breakfasts.

Bisquick: This is a powdered mix for making pancakes, waffles, biscuits, and quick breads, and it is found in the baking section of the grocery store.

Carnation Instant Breakfast: A powdered supplement that can be combined with milk and other ingredients. Can be served hot or cold.

Bananas: Have them 2 ways: fresh or frozen (made from the fresh you bought). To freeze, let some bananas ripen until the skins turn from green to deep yellow (a few brown spots are fine), or select some really ripe bananas from the "seconds" table at the grocery store. Peel them, and cut them into 1-inch slices (approximately the length of the first joint of your thumb). Store in a plastic bag in the freezer. Frozen bananas are a perfect base for a quick breakfast drink.

Assorted nuts (sliced almonds, peanuts, walnuts, pecans, and cashews): Store these in plastic bags in the freezer, then toss a handful of them on top of your cereal, be it hot or cold.

Dried fruits (dried coconut, apricots, apples, dates, figs, peaches, and raisins): All these are available in health food stores or the health food section of the grocery store. Store the coconut in the freezer and the other dried fruits in plastic or glass containers on the shelf. Add to cereal, or eat plain while running out the door.

Nut butters (peanut butter, cashew butter, or almond butter): These are found in the health food section of the grocery store or in health food stores. They are rich in protein and fiber and taste delicious. Spread them on wheat toast or on whole-grain crackers.

Fruit spreads: Also called fruit butters, these are available in grocery stores and health food stores and they have less sugar and more

169

personality than jams and jellies. Try them on toasted English muffins.

Hot cereals: Quick-cooking oatmeal, Cream of Wheat, or Wheatena. I'm not talking about the individually packaged, sugar-drenched instant hot cereal. You pay four times as much for that and get something with all the nutritional benefit of cotton candy. In the same aisle, pick up processed bran and store it in the refrigerator. Buy wheat germ at the same time to sprinkle on yogurt or hot or cold cereal. Store in the refrigerator, too.

Potatoes: If you own a microwave, you can nuke a potato and fill it with all kinds of interesting leftovers (see page 224).

English muffins or bagels: Buy lots, slice them in half (this saves time when you want to defrost them), and store them in plastic bags in the freezer.

Powdered milk (skim or otherwise): So you'll never be caught short.

Evaporated skim milk: Have this on hand if you like the taste of cream, but not the fat. Comes in a can that you store in the refrigerator after opening.

Other dairy products: Plain yogurt (available in regular, low-fat and nonfat); cottage cheese; Cheddar cheese (pre-shredded is very convenient, but more expensive); cream cheese, or its great low-fat substitute, farmer cheese, available in some supermarkets and delis.

Fresh fruit: Grapefruits, oranges, tangerines, apples, and pears are all sturdy fruits with a long shelf life. In other words, you can keep them for a time before you have to worry about their going bad.

It's much easier to chop candied or dried fruits if you freeze them for one hour. And dip the knife into hot water before cutting them.

Creamsicle
(Frozen Yogurt Shake)

This is a great, low-cal way to start off your morning with a healthy dose of vitamin C and calcium, and it also makes a super pick-me-up snack. You'll need a blender.

Preparation time: 10 minutes
Yield: 1 serving
Can be made ahead? No.
Can be frozen? No.
Can be doubled? Only if you have a really *big* blender. Tripled? No.
Good for leftovers? No.

> 1 cup (½ pint) nonfat vanilla or low-fat frozen yogurt
>
> 1 cup orange juice
> 3 ice cubes

Place all the ingredients in a blender and blend on high speed until smooth.

Fruit Shake 1

A terrific source of calcium, this tastes great, too.

Preparation time: 10 minutes
Yield: 1 large serving
Can be made ahead? No. It will lose its foamy consistency and get watery.
Can be frozen? No.
Can be doubled? Yes. But be careful not to overload the blender or it will overflow.
Good for leftovers? No.

> 1 cup frozen banana slices, or 1 ripe banana, peeled and sliced
> 2 ice cubes
> 1 ripe peach, pear, nectarine, mango, or papaya, coarsely chopped
>
> ½ cup plain yogurt (regular, nonfat, or low-fat)
> ½ cup milk (regular, low-fat, or skim)

Place all the ingredients in a blender and blend on high speed until smooth. Add more liquid if a thinner consistency is desired.

Fruit Shake 2

Choose your favorite fruit juice for this delicious concoction.

Preparation time: 10 minutes
Yield: 1 large serving
Can be made ahead? No. It will lose its foamy consistency and get watery.
Can be frozen? No.
Can be doubled? Yes. But be careful not to overload the blender or it will overflow
Good for leftovers? No.

*1 cup plain or flavored
 yogurt (regular, nonfat,
 or low-fat)
1 cup fruit juice
1 cup frozen banana slices
 or 1 banana, peeled and
 sliced*

*2 ice cubes
1 tablespoon honey
Pinch of cinnamon
 (optional)*

Place all the ingredients in the blender and blend on high speed until smooth.

Cinnamon Toast

Comfort food in the truest sense.

Preparation time: 5 minutes
Cooking time: 5 minutes
Yield: 1 serving
Can be made ahead? No.
Can be frozen? No.
Can be doubled and tripled? Yes. Keep repeating the recipe.
Good for leftovers? No. It gets soggy after it cools.

*2 slices bread (I like to use
 thick-cut whole-wheat or
 challah)*

*1 tablespoon sugar
¼ teaspoon cinnamon
Butter*

Put the bread in the toaster. While it is toasting, combine the sugar and cinnamon and set the broiler on high. When the bread is lightly toasted, butter it and sprinkle on the cinnamon sugar. Place under the broiler for 30 seconds or so, until the sugar has melted. Watch it carefully so it doesn't burn. Serve immediately.

French Toast

Make extra and freeze it. Pop it into the toaster (no need to defrost) for a quick breakfast or supper. Be sure to cool French toast completely before freezing.

Preparation time: 15 minutes
Cooking time: 10 to 15 minutes
Yield: 2 servings
Can be frozen? Yes.
Can be made ahead? Yes, the day before. Refrigerate covered with plastic wrap. Then heat on a cookie sheet in a 400°F. oven for 10 minutes.
Can be doubled and tripled? Yes.
Good for leftovers? Yes. See above for reheating instructions.

>*2 tablespoons butter or* *1 tablespoon sugar*
> *margarine* *1 teaspoon cinnamon*
>*1 whole egg* *4 thick slices challah or*
>*1 egg yolk* *other egg bread*
>*½ cup milk or cream* *Maple syrup*

Melt the butter in a skillet or sauté pan over low heat. Mix together the egg, egg yolk, milk or cream, sugar, and cinnamon. Dunk each slice of bread into the egg mixture long enough for some of the liquid to soak in. Use a spatula to transfer it to the pan. Cook on one side until golden brown, then flip over to cook the other side, adding more butter if necessary. Serve with maple syrup.

You can use evaporated skim milk as an ingredient when cream is called for and save more than 500 calories a cup, without sacrificing flavor. It won't whip, though.

Pancakes

If you use a nonstick skillet, there is no need to grease the pan.

Preparation time: 20 minutes
Cooking time: 20 minutes
Yield: approximately 12 to 14 3-inch pancakes
Can be made ahead? The batter up to 24 hours in advance—keep covered and refrigerated; cooked pancakes up to 1 hour before serving—keep at room temperature and reheat on a cookie sheet in a low (250°F.) oven for 10 minutes.
Can be frozen? Yes. Cool completely first. Package in layers with plastic wrap between, then place in a plastic bag. Reheat in the toaster, toaster oven, or conventional oven set at 350°F. for about 10 minutes.
Good for leftovers? Yes. Refrigerate for up to 2 days. Reheat in the toaster.

*2 cups flour, measured
 after sifting
4 teaspoons baking powder
1 teaspoon salt
2 tablespoons sugar
2 eggs*

*2¼ cups milk
½ cup (1 stick) butter or
 margarine, melted
Additional butter or
 margarine for greasing
 the pan, if necessary*

Sift the flour together with the baking powder, salt, and sugar into a mixing bowl. In a separate bowl mix together the eggs, milk, and butter. Add the wet ingredients to the flour mixture and mix gently, taking care not to overbeat, which will make the pancakes tough.

Heat the skillet with additional butter or margarine if desired until a drop of water sizzles on the surface. Pour about ¼ cup of batter at a time into the skillet. When bubbles form on top, gently turn the pancakes with a spatula (a plastic one if your pan is of the nonstick variety). Cook on the other side until golden brown.

Blueberry or Raspberry Pancakes For each recipe of batter, add 1 cup fresh or frozen berries just before cooking. No need to defrost them, but the berries do need to be separated. Stir them in very gently and try not to mash them. Cook as above.

Chocolate-Chip Pancakes Sprinkle 2 teaspoons of chocolate chips over the pancake batter right after you pour it into the pan. Press down gently with a spatula or your fingers to push the chips in slightly. Watch that they don't burn when you cook the second side.

Jiffy Waffles

Double the recipe and freeze the extras.

Preparation time: 15 minutes
Cooking time: 20 to 30 minutes
Yield: approximately 8 waffles
Can be made ahead? They get sort of soggy, but you can make them a few hours ahead and reheat them in the toaster oven or in the conventional oven on a cookie sheet for 10 minutes at 300°F.
Can be frozen? Yes. Cool completely first, then wrap in plastic wrap or store in an airtight plastic bag. Place directly in toaster. Do not defrost.
Can be doubled and tripled? Yes.
Good for leftovers? Refrigerate or freeze. Reheat in the toaster oven or microwave. No need to defrost first.

1 cup flour, measured after sifting
1 teaspoon baking powder
1/4 teaspoon baking soda
1/4 teaspoon salt
1 cup milk (whole or skim)

2 teaspoons white vinegar or lemon juice
2 tablespoons butter or margarine, melted
1 egg, slightly beaten

Sift together the flour, baking powder, baking soda, and salt. Stir in all the remaining ingredients. Mix gently. Too much stirring will make the waffles tough.

Pour 1/4 to 1/3 cup of batter onto a greased, preheated waffle iron. Cook the first side until steam has stopped coming from the waffle maker. If necessary* flip the wafer maker once and cook until golden brown.

*Electric waffle makers cook both sides at once.

How to Cook Bacon

Preparation time: 5 minutes
Cooking time: 15 to 20 minutes
Yield: 1 pound of bacon will serve 4 to 6 people
Can be made ahead? Yes. Up to 2 hours. Drain fat off. Keep, uncovered, at room temperature. Reheat in a 300°F. oven for 10 minutes.
Can be frozen. Yes, although it won't stay crisp.
Can be doubled? Yes.
Good for leftovers? Yes. Crumble on top of a salad or casserole. Refrigerate until ready to use, up to 1 week.

The easiest way to cook bacon is in the microwave. If you have one, simply line an 8- or 9-inch square Pyrex dish with paper towels. Separate 4 strips of bacon and lay them on top of the paper towels. Add another layer of paper towels and another layer of bacon. With the microwave set on high, cook for 90 seconds, turn the pan, and cook for 60 seconds. Check to see how crisp the bacon is. Be careful. It will be hot! If it's not crisp enough, continue to microwave at 15-second intervals until done.

The trick to cooking bacon or sausage successfully in a skillet is to drain off the fat frequently (into a coffee can or its equivalent). This way the bacon or sausage will be crisp and nicely browned, and you will have removed a great deal of the fat at the same time as you reduced the chances of a kitchen fire. You'll have to get used to holding the slippery pieces of bacon with a fork while you pour the scalding grease into the container. At first you'll probably lose a few pieces in the process. Keep practicing.

Reserve items like bacon, ham, bologna, and smoked cheeses for special occasions. They contain lots of fat, nitrates, and heavy doses of salt.

Muffins and Quick Breads

Basic Muffin Mix

Muffins are a great weekend baking project. They are easy and satisfying and make the kitchen smell like heaven. Muffins freeze well as long as you remember to first cool them completely. Using paper or foil liners or spraying with nonstick vegetable cooking spray on the muffin tins will facilitate cleanup.

Here is a basic muffin mix to which you can add your favorite ingredients. Possible suggestions follow.

Preparation time: 20 minutes
Baking time: 20 to 25 minutes
Yield: 1 dozen muffins
Can be made ahead? Yes. The day before. Cool, then store in an airtight plastic bag at room temperature.
Can be frozen? Yes. Cool completely, and store in airtight freezer bags. Defrost at room temperature and warm in a 300°F. oven or toaster oven for 5 to 10 minutes.

Continued

177

Can be doubled? Yes, if you have several muffin pans.
Good for leftovers? Muffins will keep 2 to 3 days stored in a plastic bag at
room temperature and up to 4 days, refrigerated.

2 cups flour, measured	*1 cup milk*
after sifting	*⅓ cup butter or margarine,*
⅓ cup sugar	*melted*
3 teaspoons baking powder	*1 egg*
½ teaspoon salt	

Preheat the oven to 350°F. with the rack in the center position.

Spray a muffin pan with nonstick vegetable cooking spray and
set a paper or foil liner in each tin. Or lightly grease the tin with
butter or vegetable shortening.

Sift the flour, sugar, baking powder, and salt into a mixing bowl.
Add the milk, the butter or margarine, and the egg, mixing just until
the dry ingredients are moistened. The batter may appear to be
slightly lumpy; that's okay.

Spoon the batter into the prepared tins, filling the cups only
two-thirds full. Bake 20 to 25 minutes, until the tops are golden
brown. Remove the muffins from the pan and let them cool on a
rack. Or tilt each muffin on its side in the pan to let them cool.

Variations　　Add one of the following to the finished batter and mix
gently:

- 1 cup fresh or frozen blueberries, raspberries, or sliced strawberries
 (frozen berries do not have to defrosted, but should be separated)
- ⅔ cup peeled and diced apple
- 1 ripe banana, mashed
- 1 medium ripe pear, peeled and diced
- ⅔ cup diced dried fruit, such as apricots, prunes, dates, apples,
 peaches, or papaya
- ½ cup bran
- ⅔ cup chopped nuts
- ⅔ cup cranberries (increase the sugar in the batter to ½ cup)
- ⅔ cup raisins
- 2 tablespoons grated lemon or orange peel

Apricot and Poppy Seed Muffins

This innovative recipe calls for a rather unusual but easily found ingredient: baby food! These muffins are world class. You may substitute chopped nuts for the poppy seeds.

Preparation time: 25 minutes
Baking time: 20 to 25 minutes
Yield: 12 large muffins
Can be made ahead? Yes, the day before. Cool completely and then store in a covered container or plastic bag.
Can be frozen? Yes. Cool completely and then store in an airtight freezer bag. Defrost covered, at room temperature.
Can be doubled? Yes, if you have several muffin pans
Good for leftovers? Yes. These muffins will keep well wrapped at room temperature for three days and refrigerated up to a week.

1 jar "Junior" baby food apricots (about ⅔ cup)	*2 eggs*
1 teaspoon baking soda	*1 ¼ cups flour, measured after sifting*
10 tablespoons (1¼ sticks) butter or margarine, very well softened	*¼ teaspoon salt*
	1 teaspoon vanilla
1 cup sugar	*3 tablespoons poppy seeds, or finely chopped nuts*

Preheat the oven to 350°F. with the rack in the center position. Spray a muffin pan with nonstick vegetable cooking spray and line each tin with a paper or foil liner. Or grease the pan well with butter or vegetable shortening.

Spoon the baby food into a small bowl and stir in the baking soda. The mixture will foam up.

In a large bowl cream the butter and sugar until the mixture is smooth, then add the eggs and mix well. Add the flour, salt, vanilla, the apricot mixture and the poppy seeds or nuts, and mix just until all the dry ingredients are moistened. Do not overmix!

Divide the batter among the 12 cups, filling each cup two-thirds full, and bake for 20 to 25 minutes, or until a cake tester or toothpick inserted into the middle of a muffin comes out clean. Cool the muffins on a wire rack.

Raisin Bran Muffins

Preparation time: 20 minutes
Baking time: approximately 20 minutes
Yield: 1 dozen muffins
Can be made ahead? Yes. The day before. Cool, then store in an airtight plastic bag at room temperature.
Can be frozen? Yes. Cool completely, and store in airtight freezer bags. Defrost at room temperature and warm in a 300°F. oven or toaster oven for 5 to 10 minutes.
Can be doubled? Yes, if you have several muffin pans.
Good for leftovers? Muffins will keep 2 to 3 days stored in a plastic bag at room temperature and up to 4 days, refrigerated.

1 egg	*3 teaspoons baking powder*
1 cup milk	*½ teaspoon salt*
2 tablespoons butter or margarine, melted	*½ cup dark brown or white granulated sugar*
1 cup bran flakes	*¾ cup raisins*
1 cup flour, measured after sifting	

Preheat the oven to 375°F. with the rack in the center position. Spray a muffin pan with nonstick vegetable cooking spray and line each tin with a paper or foil liner. Or grease the pan with butter and flour it, knocking out the excess flour.

In a large mixing bowl combine the egg, milk, butter or margarine, and bran flakes. Mix and let stand for 10 minutes while you prepare the other ingredients.

Sift the flour, baking powder, and salt over the mixture in the bowl. Add the sugar and raisins and mix just enough to combine the ingredients. Spoon the batter into the prepared pan, filling each cup two-thirds full. Bake for 20 minutes, or until a cake tester or a toothpick inserted in the middle of a muffin comes out clean and dry. Cool the muffins on a rack, or tilt them on their sides in the pan to cool.

Cheddar Bran Muffins

Preparation time: 25 minutes
Baking time: 25 to 30 minutes
Yield: 1 dozen muffins
Can be made ahead? Yes. Up to 3 days in advance. Wrap in plastic or place in a plastic bag and refrigerate.
Can be frozen? Yes. Cool completely beforehand.
Can be doubled? Yes, if you have 2 muffin pans and room in the oven to accommodate them both at the same time.
Good for leftovers? Yes. Heat in the oven or toaster. Will keep refrigerated for up to 1 week.

*1½ cups flour, measured
 after sifting
1½ teaspoons baking
 powder
¼ teaspoon baking soda
½ teaspoon salt
1 cup bran cereal
1¼ cups buttermilk (whole,
 low-fat, or made with
 reconstituted powdered
 buttermilk)*

*¼ cup vegetable oil
1 egg
⅓ cup sugar
1 cup shredded Cheddar
 cheese*

Preheat the oven to 375°F. with the rack in the center position. Lightly spray a muffin pan with nonstick vegetable cooking spray and line each tin with a paper or foil liner.

Sift the flour, baking powder, baking soda, and salt together into a mixing bowl. Combine the bran and buttermilk in a small bowl and set aside for a moment.

Add the oil, egg, and sugar to the flour mixture and mix well. Add the bran/buttermilk mixture along with the cheese and mix gently, just until all the dry ingredients are moistened. Fill each muffin cup three-quarters full and bake for 25 to 30 minutes, or until the muffins are browned. Cool the muffins on a rack or by turning them on their sides in the muffin tin.

Banana Bread

This moist loaf makes a wonderful breakfast or tasty snack.

Preparation time: 20 minutes
Baking time: 1 hour
Yield: 1 loaf
Can be made ahead? Yes. The day before. Cool thoroughly and then wrap in foil. Store at room temperature or refrigerate.
Can be frozen? Yes. Cool completely, slice, then wrap in foil and store in a plastic bag. Defrost at room temperature, still wrapped. Toast before serving.
Can be doubled? Yes. Use 2 bread pans.
Good for leftovers? Yes. Will keep well wrapped in foil and in a plastic bag in the refrigerator for 5 days.

3 very ripe bananas	*1 teaspoon salt*
2 eggs	*1 teaspoon baking soda*
2 cups flour, measured	*¾ cup chopped nuts, such*
* after sifting*	* as walnuts or pecans*
¾ cup sugar	

Preheat the oven to 350°F. with the rack in the center position. Butter and flour a 6-cup loaf pan, knocking out the excess flour.

Use a fork to mash the bananas in a large bowl. Add the eggs and mix well. Sift the flour, sugar, salt, and baking soda over the bananas. Stir well and mix in the nuts. Spoon the batter into the prepared pan and bake for 1 hour, or until a cake tester or toothpick inserted in the center comes out clean. Turn the cake out onto a wire rack to cool.

Squeeze fresh lemon or lime juice on sliced bananas, apples, or avocados to keep them from turning dark.

Corn Bread

Great for breakfast or with soup and a salad for lunch or dinner. The sweet nutty taste is irresistible.

Preparation time: 15 minutes
Baking time: 20 to 25 minutes
Yield: 8 servings
Can be made ahead? Yes. Up to 3 hours, but it's best right out of the oven.
Can be frozen? Yes. Cool completely, and cut into squares; or freeze whole, wrapped in plastic or in a plastic bag. Defrost at room temperature, still wrapped. Heat wrapped loosely in foil in a toaster oven or a 300°F. oven for 10 minutes, or in the microwave.
Can be doubled? Yes. Use an 17 × 11-inch pan and bake an additional 10 minutes.
Good for leftovers? Not wonderful. Corn bread gets stale very fast. It makes delicious bread crumbs, however. They can be sprinkled on top of scrambled eggs or an omelet.

3 tablespoons butter or margarine	*2 tablespoons sugar*
1 cup yellow cornmeal (available near the flour in the supermarket) or in health food stores	*2 teaspoons baking powder*
	½ teaspoon salt
	2 eggs
	1 cup milk
½ cup all-purpose flour, measured after sifting	*1 cup grated Cheddar or Monterey Jack cheese*

Preheat the oven to 350°F. with the rack in the center position. Place the butter in a 9 × 9-inch baking pan or in a 10-inch cast-iron skillet and put the pan in the oven until the butter or margarine melts.

Place the cornmeal in a large bowl and then sift the flour, sugar, baking powder, and salt over it. Mix well.

Add the eggs, milk, and cheese and stir until combined, taking care not to overbeat, which will make the bread tough and chewy. Pour into the prepared pan and bake for 20 to 25 minutes. The top will be golden brown. Serve warm.

Pasta and Macaroni

Tuna and Caper Sauce

Preparation time: 10 minutes
Yield: 2 servings
Can be made ahead? Yes. Refrigerate until ready to use.
Can be frozen? No.
Can be doubled and tripled? Yes.
Good for leftovers? Yes. Store in a covered container and refrigerate for up to 4 days. Use on salad or as a sandwich spread.

> One 6½-ounce can tuna, *Juice of 1 lemon*
> *either packed in oil or* *1 tablespoon capers*
> *water, drained* *2 tablespoons olive oil*

In a bowl mix all the ingredients together, breaking the tuna into small pieces. Toss with hot pasta.

Pasta

When I was a kid pasta was called spaghetti and it came only two ways: with red sauce or with butter sauce. It was usually so over-cooked that it had all the personality and texture of a jar of library paste. Along came the backlash in the form of *nouvelle cuisine* that said everything from chicken to linguine had to be undercooked—al dente (this means "fracture your molars" in Italian). Consequently, you were handed a hacksaw to cut your carrots and beans and a pair of pliers to twist your pasta around your fork. The chicken ran squawking off the plate when you jabbed it.

Fortunately, that crunchy phase has passed and now we've set-tled comfortably into the era of moderation, where we cook both the pasta and the vegetables to an agreeable stage of palatability, and it's no longer trendy to eat rare chicken.

Timing is everything in cooking pasta. It may take you a few tries to get it right, but try to think of it like blowing a bubble, or whistling. Once you've got it down, you get to keep it.

If you can integrate the idea that sauce doesn't have to be a big deal, you're home free. Trust me when I say that you can get home from work, boil up some water, throw a few ingredients together, and have a delicious meal in 20 minutes.

Pasta goes with anything short of pickles and chocolate sauce. Let's open the fridge and see what's lurking. Ah-ha! Half a can of tuna, a lemon, half a jar of capers. Grab the can of olive oil and a box of pasta—any shape, any size—and you're in business. While the pasta is boiling (follow the package directions for cooking time), mix the tuna together with the juice of the lemon, a tablespoon of capers, and a splash of olive oil. Drain the pasta, put it in a bowl, add your tuna sauce, and you are all set (see real recipe on page 185).

I know it still makes you nervous to cook without a recipe, so I've collected several very simple, but very good-tasting, sauces. After you see how easy they are, go on and start experimenting.

Remember that you can use any kind of pasta you like from angel hair, which is very fine and somewhat tricky to cook since it's so easy to overcook, to linguine and macaroni, both of which are thicker and make for a hearty dish. All of these dishes can be doubled, tripled, or quadrupled. If you are looking for more of a challenge, there is a recipe for Homemade Tomato Sauce on page 189.

Fresh Tomato
and Cheese Sauce

You should wait to make this until you can get local tomatoes—regular or plum—and fresh basil.

Preparation time: 15 minutes
Cooking time: about 1 minute
Yield: 2 servings
Can be made ahead? Yes. Up to 4 hours. Don't refrigerate.
Can be frozen? Yes. Up to 6 months. Store in a covered plastic container. Defrost at room temperature.
Can be doubled? Yes.
Good for leftovers? Yes. Also as a sauce for fish or on rice.

2 large ripe tomatoes, or 4 ripe plum tomatoes
½ cup fresh basil leaves
6 ounces goat cheese, such as Montrachet
2 tablespoons olive oil
Salt and pepper to taste

Bring a large pot half full with water to a boil. Add the tomatoes and count to 30. With a slotted spoon lift out the tomatoes; slip off the skins and discard. If you want your sauce seedless, then squeeze each tomato gently in your hand over the sink and the seeds will pop out.

Chop the tomatoes coarsely. Place in a bowl. Rinse the basil leaves, pat dry, and chop. Add to the tomatoes. Crumble the cheese and add to the tomatoes. Add the olive oil and stir gently. Season with salt and pepper. Serve over hot pasta.

How to Cook Pasta

Some people rinse pasta after they cook it to get rid of the starch. I don't get this. It's already had a bath; why does it need a shower? If you cook pasta in lots of water (1 pound needs at least 4 quarts of water) and add 1 tablespoon of oil, you won't have to rinse it afterward.

Use a big pot, fill it with water, and bring the water to a boil. For two people as a main course, use ½ pound of pasta and 2 quarts of water. Add 1 tablespoon of salt and 2 tablespoons of vegetable oil. When the water is boiling rapidly, add the pasta. *Don't break it in half!* Use a long-pronged fork to stir the water and move the pasta around so that the strands separate. When the water returns to a boil, set the timer and don't leave the kitchen.

Place a large strainer in the sink, and get your potholders ready as well as your plates. When the timer goes off, use the fork to fish out a strand of pasta, wave it around to cool it a bit, and bite the end off. It should be tender, yet offer a little resistance—but not crunchy. If it's mushy, you've cooked it too long. You can still eat it, but remember for next time. Drain the pasta into the waiting sieve or colander. Shake the sieve a few times to get rid of excess water, then toss the pasta with the sauce.

By the way, there is a great gadget called a spaghetti fork or spaghetti server. It looks like a weird spoon with claws. It makes serving a whole lot easier. You can also use two large forks or tongs.

Homemade Tomato Sauce

Make extra and freeze it!

Preparation time: 25 minutes
Cooking time: 2¾ hours
Yield: about 2 quarts, or enough for 16 servings
Can be made ahead? Yes. Up to 4 days. Cool, store in glass or plastic contain-
ers, cover, and refrigerate. Reheat over low heat, stirring frequently,
or in the microwave.
Can be doubled and tripled? Yes.
Can be frozen? Yes. Cool, then store in plastic containers. Defrost at room
temperature or in the microwave. Reheat as above.
Good for leftovers? Yes. Will keep for 1 week, covered and refrigerated.
Reheat as above or use in casseroles, vegetable dishes, and lasagna, or
over rice.

⅓ cup olive oil	*2 cups water*
1 large onion, chopped	*⅓ cup chopped parsley*
1 green bell pepper,	*1 tablespoon dried basil*
chopped	*2 teaspoons dried oregano*
4 cloves garlic, peeled and	*One 6-ounce can tomato*
finely chopped	*paste*
3 cans (28 ounces each)	*2 bay leaves*
crushed tomatoes	*Salt and pepper to taste*

Heat the oil in a large pot and add the onion and bell pepper. Cook
over moderate heat for 5 minutes, stirring occasionally. Add the garlic
and cook 2 minutes. Don't let the garlic burn.

Add the remaining ingredients and lower the heat so that the
sauce barely simmers. Cook 2½ hours, adding more water if the sauce
gets too thick. Stir the sauce every 20 minutes or so, taking care to
scrape the bottom of the pot with the mixing spoon. Cool slightly,
remove the bay leaves, and store in the refrigerator for up to a week.
Or cool and freeze.

Variations Add sliced mushrooms during the last half hour of cook-
ing. To make meat sauce, add 1 pound chopped hamburger meat,
cooked and crumbled, to the finished sauce.

Roasted Peppers
and Shrimp Sauce

Preparation time: 20 minutes
Cooking time: 15 minutes
Yield: 2 servings
Can be made ahead? Yes. Up to 4 hours. Refrigerate in a covered container, then gently reheat in a pan set over low heat. Stir constantly and heat only until warm.
Can be frozen? No.
Can be doubled? Yes.
Good for leftovers? Yes. Will keep refrigerated in a covered container for up to 3 days. Add to rice or a sandwich.

1 small jar pimientos	*Juice of 1 lemon*
(roasted red peppers)	*2 to 3 tablespoons olive oil*
8 to 10 pitted black olives	*½ teaspoon dried oregano*
8 boiled, shelled shrimp	*Salt and pepper to taste*
(see below)	*Grated Parmesan cheese*

Drain the pimientos and cut into small strips. Slice the olives. Cut the shrimp into large pieces. Place these 3 ingredients in a bowl and add the lemon juice, olive oil, and oregano. Add salt and pepper to taste. Toss and serve over hot pasta. Pass the cheese separately.

To cook frozen shelled shrimp:

1 cup water	*1 teaspoon salt*
¼ cup white wine	*1 bay leaf*
(optional), or ¼ cup	
cider vinegar	

Place all the ingredients in a small saucepan and bring the liquid to a boil. Add the shrimp—still frozen—and when the liquid returns to the boil, lower the heat to a simmer and cover the pot. Cook for 5 to 6 minutes or just until the shrimp are pink. Drain and rinse. Reserve. Discard the bay leaf; do not eat it!

To cook fresh shrimp still in the shell:

1 cup water	*1 teaspoon salt*
¼ cup white wine	*1 bay leaf*
(optional), or ¼ cup	
cider vinegar	

Rinse the shrimp under cold running water and then pull off the legs and shells and discard. To remove the dark vein from the back of the shrimp, hold the shrimp under running water and use a small sharp knife to make a shallow slit the length of its back. The water will flush the vein out.

Heat the liquids, salt, and bay leaf in a small saucepan. When the liquid simmers add the shrimp and allow the liquid to come to a boil. Lower to simmer, cover, and cook 4 to 5 minutes or until the shrimp are pink and have lost any translucency.

Garlic and Oil Sauce

Eat this with someone you love.

Preparation time: 10 minutes
Cooking time: 5 minutes
Yield: 2 servings
Can be made ahead? Yes. Up to 4 hours. Don't refrigerate.
Can be frozen? No.
Can be doubled? Yes.
Good for leftovers? Yes. Use it to make Garlic Bread. See recipe on page 122.

½ cup olive oil
4 cloves garlic, peeled and
* finely minced*
½ cup chopped parsley

Salt and pepper to taste
Freshly grated Parmesan
* cheese*

Heat the olive oil in a small pan over low-to-moderate heat. Add the garlic and cook for 5 minutes, stirring often and taking care not to let the garlic brown. Off the heat, stir in the parsley. Add salt and pepper to taste. Serve over hot pasta. Pass the grated cheese.

When a recipe calls for dried herbs, soak them in a small amount of olive oil before using to bring out their flavor. Add the olive oil to the dish as well.

Vegetable Sauce

You can make this a diet dish by using chicken broth instead of cream and eliminating the nuts and cheese. Use one kind of vegetable or mix and match.

Preparation time: 15 minutes
Cooking time: 15 minutes
Yield: 2 servings
Can be made ahead? No. The vegetables will get soggy. You can peel and cut up the vegetables up to 4 hours in advance. Store in a plastic bag in the refrigerator.
Can be frozen? Yes, but the vegetables will lose their crunchiness.
Can be doubled and tripled? Yes.
Good for leftovers? Yes, although the vegetables will be soggy.

2 cups fresh or frozen vegetables, such as asparagus, peas, artichoke hearts, broccoli, carrots, mushrooms, zucchini, summer squash, or string beans
1 cup heavy cream, or 1 cup chicken broth (either canned or made with 1 cup water and ½ bouillon cube)

½ cup slivered almonds (optional)
Salt and pepper to taste
Grated Parmesan cheese

Bring a medium pan of water to a boil. Slice the vegetables and cook them in the water until just tender. Drain. In the same pan bring the cream or broth to a boil and cook for 10 minutes. Watch the cream carefully as it will overflow the pan if cooked over too high a heat.

Add the vegetables and the optional nuts. Add salt and pepper to taste. Serve over hot pasta. Pass the cheese separately.

Lasagna

Until I discovered no-boil lasagna noodles I hated to make lasagna. Since I loved to eat it, however, I forced myself to fish those slippery suckers out of the boiling water (usually burning myself in the process), transfer them to paper towels to drain, and then wrestle them into the baking dish. What a pain!

Those travails are a thing of the past. The Shade Pasta company sells (and mass markets) a delight called (oddly enough) No-Boil Lasagna. Layer them in the pan with the ingredients and sauce of your choice, and, you have it: no-tears lasagna.

Preparation time: 25 minutes
Baking time: 30 minutes
Yield: 8 servings
Can be made ahead? Yes. Assemble, cover with foil or plastic wrap, and refrigerate until ready to bake.
Can be frozen? Yes. After cooking. Cool first, and wrap in foil or plastic. Partially defrost and heat in the oven or microwave.
Can be doubled? Yes. Use 2 pans.
Good for leftovers? Yes. Cover with plastic wrap and refrigerate for up to 3 days. Reheat in the microwave or in the oven.

One 32-ounce jar tomato sauce
One 15-ounce carton ricotta or cottage cheese
One 8-ounce package shredded mozzarella cheese
One 8-ounce package no-boil lasagna noodles
½ cup grated Parmesan cheese

Preheat the oven to 350°F. with the rack in the center position. Spray an ovenproof baking dish, approximately 13 × 9 inches, with nonstick vegetable cooking spray, or grease it lightly with solid vegetable shortening.

Open all the containers of ingredients. Line the bottom of the prepared pan with a layer of noodles.

Spread one third of the sauce, sprinkle with half the ricotta, and top it with half the mozzarella. Spread the ingredients all the way to

the edges of the pan. Add a layer of noodles to cover the cheeses. Repeat the layers, using one third of the sauce and the remaining ricotta and mozzarella. Top with more noodles and the remaining sauce and sprinkle the top with the Parmesan cheese.

Bake for 30 minutes. Serve hot, cut into squares.

Variations Add any of the following ingredients between the layers of cheese:

- Homemade Tomato Sauce (page 189)
- 1 cup sliced mushrooms, sautéed
- 1 cup chopped red or green peppers, sautéed
- 1 pound hamburg, sautéed and fat drained off
- 1 large can tuna, drained and flaked
- Two 9-ounce packages chopped frozen spinach, defrosted and drained (take care to squeeze the water out completely)
- One 10-ounce package frozen artichoke hearts, defrosted, drained, and cut into fourths
- 2 cups chopped cooked chicken or turkey
- 2 cups cooked sausage meat, drained
- 1 Spanish onion, thinly sliced
- For a Mediterranean flavor, substitute crumbled feta cheese for the ricotta and add 4 hard-boiled eggs, sliced, ½ cup pitted olives, 4 to 6 anchovies, drained and chopped, and 1 tablespoon capers

Watching your weight? Avoid cheeses like Brie, Cheddar, and Swiss that are high in fat. Instead, use skim-milk cheese—ricotta, cottage cheese, mozzarella—as well as reduced-fat cheeses. *Read the labels!*

Things to Do with Noodles

Before there was fettuccine made with beet juice or squid-ink linguine, there were noodles. I'm talking about good old egg noodles that come in a box and are the basis for lots of easy-to-make, inexpensive dishes that taste great. You can make noodle pudding, noodles and sour cream and cottage cheese, and, of course, that classic—tuna noodle casserole.

I'm also talking about macaroni, which is good for making things like macaroni and cheese and American chop suey (see page 199).

There are a couple of tricks to successful noodle cooking. *Cooked* noodles are the first ingredient in all the recipes that follow: Use at least 8 cups (2 quarts) of boiling water for every 8 ounces of noodles. Add a teaspoon of salt to the pot and make sure the water is boiling like crazy. (Use a big enough pot so the water doesn't boil all over the stove.) Dump in the noodles, stir like crazy for a few seconds so they don't stick to the bottom of the pot, and set a timer for the minimum recommended time on the package. You don't want the noodles crunchy, but you don't want them falling apart, either. A good rule of thumb is to shorten the cooking time by 2 minutes if you are going to also bake the dish.

While the noodles are cooking, assemble all the other ingredients, preheat the oven, if necessary, and place a colander in the sink. When the timer goes off, drain the noodles into the colander and proceed with the recipe.

For the most part, dishes made with noodles freeze very well (even though some of them may contain mayonnaise). So, if you have the time, double the recipe and freeze half.

Here are some relevant equivalents to refer to:

4 ounces noodles (approximately 1 cup) = 3 cups cooked noodles

5 ounces macaroni (approximately 1 cup) = 2 cups cooked macaroni

Tuna Noodle Casserole

There are probably thousands of versions of this recipe and after you make it once or twice, you'll find yourself substituting or adding your own favorite ingredients. This is a loosey-goosey affair, so don't be shy about experimenting—after you make it once my way.

Preparation time: 30 minutes, including cooking the noodles
Cooking time: 7 to 8 minutes to cook the noodles; 35 minutes to bake
Yield: 8 servings
Can be made ahead? It can be assembled as much as 8 hours ahead, covered with plastic wrap, and kept refrigerated until cooking time.
Can be frozen? Yes. Both baked and unbaked. Freeze in a freezer-to-oven baking dish. Note: Consider dividing the recipe between 2 baking dishes. Bake one and freeze the other after it's cooled. Partially defrost at room temperature for an hour, then bake as directed. Test to see if it's cooked all the way through by inserting a small sharp knife into the center. If it feels hot, then it's done.
Can be doubled and tripled? Yes. In one very large baking dish or 2 or 3 smaller ones.
Good for leftovers? Yes. Both hot and cold. When reheating in a conventional oven, cover carefully with foil so it doesn't get dried out. Or reheat in the microwave.

8 ounces egg noodles (I use those 1 inch wide, but use any width that appeals to you)
One 10-ounce package frozen peas
One 8-ounce can cream of mushroom soup
1 cup milk
One 12½-ounce can tuna, drained

2 cups plain or seasoned bread crumbs, tossed with 3 tablespoons melted butter or margarine, or 2 cups crushed Ritz crackers, tossed with 3 tablespoons melted butter or margarine

Preheat the oven to 375°F. with the rack in the center position. Grease or spray nonstick vegetable cooking spray on 1 large medium-sized ovenproof baking dish or 2 smaller dishes.

Cook the noodles according to the directions on the package, but shorten the cooking time by 2 minutes. Drain the noodles and combine with the peas, soup, and milk. Mash the tuna with a fork to break it up and add it to the noodles. Mix gently and spoon into the prepared pan. Sprinkle the crumbs over the top and bake for 35 minutes, until hot.

Noodle Pudding

This dish makes a fabulous main course for brunch or even an informal supper. You can also serve it with roast turkey or chicken. This recipe makes a lot, so if you're not feeding a crowd make it in two dishes and freeze one.

Preparation time: 30 minutes, including the time to cook the noodles
Cooking time: approximately 10 minutes for the noodles; 1 hour to bake the pudding
Yield: 10 servings
Can be made ahead? Yes. Can be assembled up to 6 hours ahead and cooked according to the directions. Or it can be fully cooked ahead and served either at room temperature or reheated. Reheat, covered with foil, in a 350°F. oven for 20 minutes.
Can be frozen? Yes. Cool completely beforehand. Partially defrost at room temperature, cover with foil, and bake for 30 minutes in a 350°F. oven. Test by inserting a small, sharp knife into the center. If it comes out hot, it's done.
Can be doubled? Yes. Use two baking dishes.
Good for leftovers? Wonderful, either cold or reheated in a conventional oven or in the microwave.

*1 pound wide egg noodles,
 cooked 2 minutes less
 than the package
 directions call for,
 drained
4 eggs
½ cup sugar
2 teaspoons baking powder*

*½ cup sour cream
1 cup cottage cheese
½ cup apricot preserves
1 teaspoon vanilla
1 stick (4 ounces) sweet
 butter, melted
1 cup golden raisins*

Preheat the oven to 350°F. with the rack in the center position. Generously butter a 13 × 9-inch ovenproof casserole.

With a whisk, egg beater, or electric mixer beat the eggs and sugar until the mixture is thick and pale yellow in color. Add the baking powder, taking care that it is well mixed in. Mix in the sour cream, cottage cheese, preserves, and vanilla. Stir in the melted butter.

Mix the egg mixture, the noodles, and the raisins together in a large bowl. Pour in the prepared pan and bake for 1 hour, or until the top is golden. Cut into squares and serve hot.

Noodles with Sour Cream
and Cottage Cheese

This is a traditional Sunday night supper in our house. You can throw it together in 5 minutes (not counting the time it takes to cook the noodles). Substitute plain yogurt for the sour cream and use low-fat cottage cheese, if you wish.

Preparation time: 15 minutes, including the time to cook the noodles
Cooking time: approximately 10 minutes following the directions on the noodle package
Yield: 4 to 6 servings
Can be made ahead? No.
Can be frozen? No.
Can be doubled and tripled? Yes.
Good for leftovers? Okay.

1 teaspoon salt
8 ounces wide egg noodles
1 cup (8 ounces) sour cream or plain yogurt
1 cup (8 ounces) creamy style or low-fat cottage cheese
Salt and pepper to taste

Bring a large pot with 2 quarts of water and the salt to a boil. Add the noodles, and stir for a moment to separate them. Cook for the minimum time recommended on the package.

While the noodles are cooking, empty the sour cream and cottage cheese into a serving bowl and mix together. When the noodles are cooked drain them, then mix them gently with the sour cream/cottage cheese mixture. Add salt and pepper as desired.

Replace cream cheese with one of the following: blenderized cottage cheese, a mixture of half tofu and half skim-milk ricotta, or farmer cheese.

American Chop Suey

What the connection here is to Chinese food is beyond me. This is what my mother called this dish and this is what my kids call it. Who am I to change tradition?

Preparation time: 25 minutes, including the time to cook the macaroni
Cooking time: according to package directions
Yield: 6 servings
Can be made ahead? Yes. Reheat in a microwave or cover with foil and bake in a 350 degree conventional oven for 20 minutes
Can be frozen? Yes. Defrost for 1 hour at room temperature, then proceed as above.
Can be doubled and tripled? Yes.
Good for leftovers? Yes. Reheat, or eat cold.

8 ounces small elbow macaroni
3 tablespoons vegetable oil
1 medium onion, chopped
1 green bell pepper, chopped

1 pound ground beef
One 16-ounce can tomato sauce of your choice
Grated Cheddar or mozzarella cheese (optional)

Cook the macaroni according to the directions on the package. Drain well.

Heat the oil in a skillet and sauté the onion and bell pepper for 10 minutes. Crumble the ground beef and add it to the vegetables, cooking it until brown. Add the tomato sauce and cook for 5 minutes more.

Combine the macaroni and the tomato mixture well, top with cheese, if desired, and serve.

Macaroni and Cheese

There are a couple of ways to make this that range from ridiculously easy (no offense meant) to upscale la-di-da.

For starters, you could open a box of Kraft M & C and there you be. Or, you could cook up some macaroni and pour on a can of Campbell's Cheddar Cheese Soup that has been cut with half a can of milk. An almost homemade version can be obtained by adding a tablespoon of butter, 1 cup cubed Velveeta, and ½ cup grated Cheddar cheese to 2 cups cooked macaroni. Pour in ½ cup of milk, stir gently over low heat until the cheese melts, and enjoy.

Or, you could live dangerously and try to make real macaroni and cheese. You can do this. Trust me. First you have to make a white sauce. . . .

Preparation time: 25 minutes
Cooking time: As per macaroni package instructions
Yield: 4 large servings
Can be made ahead? Yes. Up to 8 hours. Cool, cover, and refrigerate. Reheat in a microwave, or cover with foil and heat in a 350°F. conventional oven for 15 to 20 minutes.
Can be frozen? Yes. Partially defrost at room temperature, and reheat in a microwave or as above.
Can be doubled and tripled? Yes. Use an enormous pot.
Good for leftovers? Yes. Good cold and reheated.

8 ounces elbow macaroni
1 cup whole milk
2 tablespoons butter or
* margarine*
2 tablespoons flour
½ cup grated Cheddar
* cheese*

Salt and pepper to taste
½ cup plain (unseasoned)
* bread crumbs (optional)*
Grated Parmesan cheese
* (optional)*

Cook the macaroni in 2 quarts boiling water. Heat the milk in a small saucepan over medium heat. Watch it carefully; you want it just to barely simmer—small bubbles form around the edge—don't let it boil over.

Meanwhile, make the white sauce: Melt the butter or margarine in a medium skillet. Stir in the flour and with a whisk or fork stir constantly until the mixture bubbles. Don't let it brown. Dribble the hot milk into the butter/flour mixture, whisking constantly over medium heat until the milk is added and the sauce is smooth and

thickened. Lower the heat and continue cooking another 3 minutes, whisking constantly. Add the Cheddar and stir until it melts. Turn off the heat, and add salt and pepper to taste.

Drain the noodles. In a bowl combine the noodles and the sauce. Serve. Or place the macaroni and cheese in an ovenproof casserole, top with bread crumbs and grated cheese, and heat in a 350°F. oven for 20 minutes.

Shells with Peas and Ham (or Turkey)

Preparation time: 10 minutes
Cooking time: According to noodle package directions
Yield: 4 main course servings
Can be made ahead? No.
Can be frozen? No.
Can be doubled and tripled? Yes.
Good for leftovers? Yes. Eat cold or reheat in the microwave.

2 tablespoons butter or margarine
8 ounces small shell noodles, cooked and drained
One 10-ounce package frozen peas, cooked
1 cup ham, turkey, or smoked turkey, cut into ½-inch pieces
Salt and pepper to taste

Let the butter or margarine melt in the hot shells. Add the peas and meat, if desired. Toss gently. Season to taste.

To serve as a salad: Cook the shells and add ⅓ cup mayonnaise instead of the butter. Stir in the remaining ingredients and chill before serving.

Try substituting whole-wheat noodles or some of the Japanese noodles, like *udon* or *soba*, found in health food stores, for regular pasta. You can also use spaghetti squash with any pasta sauce. Spaghetti squash looks like a small yellow watermelon. Its fibrous threads are of a spaghetti-like consistency when baked. Here are directions for baking:

Cut the squash in half, dot with a tablespoon of butter or margarine, place the halves, cut sides up, on a foil-lined baking sheet, and bake in a 350°F. oven for 30 to 40 minutes or until tender. Scoop out the stringy flesh (that's the spaghetti) and top with your favorite sauce.

Rice and Grains

Boiled Rice

Perfectly cooked, fluffy rice is easy to make if you follow these simple directions.

Preparation time: 5 minutes
Cooking time: 20 minutes
Yield: 4 servings or approximately 3 cups
Can be made ahead? Yes. Up to 1 hour. Fluff with a fork, then cover with plastic wrap. Leave at room temperature.
Can be frozen? No.
Can be doubled? Yes. Use a large pot.
Good for leftovers? Yes. Either reheat in a microwave or add to casseroles, salads, or soups.

Continued

Rice and Grains

Boy, times sure have changed. I remember that when I first started cooking that rice was something white and bland that formed a little pillow under the creamed chicken and was used to sop up the sauce. Grain was something animals ate. These days rice—white and brown—lentils, buckwheat groats, wild rice (a grass), and couscous are usually the star ingredients in the dishes I cook.

It will expand your culinary repertoire if you learn, as I did, to think of rice and grains as more than just mounds of carbohydrates heaped next to the protein on your dinner plate. Rice can be the underpinning of a great variety of easy-to-put-together dishes. (See my suggestions on pages 206 and 210.) You can use these foods to make deliciously nutritious meals and help cut back on animal proteins, which Americans tend to eat to excess.

Buy rice and grains that have been grown without pesticides with caution. Often these items (this includes flour) will be infested with or attract mealworms. Make sure to store them in tightly sealed jars or plastic containers in the refrigerator; or you can place the containers overnight in the freezer to kill off any worm infestation. Then store in the refrigerator. If you discover moths in your grains, throw them away—and check around—they might have traveled to your cereal, cookies, or other grain products.

1¾ cups water, or 1¾ cups canned broth, or 1 bouillon cube (beef, chicken, fish, or vegetable, depending on what you're serving the rice with), dissolved in 1¾ cups hot water

1 cup long-grain white rice
Salt and pepper to taste

Bring the liquid to a boil in a 1-quart saucepan. Lower the heat to a simmer and add the rice. Cover tightly and simmer for 20 minutes. At the end of that time, turn off the heat, but do not remove the pot from the heat or remove the cover for another 20 minutes. Fluff the rice with a fork. Add salt and pepper to taste.

Baked Rice

You will need a pan with a tight-fitting lid that can be used both on the stove top and in the oven; otherwise you will have to switch pans.

Preparation time: 10 minutes
Cooking time: 20 minutes
Yield: 4 servings, or approximately 3 cups cooked rice
Can be made ahead? Yes. Up to 1 hour. Fluff with a fork, cover, and return to the turned-off oven where it should stay warm.
Can be frozen? No.
Can be doubled? Yes. Use a larger pan.
Good for leftovers? Yes. Add to soups, salads, or casseroles or reheat in the microwave oven.

2 tablespoons butter or margarine
1 small onion, finely chopped
1¾ cups canned or homemade chicken broth, or 1 chicken, beef, fish, or vegetable bouillon cube dissolved in 1¾ cups hot water

1 cup long-grain white rice
1 tablespoon fresh or 2 teaspoons dried herbs, such as parsley, chervil, oregano, thyme, sage, or rosemary (optional)
Salt and pepper to taste

Preheat the oven to 400°F. with the rack in the center position. Melt 1 tablespoon of the butter or margarine in an ovenproof pan or an ovenproof skillet. Add the onion and cook over moderate heat, stirring frequently, until it becomes translucent.

Add the rice and the remaining tablespoon of butter and stir until the grains are coated with the butter. Stir in the liquid and the optional herbs. Cover with a tight-fitting lid and place in the oven. Bake for 20 minutes.

Fluff the rice with a fork and season with salt and pepper.

Rice

When I say white rice, I do not, under any circumstances, mean instant or "minute" rice. I mean long-grain Carolina rice, which is most commonly found in an orange box with Uncle Ben's name printed on it. Be careful, because Uncle Ben's also makes that travesty called quick rice. I'd rather eat the cover of this book; it would have more flavor and personality.

If you use bouillon cubes or canned chicken broth in which to cook rice, you probably won't need to add additional salt.

The recipes on pages 203 to 209 deal exclusively with white rice. Recipes for brown and wild rice can be found on pages 210 to 211.

These variations can be used with any of the methods given for cooking rice:

- Use a combination of 1 cup milk or water or dry white wine and 1 can creamed condensed soup, such as mushroom or celery, instead of broth.
- Add ½ cup grated Cheddar cheese before cooking the rice.
- Add 1 cup uncooked chopped vegetables, such as carrots, broccoli, peppers, green beans, and so on, before cooking the rice.
- Stir in ⅓ cup grated Parmesan cheese after cooking the rice.
- After cooking, stir in up to 2 cups cubed leftovers like ham, beef, chicken, seafood, bacon, or cooked vegetables at room temperature.
- Make an easy rice salad by adding cut-up vegetables—carrots, celery, cauliflower, cucumber, red onion, or shredded cabbage—and add enough mayonnaise to moisten them and the cooked rice.

Microwave Rice

This is ridiculously easy.

Preparation time: 5 minutes
Cooking time: 12 to 15 minutes
Yield: 4 servings, or 3 cups cooked rice
Can be made ahead? Yes. Reheat in the microwave.
Can be frozen? No.
Can be doubled? No. Make the recipe twice if you need more.
Good for leftovers? Yes. Reheat in the microwave or add to soups, salads, or
 casseroles.

1 cup long-grain white rice
2 cups water, beef, or
 chicken broth, or 1
 bouillon cube of your
 choice dissolved in 2
 cups hot water

1 tablespoon butter or
 margarine (optional)
Salt and pepper to taste

Select a large glass or other microwave-safe bowl at least 2 quarts in
size to prevent the rice from boiling over and a dinner plate that will
rest on top of the bowl. Place the rice in the bowl and add the liquid.
Cover the bowl tightly with plastic wrap and place the plate on top.

Microwave on high for 12 minutes. At the end of that time check
to see if all the liquid has been absorbed. If not, rotate the bowl 180°
and microwave another 2 to 3 minutes. Let the bowl sit, either in
the microwave or on the counter, still covered, for another 5 minutes.

*Take care when you remove the plastic wrap from the top of
the cooked rice. Release it on a side away from you so you don't get
burned by the steam.* Fluff the rice with a fork. Add the optional
butter and season to taste.

Polynesian Rice Salad

Ready to go beyond potato salad and coleslaw? Here's a lively Oriental-style side dish that can be made ahead of time.

Preparation time: 20 minutes plus 20 minutes to prepare the rice
Yield: 8 to 10 servings
Can be made ahead? Yes. Up to the day before. Store in the refrigerator in a covered bowl.
Can be frozen? No.
Can be doubled and tripled? Yes.
Good for leftovers? Yes. Will keep, covered and refrigerated, for 4 days.

*3 cups cooked white rice
(follow any of the
preceding recipes for
white rice, pages 203 to
207)
2 small cans water
chestnuts, drained and
sliced
3 stalks celery, sliced
1 bunch scallions, sliced
1 tablespoon peeled and
finely chopped fresh
gingerroot*

*½ cup raisins
One 10-ounce can
pineapple chunks with
the liquid, or 1 small
fresh pineapple, cored
and cut into small
chunks
1 cup slivered almonds
2 tablespoons soy sauce
1 tablespoon Dijon mustard
½ cup mayonnaise*

Place all the ingredients in a large bowl and mix thoroughly. Chill well.

Fried Rice

In this recipe you start with cooked rice. Please refer to page 203 for how to boil rice. You will need 3 cups cooked rice.

Preparation time: 20 minutes
Cooking time: 5 to 10 minutes
Yield: 3 to 4 servings
Can be made ahead? Yes. Up to several hours, but it loses a lot of personality. Store at room temperature.
Can be frozen? No.
Can be doubled? Yes.
Good for leftovers? Great cold as a snack or light meal.

> 3 tablespoons vegetable oil
> 3 cups cooked white rice
> (see introduction to this
> recipe)
> 4 scallions, chopped
> 1½ tablespoons soy sauce
>
> 1 cup or more chopped
> cooked chicken, beef,
> seafood, or vegetables
> (optional)
> Pinch of pepper
> 2 eggs, slightly beaten

Heat the oil in a wok or large frying pan. Add the rice, scallions, soy sauce, and any of the optional ingredients. Stir with a chopstick or long-handled spoon over moderate heat for about 6 to 7 minutes. Make sure all the clumps of rice are broken up.

Mix in the pepper and eggs and stir, cooking only until the eggs are set. (They will look scrambled.) Serve immediately.

To keep cauliflower white, add a teaspoon of lemon juice or vinegar to the cooking water.

Brown Rice

Brown rice is more nutritionally "correct" than white rice as you get to eat the ultra-nutritious bran layer that covers the grain. Its whole personality—texture and taste—is different from that of its pale cousin. I've found it to be an acquired taste, and it is easier to acquire if it has been cooked right, meaning still slightly crunchy instead of mushy.

Store brown rice in the refrigerator to extend its shelf life, which is shorter than that of white rice.

Preparation time: 5 minutes
Cooking time: 45 to 50 minutes
Yield: 4 servings
Can be made ahead? No.
Can be frozen? No.
Can be doubled? Yes. Use a big pot and take care to stir, scraping the bottom of the pan during cooking.
Good for leftovers? Yes. Use in salad or soup.

*3¾ cups water, or chicken
 or beef broth
1 tablespoon butter or
 margarine*

*1 cup brown rice
Salt and pepper to taste*

Bring the water or broth and butter to a boil in a medium saucepan. Stir in the rice and lower the heat to a simmer. Cover the pan and cook for 45 to 50 minutes, stirring once or twice, toward the end. Season to taste.

Variations Add one or more of the following ingredients to the cooked rice:

- 1 medium onion, diced and sautéed in 2 tablespoons oil
- 2 cloves garlic, minced and sautéed in 1 tablespoon oil
- 2 stalks celery, chopped
- ½ cup nuts, such as cashews, pecans, walnuts, or hazelnuts, broken into large pieces
- ½ cup raisins
- ½ cup diced dried fruit, such as apricots or apples
- seeded cut-up sections of 1 large orange
- 1 cup dry roasted peanuts

Wild Rice with Pecans

Wild rice isn't a rice at all, but the seed of a grass that grows wild along the edges of rivers and lakes in parts of Minnesota, Wisconsin, and Canada. It is still hand-harvested the old-fashioned way, a method that is reflected in the price.

When I was a kid and went out to dinner where wild rice was served we thought that meant that the family was either really rich or incredibly pretentious—or both. Nowadays, though, the escalating price of gasoline has made the relatively stable price of wild rice look like a bargain.

Save wild rice for a special occasion. Its strong, pleasant taste makes me think of dark beer or game. It's a natural to serve with any kind of poultry or meat.

Preparation time: about 20 minutes
Cooking time: 45 to 50 minutes
Yield: 6 servings
Can be made ahead? Yes. The day before, although it is not as easy to reheat as regular rice. Fluff with a fork, cool slightly, then cover with plastic wrap, and refrigerate. Reheat in the microwave or in a buttered casserole in a 350°F. oven for 20 minutes.
Can be frozen? Yes. Cool and place in an airtight plastic bag. Defrost, then reheat as above.
Can be doubled? Yes. Use a big pot.
Good for leftovers? Yes. Great cold or in soups, rice salad, in an omelet.

1 cup wild rice	*4 tablespoons butter or*
3 cups water	*margarine*
2 teaspoons salt	*1 cup chopped pecans*

Pour the wild rice into a sieve and place the sieve in a bowl. Fill the bowl with cold water and wash the rice carefully, looking out for and removing small stones or other foreign matter. Remember this is a natural product in the truest sense. Change the water 3 or 4 times. Drain.

Bring the water to a boil in a medium saucepan. Add the salt and then stir in the wild rice. Lower the heat to a simmer and cover the pan. Simmer, stirring occasionally, until all the water has been absorbed, about 45 to 50 minutes. Stir in the butter and pecans and fluff the wild rice with a fork to separate the grains.

Couscous from Fez

Couscous is a quick-cooking grain from North Africa that's sort of a cross between pasta and fluffy rice. I had the following dish in the 1960s in Morocco and the smell of it cooking, every fragrant sniff, makes me long for both the 1960s and an exotic trip.

You can find couscous in either the rice section of your supermarket, in the fancy food section, or in a health food store. Typically it is steamed over boiling water, but the following way works almost as well.

Preparation time: 20 minutes
Yield: 6 servings
Cooking time: 7 minutes
Can be prepared ahead? Yes. If you plan to eat it cold or have a microwave to reheat it.
Can be doubled? Yes. Use a very large pot.
Good for leftovers? Wonderful as a cold dish.

2 tablespoons butter or margarine
1 large onion, peeled and finely chopped
1 clove garlic, peeled and finely chopped
2 teaspoons curry powder
1 cup canned chicken broth, or ½ chicken bouillon cube dissolved in 1 cup boiling water
1 cup couscous
½ cup raisins
½ cup cashews,* cut in half
Salt and pepper to taste

Melt the butter or margarine in a medium saucepan. Add the onion and cook for several minutes until wilted. Add the garlic and cook 1 more minute. Add the curry powder and the liquid and bring the mixture to a boil. Stir in the couscous, the raisins, and the cashews. Cover the pan and remove it from the heat. Let the couscous stand for 5 minutes, covered, then check to see if all the liquid has been absorbed. If not, cover the pan and let stand another few minutes. Season with salt and pepper and serve.

*If you buy salted cashews, shake them into a strainer to remove some of the salt and do not add any additional salt to this recipe. Do not use raw cashews available at health food stores in this combination.

Kasha Varnishkas
(Buckwheat and Bow-tie Noodles)

You can make this a vegetarian dish by substituting vegetable broth or bouillon for the chicken or beef broth. Serve as a main course or as a side dish.

Preparation time: 15 minutes
Cooking time: 15 minutes
Yield: 6 servings
Can be made ahead? Yes. The day before. Cool, cover, and refrigerate until ready to reheat. Warm in a microwave or cover with foil and heat in a conventional 350°F. oven for 15 to 20 minutes.
Can be frozen? Yes. Cool first, then freeze. Partially thaw at room temperature for 1 hour, then reheat as above.
Can be doubled? Yes.
Good for leftovers? Great. Each time you reheat it, it tastes better.

1 egg
1 cup coarsely granulated kasha (buckwheat groats)
2 cups canned chicken or beef broth, or 1 beef, chicken, or vegetable bouillon cube dissolved in 2 cups hot water
1 teaspoon salt (if you use canned broth, which tends to be salty, add the salt at the very end)

½ teaspoon white pepper
3 tablespoons butter or margarine
2 large onions, chopped
¼ cup vegetable oil
8 ounces bow-tie egg noodles, cooked and drained

Break the egg into a medium bowl and mix with a fork. Combine the kasha with the beaten egg, making sure all the grains are well moistened. Place the kasha in a large frying pan set over medium heat and cook, stirring frequently, until the egg has dried.

Bring the broth, salt, pepper, and butter to a boil in a medium pot. Add the liquid to the cooked kasha, stir gently, then cover and cook over low heat for 15 minutes. Remove the cover and fluff the grains with a fork. If the grains are very moist, cover again and continue cooking for another few minutes.

Sauté the onions in the oil in a skillet until lightly browned. Combine the kasha, onions, and the noodles. Season with salt and pepper. Serve hot, cold, or at room temperature.

Rice and Lentils

The foods combined in this recipe equal protein in your diet. I like to add a cup of grated Cheddar cheese to this right after it has finished cooking.

Preparation time: 10 minutes
Cooking time: 50 minutes
Yield: 8 servings
Can be made ahead? Yes. Reheat in a covered dish in the microwave or conventional oven.
Can be frozen? No.
Can be doubled? Yes.
Good for leftovers? Yes. Reheat as above.

7 cups water (if using canned broth, reduce water to 5 cups)
2 chicken, beef, or vegetable bouillon cubes, or 2 cups canned beef or chicken broth
3 cups long-grain brown rice
2 cups lentils

1 carrot, peeled and finely sliced
2 stalks celery, finely sliced
2 cloves garlic, peeled and minced
Salt and pepper to taste

Place the water and the bouillon cubes in a large pot, cover, and bring to a gentle simmer. Add the brown rice, lentils, and vegetables. Cover and simmer over low heat for about 50 minutes, or until the liquid is absorbed. Add salt and pepper to taste.

Vegetables and Vegetarian Dishes

Vegetables

If you've grown up on overcooked vegetables, or worse, the oversalted canned variety, then you are in for a treat. A simple dish of perfectly steamed or quickly blanched vegetables will change your life forever . . . well, maybe for ten minutes.

You can use a collapsible metal steamer, the kind that sits in the bottom of a large pot, but I find it a pain. It's just as effective to bring a large (in most cases) amount of water to which a little salt has been added to a rapid boil in a large pot. Drop in the vegetables of choice, cover, and cook until just tender.

Vegetables like green beans, spinach, and asparagus will cook quickly, say in 3 to 4 minutes, so all you will have to do is wash them thoroughly (especially in the case of spinach), or peel them (in the case of thick stalks of asparagus) and boil them. With vegetables like

carrots, broccoli, and cauliflower, you'll need to slice or cut them up first into relatively equal sizes so that the pieces finish cooking together.

Below is a list of vegetables that can be steamed or blanched and preparation tips. Use a large skillet in which to cook a small amount of vegetables. Use a large pot for more, fill it with water, and bring to a rapid boil. Add a teaspoon of salt, then the vegetables. Lower the heat to a brisk simmer, cover, and cook only until the vegetables can be penetrated easily with a fork. The suggested cooking times are only guidelines. If you like really crunchy vegetables, cook them less. Drain and serve with butter or margarine or a little olive oil, lemon juice, and salt and pepper. We're not talking about a big production here.

If you want to make two different kinds of vegetables but not cook them together (say, cauliflower and carrots), use a small strainer to fish out the first vegetable. Use the same boiling water to cook the remaining one.

Artichokes: I didn't learn about artichokes until I was in college. Some poor misguided guy, thinking that the way to my heart was through my stomach, took me to a fancy French restaurant for dinner. At that point in my life a beer and the background noise of Janis Joplin would have done it.

Anyway, my date, who in accordance with his to-the-manner-born upbringing had been weaned on caviar and Swiss chocolate, ordered steamed artichokes. The waiter put these small, sturdy plants down on the table in front of us. I thought they were centerpieces. He said, "Yum yum," and started eating his. Actually, he didn't eat in the traditional sense of the word. He pulled off a leaf with his fingers (my mother would have died seeing him play with his food that way), stuck most of it in his mouth, clamped down his teeth, and pulled the leaf out. He rolled his eyes and gave me this dopey smile. "God, this is heaven," he sighed. Right away I knew this was not the guy for me.

Year later when I went to France for the first time I met a very unpretentious lady who introduced me to the joys of artichokes. The taste is indeed sublime and the execution is fun. When I went through the corporate-wife stage and had to entertain people who didn't know each other, I served artichokes as a first course. There's nothing like playing with your food to loosen up a crowd.

Here's the program: Pick artichokes that are bright green and have tightly packed leaves. If the leaves look dried out, or have begun to pull away from the stem, the artichokes are not fresh. The size does not affect the taste, although small and large require the same

amount of effort to eat. So, as far as I'm concerned, it's better to have a big artichoke. Allow one per person.

Lay the artichoke on its side and with a serrated knife slice off the top quarter. Cut off the stem as well, but don't throw it away. Boil it with the artichoke and eat it yourself. It's delicious. If the artichoke has very prickly leaves, use scissors to trim off the top of each leaf.

Turn each trimmed artichoke upside down and slam it down once on the counter. This will help separate the leaves and expedite cooking.

Cook the artichokes in salted rapidly boiling water (1 teaspoon per 2 quarts). If you want to maintain their bright green color, add a teaspoon of baking soda to the boiling water. Cook for 20 to 35 minutes, depending on the size. When you can easily stick a knife up into the stem section and the bottom leaves pull away easily, the artichokes are done. Use tongs to remove the artichokes from the cooking water, turn them upside down to drain for a few minutes, and serve, hot, room temperature, or cold, either with salad dressing or mustard, or with plain butter, or garlic or herb butter.

To eat: Pull off the outer leaves, one at a time, starting at the bottom. Pull the leaf through your teeth to scrape off the "meat" that is at the base of each leaf. When you get to the fibrous "heart," use a knife to cut off the grassy-looking top. *Don't eat it.* It is the "choke" of artichoke and if you eat it that's what will happen to you. Under the "grass" is the heart—the most delicious part. Cut it in several pieces and enjoy.

You can eat the artichoke as is, or dip the leaves in sauce or salad dressing. My favorite sauce combines ⅓ cup Dijon mustard with the juice of one lemon. Many people prefer garlic butter or simple lemon juice. Whatever you chose, bear in mind that you can make a satisfying whole meal of a large artichoke. Who would have dreamed that playing with your food could be so much fun?

Asparagus: This is another vegetable that could constitute a whole meal. Cut off the woody ends of the stalks and use a vegetable peeler to remove the outer green skin from just below the tip of the asparagus stalk to the end. Don't bother peeling thin asparagus. Cook for 3 to 4 minutes in salted rapidly boiling water. Don't cook asparagus too long or it will take on the personality of a wet noodle. After 3 to 4 minutes of cooking, insert the tip of a sharp knife into the stem— the asparagus should be just tender. Drain. Eat hot, cold, or at room temperature. The mustard with lemon juice dressing mentioned above is also delicious with asparagus.

Broccoli: Cut off and discard the fibrous ends of the stems. Cut the broccoli head lengthwise into spears, leaving the stems attached to the flowerettes, or blossom ends. Cook in salted rapidly boiling water 4 to 5 minutes, until the stems can be pierced with a fork. Drain. Toss with olive oil and lemon juice, or butter or margarine. Add grated cheese, if desired.

Carrots: Peel and cut into ½-inch slices. Cook in salted rapidly boiling water for 7 to 9 minutes, until fork-tender. Drain. Toss with butter or margarine, lemon, a little brown sugar, and a sprinkling of powdered ginger.

Cauliflower: Cut off the tough bottom part on the head and trim away any discolored places. Cut into lengthwise pieces, leaving the trimmed stems attached. Cook in salted rapidly boiling water for 4 to 6 minutes, until fork-tender. Drain. Toss with butter or margarine and a little grated cheese, if desired.

Corn on the cob: The sugar, which makes corn on the cob so delicious, starts turning to starch the moment it's picked. That's why it's essential to buy fresh corn that has been picked that day, that *hour* is even better. Roadside stands in midsummer are the best places to look for the freshest corn.

Husk the corn while you boil up a big pot of salted water. Pull off the silk and break off the stems. Drop the corn into the boiling water and let the water return to the boil. Turn off the heat and cover the pot. After 5 to 7 minutes, fish out the corn. Enjoy with butter or margarine and salt, if desired.

Green beans: Rinse the beans well, and trim off the stem ends (the ones without the tails). If the beans are large, cut them in half or into thirds. Cook in salted rapidly boiling water for 2 to 3 minutes. Drain. Toss with olive oil, butter or margarine, a clove of chopped garlic, or toasted almonds.

Peas: Shell fresh peas and cook them in rapidly boiling water for 2 to 3 minutes. Toss with butter or margarine and a pinch of sugar or a sprinkling of dried mint.

Potatoes: For added vitamins and minerals leave the potato skins on. If the potatoes are small, keep them whole; if not, cut them into chunks. Cook in rapidly boiling water for 15 to 20 minutes, until fork-tender. Toss with butter or margarine or olive oil and a little chopped parsley. A clove of finely chopped garlic is a nice touch, too.

Spinach: Always assume fresh spinach is sandy and will need washing, even if it says "washed" on the bag and the leaves look clean as a whistle. The easiest way to wash a large quantity of spinach is to fill your sink with cold water and dump in the spinach. Swish it around for a minute, then let the dirt settle to the bottom. If there is lots of dirt on the bottom of your sink, you'd be smart to lift out the spinach (do so gently not to disturb the dirt), drain the sink, wipe it out, and repeat the procedure.

Tear the stems off the spinach as well as any thick veins running up the leaves. Don't make yourself crazy doing this. Just eliminate the really thick ones.

Place the spinach in a large pot and add ½ cup water. You can fill the pot with as much spinach as you wish. You will end up with about a fifth of the volume with which you started. Cover the pot and place over high heat. When you see steam coming out from under the lid, lower the heat and let the spinach cook 1 minute. Remove the cover to check to see that the spinach has just wilted. If so, drain well. Toss with a little butter or margarine, lemon juice or oil, and salt and pepper. Other good additions are finely chopped garlic, grated cheese, or bits of cooked bacon or ham.

Summer squash and Zucchini: Rinse these squashes well, slice into ½-inch rounds, and drop into salted rapidly boiling water for 2 minutes. Drain and serve hot with butter or margarine and fresh lemon juice.

Winter squash: You'll find butternut squash peeled and halved in plastic bags in many supermarkets. It is pumpkin-colored. Think of it as a sexy orange potato. Cut it into chunks, and cook it in salted rapidly boiling water for 10 to 15 minutes, or until tender. Drain. Add butter or margarine, some cinnamon and nutmeg, and a pinch of powdered ginger, then with your potato masher, mash it until smooth. If you want to jazz it up, add some brown sugar or maple syrup.

Tired of carrots? For vitamin C, try melon, beans, broccoli, red peppers, red lentils, and sweet potatoes. Even fish chowders.

Fried Eggplant

The only trouble with eggplant is its unfortunate name. If it were called purple melon or Fatima's Passion, then stores wouldn't be able to keep the bins stocked.

Eggplant has a mild, appealing taste. It can have a variety of appealing textures and shapes depending on how it is cooked, *and* it is economical. Hell, it's cheap. It lends itself to different cuisines, from Italian to Middle Eastern. Give it a try. As Mom would say, "Would I feed you something bad?"

Preparation time: 15 minutes
Cooking time: about 30 minutes
Yield: 6 servings
Can be made ahead? No.
Can be frozen? No.
Can be doubled? Yes. But don't crowd the slices in the frying pan. It's better to make several batches.
Good for leftovers? A bit on the soggy side, but yes. Wrap in plastic wrap, and refrigerate for up to 2 days. Eat cold, or add to a salad or the top of a baked potato or an omelet. Or reheat, wrapped in foil, in a oven or toaster oven, or in plastic in the microwave.

2 eggs
1 teaspoon salt
½ teaspoon pepper
2 cups seasoned bread
 crumbs
2 medium eggplants, peeled
 and cut crosswise (you
 want rounds) into ¾-
 inch slices

Approximately ⅔ cup
 vegetable oil

Break the eggs into a shallow bowl, add the salt and pepper and beat briefly with a fork. Place the bread crumbs in a shallow pan or on a piece of waxed paper. Dip both sides of each eggplant slice in the egg mixture, then coat with the bread crumbs. Continue until all the slices have been coated.

Heat about 3 tablespoons of the oil in a large skillet and when it's hot, add a few slices of eggplant. Cook for about 5 to 7 minutes on each side over moderate heat until brown. Drain the slices on paper towels, then stack on a cookie sheet in a 250°F. oven to keep them warm. Repeat with the remaining slices, adding more oil as necessary, until all the eggplant is cooked.

Eggplant Parmesan

This is a wonderful vegetarian entrée.

Preparation time: 40 minutes
Cooking time: 30 minutes for frying the eggplant; and 15 minutes for the baking
Yield: 6 servings
Can be made ahead of time? Yes. Up to the day before. Wrap well and refrigerate. Assemble in an ovenproof dish so you don't have to transfer it to another dish to cook.
Can be frozen? Yes, uncooked. Freeze in disposable aluminum pans or a freezer-to-oven pan. Partially defrost at room temperature for 3 hours, then follow cooking directions.
Can be doubled? Yes.
Good for leftovers? Yes. Microwave or reheat, covered in foil, in the oven or toaster oven.

> *1 recipe Fried Eggplant
> (preceding recipe)
> 2 cups grated mozzarella
> cheese*
>
> *3 cups bottled or
> homemade spaghetti
> sauce
> 1 cup grated Parmesan
> cheese*

Preheat the oven to 400°F. with the rack in the center position. Grease or spray with nonstick vegetable cooking spray a casserole or baking dish. Place a layer of fried eggplant over the bottom of the dish. Sprinkle on some of the mozzarella cheese and a third of the sauce. Top with a layer of eggplant and more cheese and another third of the sauce. Top with the remaining eggplant and the remaining cheese. Add the remaining tomato sauce, spreading it to the edges of the pan. Sprinkle the grated Parmesan cheese on top.

Bake for 15 minutes, or until the sauce starts to bubble and the cheese has melted.

Vegetable Stir-Fry

You can make this in a wok or in a nonstick skillet. Remember, *stir* is the operative word here. Add the vegetables and use a chopstick or other long-handled utensil to agitate them.

Preparation time: 20 minutes
Cooking time: 15 minutes
Yield: 4 servings as a main course; 6 as a side dish
Can be made ahead? No. This is a last-minute dish.
Can be frozen? No.
Can be doubled? Only if you have a very large wok or pan.
Good for leftovers? Yes, if you are used to reheated Chinese food. It will keep for another day, covered and refrigerated.

> *3 tablespoons vegetable oil*
> *1 carrot, peeled and shredded*
> *4 stalks celery, thinly sliced*
> *1 cup broccoli flowerettes and stems, thinly sliced*
> *1 onion, thinly sliced*
> *1 package frozen peas or frozen Chinese pea pods, separated but not defrosted*
>
> *1 zucchini, thinly sliced*
> *1 cup sliced fresh mushrooms*
> *2 cloves garlic, peeled and minced*
> *20 ounces extra-firm tofu, drained and crumbled*
> *¼ cup soy sauce*

Heat the oil in a wok or large nonstick skillet. Add the carrot, celery, broccoli, onion, and peas or pea pods and stir constantly until tender but still crisp. Add the zucchini, the mushrooms, and the garlic and cook and stir 2 minutes. Add the tofu and the soy sauce, and cook and stir 2 more minutes. Serve over rice.

Stuffed Baked Potatoes

The potato has suffered greatly and unfairly at the hands of uninformed calorie counters. A great source of complex carbohydrates and fiber, a medium baked potato (4 ounces) contains approximately 100 calories. A sweet potato (different from but interchangeable in my recipes with yams) is also high in carotene, which many nutritionists believe can help prevent some forms of cancer. A 5-ounce sweet potato contains approximately 150 calories.

White or red, the potato is a filling, satisfying food that when combined with other ingredients constitutes a meal in itself. Before you can stuff one, however, you must learn how.

Preparation time: 1 minute to wash the potato; preparation time will differ with your choice of stuffing.

Cooking time: 1 hour in a conventional oven; 12 to 15 minutes in a microwave

Yield: 1 serving per potato

Can be made ahead? Yes. Up to 1 day unstuffed. Refrigerate, stuff, then cover loosely with foil and reheat in a 300°F. oven or toaster oven for 20 minutes.

Can be frozen? Yes, already stuffed. Wrap well in foil and reheat in a 350°F. oven for 20 minutes, or until a knife inserted in the center feels hot. To reheat in the microwave, rewrap in plastic wrap.

Good for leftovers? Yes. Will keep refrigerated up to 3 days, depending on the filling. Eat cold or wrap in foil and reheat in a 300°F. oven or cut up and add to a salad.

1 white potato (Idaho is best), or sweet potato, or yam

1 teaspoon vegetable oil (optional)

Preheat the oven to 350°F. with the rack in the center position. Scrub the potato(es) very well with hot water and dry well with paper towels. If you like a very crisp skin, rub some oil on the potato. Bake for 1 hour.

To cook potatoes in the microwave: I've only had success cooking one potato at a time in the microwave. The good news is that it takes only about 14 minutes. However, the result is more steamed than baked. But if you're not fussy and you have a microwave, be my guest. Cook for 6 minutes on high, then turn the potato 180° and cook an additional 6 minutes. Test for doneness by stabbing the potato with a small sharp knife. It should go in without any resistance.

To stuff a baked potato: Slit open the top of the potato, and

squeeze both sides to soften the pulp somewhat. Place the potato in a dish or on a plate and add approximately ½ to 1 cup of any of the following in any combination. You'll be amazed at the delicious combinations you'll come up with:

- Sautéed ground beef
- Sautéed chopped turkey
- Grated cheese, such as Cheddar, mozzarella, or Monterey Jack
- Cubes of soft cheese, such as brie, Camembert, or Swiss
- Cottage cheese (plain or flavored)
- Farmer cheese
- Tofu in cubes and mixed with sprouts
- Blue cheese dressing and crumbled bacon
- Salsa
- Taco filling mixture (page 149)
- Leftover Chinese food
- Steamed or leftover vegetables
- Diced ham
- Pizza sauce
- Fried, poached, or scrambled eggs
- Onions and green peppers, diced and sautéed in olive oil
- Crumbled cooked sausage
- Diced smoked turkey with Russian dressing or grainy or Dijon mustard
- Sour cream and caviar
- Leftover thick soup or stew
- Sliced roast meat or chicken with mayonnaise or mustard or steak sauce
- Grated raw carrots, raisins, and poppy seeds mixed with a little lemon juice and topped with sprouts

Mashed Potatoes

Thank God mashed potatoes are now all the rave in restaurants both fancy and family style. What took them so long to figure out what I knew all along? Mashed potatoes, full of butter and cream, smooth as silk, and smarting with black pepper, are pure ambrosia.

Preparation time: 20 minutes
Cooking time: approximately 20 minutes
Yield: 4 servings
Can be made ahead? Yes. Up to 6 hours. Spoon into a buttered ovenproof or microwaveable casserole and dot with pats of butter or margarine. Cover with plastic wrap and refrigerate. Bake in a 350°F. oven for about 25 minutes, or until a knife inserted in the center comes out hot. Or microwave until hot.
Can be frozen? No.
Can be doubled? Yes.
Good for leftovers? Yes. Store in a covered plastic container and refrigerate for up to 4 days. Reheat in the microwave or in the conventional oven. Or use as a filling for omelets.

4 large Idaho potatoes, peeled and cut into 2-inch pieces
1 teaspoon salt
4 tablespoons butter or margarine

½ cup heavy cream, or low-fat or nonfat milk, or chicken broth
Salt and lots of black pepper to taste

Place the potatoes in a medium pot and cover with cold water and salt. Bring to a simmer and cook, uncovered, for 20 minutes, or until the potatoes are very tender. Test with a fork.

Drain off the water and return the potatoes to the pot. Add the butter and mash. Add the cream or milk or broth gradually. Some people prefer their mashed potatoes lumpy, others like them smooth. The longer you mash, the smoother they'll be. Add salt and pepper to taste. Serve at once or transfer to a baking dish for serving at another time.

Variations Add one of the following while cooking or preparing the spuds:

- 3 large carrots, cut into 1-inch pieces as the potatoes cook
- ⅓ cup grated Parmesan or Cheddar cheese with the cream during mashing
- 1 large onion, minced, sautéed with 2 tablespoons butter, and added to the potatoes during mashing
- ½ cup diced cooked ham or crumbled bacon during mashing

Stove-Top Sweet Potatoes

To go with your roast turkey.

Preparation time: 25 minutes
Cooking time: 20 minutes
Yield: 6 to 8 servings
Can be made ahead? Yes. Can be assembled the night before. Cover and refrigerate, then proceed according to the directions.
Can be frozen? Yes. Transfer from the skillet to a freezer-to-oven casserole.
Can be doubled? Yes. Use 2 pans or 1 very large one.
Good for leftovers? Yes. Reheat either in the microwave or in a 325°F. conventional oven for 20 minutes.

1 tablespoon butter or margarine
2 pounds sweet potatoes, peeled and cut into 1-inch slices, or two 8-ounce cans sweet potatoes, cut into 1-inch slices
½ cup dark brown sugar, firmly packed
½ teaspoon salt
Pinch of pepper
¾ cup orange juice

Melt the butter or margarine in a large heavy skillet over moderate heat. Layer in the sweet potatoes, and sprinkle with the sugar, salt, and pepper. Add the orange juice. Cover (if your skillet doesn't have a cover, use a baking sheet or aluminum foil), and simmer over medium-low heat for 20 minutes.

Fish and Shellfish

Baked Fish
with Mustard Sauce

In this recipe you can use any fish fillet (that means without the bones): sole, flounder, catfish, bluefish, mackerel, or salmon. You can also use tuna, halibut, or swordfish steaks, cut fairly thin, about 1 inch thick.

Preparation time: 20 minutes
Cooking time: about 15 minutes for the fillets; 20 to 25 minutes for the steaks depending on the thickness
Yield: 4 servings
Can be made ahead? Yes. Up to 4 hours, before cooking. Cover and refrigerate.
Can be frozen? No.
Can be doubled? Yes. Spread the fish in one layer in a larger pan and cook the same amount of time.
Good for leftovers? Yes. Wrap well and refrigerate for up to 2 days. Reheat or enjoy cold. The fish makes a great sandwich filling.

Continued

1 cup mayonnaise
⅔ cup Dijon mustard
1 medium onion, peeled
 and finely chopped
¼ cup chopped parsley
1 tablespoon soy sauce

4 fish fillets or steaks
 weighing about 2 pounds
 (see recipe introduction)
⅔ cup plain or seasoned
 bread crumbs

Preheat the oven to 425°F. with the rack in the upper third but not the top position. Spray a shallow baking dish with nonstick vegetable cooking spray or coat it lightly with shortening, oil, or butter. Or, line the dish completely in foil, shiny side down.

Combine the mayonnaise, mustard, onion, parsley, and soy sauce in a shallow bowl. Dip each piece of fish in the mixture to coat it, then arrange it in the prepared pan in a single layer. Sprinkle the bread crumbs on top.

Bake the fillets for 15 to 20 minutes and the steaks for 20 to 25 minutes, then test for doneness by cutting into the thickest part of the fish with a sharp knife. The fillets should flake easily and have lost all their translucence. The steaks should be a uniform color all the way through.

Grilled Fish Steaks—Two Ways

A fish steak is a thickish (¾ to 1 inch) slab cut from the center of the whole fish. It has bones that are left to the diner to remove—not a terribly difficult job because they are usually big and easy to remove in one piece. The usual choices in fish steak are salmon, halibut, tuna, swordfish, and if you want to get a tad exotic, mahimahi and mako shark.

You can broil this cut of fish in the oven, or you can grill it on the barbecue. When you "grill" in the oven you're actually broiling and the heat comes from above. When you barbecue, the heat comes from below. Either way you need a very hot heat source so your cooking will be done quickly and the fish won't dry out. Don't be tempted to overcook the fish or it will have no personality at all.

Oven-Grilled Fish Steak

Preparation time: 10 minutes
Cooking time: about 12 to 14 minutes
Yield: 4 servings
Can be made ahead? Not unless you plan to serve it cold.
Can be frozen? No.
Can be doubled and tripled? Yes.
Good for leftovers? Yes. Remove bones, wrap in plastic, and refrigerate for
 up to 2 days until ready to use. Eat cold, or flake into a salad, or use
 in a casserole with rice, or serve on top of pasta.

2 tablespoons vegetable oil
4 fish steaks such as
 salmon, tuna, halibut, or
 swordfish, cut as close as
 possible to the same
 thickness and size,
 skin on

4 tablespoons butter or
 olive oil
Juice of one large lemon
Salt and pepper to taste

Preheat the broiler to high and place the rack in the upper third but
not in the very highest position. Line a cookie sheet or very shallow
pan with foil and coat the foil with the vegetable oil.

Place the steaks on the foil, close together but not touching.
Melt the butter or heat the olive oil and add the lemon juice. Spoon
half the mixture over the steaks.

Broil for 6 minutes, then remove the tray from the oven and use
tongs or a spatula to turn the fish. Pour the rest of the lemon mixture
over the fish. Return to the oven and broil for another 5 to 6 minutes.
Use a small, sharp knife to cut into the thickest part of one steak (the
one you serve yourself if you mangle it), to make sure it's cooked all
the way through. You'll know because the flesh will flake easily and
will have lost all of the translucent look. Season with salt and pepper
(or pass them separately) and serve.

Barbecued Fish Steak

The mayonnaise prevents the fish from sticking and keeps it moist.

Preparation time: 10 minutes
Cooking time: about 12 minutes
Yield: 4 servings
Can be made ahead? Not unless you plan to serve it cold.
Can be frozen? No.
Can be doubled and tripled? Yes.
Good for leftovers? Yes. Remove bones, wrap in plastic, and refrigerate for
 up to 2 days until ready to use. Eat cold, or flake into a salad, or use
 in a casserole with rice, or serve on top of pasta

4 fish steaks such as *4 tablespoons mayonnaise*
 salmon, tuna, swordfish, *Juice of one large lemon*
 or halibut, cut as close *Salt and pepper to taste*
 as possible to the same
 thickness and size,
 skin on

Spray the grilling rack with a nonstick vegetable cooking spray, or
brush it generously with vegetable oil. Heat the barbecue until the
coals are white-hot (or preheat a gas grill to high). Use the mayon-
naise to generously coat both sides of the fish. Place the fish on the
grill and cook, uncovered, for about 5 to 6 minutes. Use a large
spatula to turn the fish, adding more mayonnaise before turning, if
necessary. Cook for another 5 to 6 minutes, then test for doneness.
Drizzle with lemon juice, season with salt and pepper, and serve.

Grilled Fish Fillets—Two Ways
❦

Fish fillets are a bit trickier than fish steaks for the novice to cook
since there are few if any bones to hold the piece together. Still, this
cut, which is the lengthwise portion of fish (from the head area to
the tail section), is tender, delicate, and worth the effort.

Fillets of halibut, farm-raised catfish, bluefish, and the thicker
cuts of salmon will be easier to handle than sole or flounder, so it
makes sense to use these for grilling and save the others for oven-
baking or sautéing.

Oven-Grilled Fish Fillets

Preparation time: 10 minutes
Cooking time: 12 minutes
Yield: 4 servings
Can be made ahead? Not unless you plan to serve it cold.
Can be frozen? No.
Can be doubled and tripled? Yes.
Good for leftovers? Yes. Wrap in plastic and refrigerate for up to 2 days until
 ready to use. Eat cold, or flake into a salad, or use in a a casserole with
 rice, or serve on top of pasta.

2 tablespoons vegetable oil
4 tablespoons butter or
 olive oil
Juice of one large lemon

4 thickish fish fillets, such
 as bluefish, cod, catfish,
 or salmon, close to the
 same size, skin on
Salt and pepper to taste

Preheat the broiler to high, with the rack in the highest position. Line a baking sheet or shallow pan with foil, and coat the foil with the vegetable oil.

Melt the butter together with the lemon juice, or mix the lemon juice and olive oil together. Use half the mixture to coat the skin side of the fish.

Place the fish, skin side up, on the prepared pan and broil for 5 minutes. Remove the pan from the oven and use a wide metal spatula to turn the fish over. Use the rest of the mixture to coat the top.

Broil for another 6 minutes and then test for doneness by inserting a small sharp knife into the thickest part of the fish. The flesh will have lost all translucence and will flake easily. Season with salt and pepper and serve.

Prepared mayonnaise generously smeared on fish fillets and fish steaks will prevent them from sticking when they are barbecued. Most of the mayonnaise will cook off, leaving the fish moist and tasty.

Barbecued Fish Fillets

Preparation time: 10 minutes
Cooking time: 12 minutes
Yield: 4 servings
Can be made ahead? Not unless you plan to serve it cold.
Can be frozen? No.
Can be doubled and tripled? Yes.
Good for leftovers? Yes. Wrap in plastic and refrigerate for up to 2 days until
 ready to use. Eat cold, or flake into a salad, or use in a casserole with
 rice, or serve on top of pasta.

*4 fish fillets such as
 bluefish, salmon, cod, or
 catfish, cut as close as
 possible to the same
 thickness and size,
 skin on*

*4 tablespoons mayonnaise
Juice of one large lemon
Salt and pepper to taste*

Coat the grill rack with a nonstick vegetable cooking spray or brush
it with vegetable oil. Heat the barbecue until the coals are white-hot,
or preheat a gas grill to high. Coat both sides of the fish generously
with the mayonnaise. Place the fish, skin side up, on the grill. Cook
for 5 minutes. Add more mayonnaise if necessary to the top side
before turning. Use a wide spatula to turn the fish over; this is tricky
and will take some practice. Don't get crazy if the fish breaks—you
can always hide the damage with parsley.

 Cook another 5 minutes and then test for doneness. Sprinkle
with lemon juice and salt and pepper, and serve.

How to Cook a Lobster

Leave the fancy baked, stuffed lobster dishes for when you go out to dinner; at home, boiled is the easy way to go. Here in Boston the only obstacle to getting a good lobster is money. Availability is rarely a problem. I know this isn't the case everywhere, but in most places every once in a while you can find live lobsters—if the price is right, there isn't a better treat.

To choose a live lobster, pull its tail straight out. It should immediately curl back. You can store lobsters for 24 hours in the bag they came in (not plastic) in the refrigerator. Don't put any water in the bag—it will kill the lobster.

It's important to know how much the lobsters weigh so you'll know how long to cook them. If you're making more than one, get them nearly the same weight so you can cook them together for the same length of time. For a 1- to 1½-pound lobster—10 to 12 minutes; for a 1½- to 2-pound lobster—13 to 14 minutes; for a 2- to 3-pound lobster—15 to 18 minutes; for a 3- to 4-pound lobster—20 to 22 minutes; for a 4- to 6-pound lobster—23 to 25 minutes; for a 7- to 10-pound lobster—30 to 35 minutes.

When you're ready to cook, fill your very largest pot two-thirds full of water. Cover it and bring to a rolling boil. Add the lobster or lobsters—don't crowd them in but you might have to cook two at a time if you're feeding a crowd. Set a timer. Meanwhile you can melt the butter, cut the lemons, get out the nutcrackers, and put the plastic tablecloth on the table. Set out a big bowl for the shells.

At the end of the cooking time, fish out the lobster and cut into the underside of the tail section to make sure the lobster's done. If the meat still looks translucent, or gelatinous, then it's not cooked enough. Throw it back for another few minutes and then test it again.

My favorite things to eat with lobster are Coleslaw (page 136) and Garlic Bread (page 122), and a cold beer.

Brown Rice Creole Shrimp

For this recipe you can use either frozen shelled shrimp or "fresh," which means previously frozen since it's almost impossible to find fresh shrimp these days.

Preparation time: 20 minutes if you use frozen shelled shrimp; about 30 minutes if you use "fresh" ones
Cooking time: 40 minutes
Yield: 4 servings
Can be prepared ahead?: Partially. The shrimp can be cleaned and the vegetables chopped.
Can be doubled? Only if you have a very large skillet.
Can be frozen? No.
Good for leftovers? Yes. Reheat in a covered dish in the microwave or in the oven or toaster oven.

*1 pound shrimp, either
 frozen or "fresh"*
2 tablespoons vegetable oil
1 medium onion, chopped
*1 large green bell pepper,
 chopped*
1 clove garlic, minced
*1 cup long-grain brown
 rice*
*1 cup canned or fresh
 chopped tomatoes*
*4 cups water mixed with 2
 chicken or vegetable
 bouillon cubes*
1 teaspoon chili powder
3 medium stalks broccoli
Salt and pepper to taste

If you are using frozen shrimp, set them out on the counter while you prepare the other ingredients. If you are using "fresh" shrimp, run them under cold water while you use your fingers to peel off the shells. Use the tip of a small sharp knife to score the back and front, pull out the thick white vein and the thin black one, and refrigerate.

Heat the oil in a large frying pan and add the onion and green pepper. Sauté over medium heat, stirring frequently, for about 15 minutes, or until the onion is slightly browned. Stir in the garlic. Add the rice, tomatoes, liquid, and chili powder. Mix to combine, and when the liquid starts to boil, lower the heat to a simmer. Cover and cook for 40 minutes. If you don't have a lid large enough for the pan, use heavy-duty foil and tuck it securely around the edges.

While the rice is cooking, cut the broccoli into 1-inch pieces. At the end of 40 minutes, add the shrimp and the broccoli to the rice. Stir just to mix. Cover and cook an additional 6 to 7 minutes, or until the shrimp are bright pink and the broccoli is just tender.

Poultry

Oven-Barbecued Chicken Wings

These are terrific as a snack, as something to pass around before dinner, or to eat during a TV halftime. They also make a great informal dinner when served with a green salad, or coleslaw, and an easy starch like corn on the cob or potato salad. You can serve them right from the baking dish. Make sure to have plenty of napkins available.

Preparation time: 15 minutes
Baking time: 1 hour
Yield: 6 servings as a snack and 4 as a meal
Can be made ahead? Yes. Either assemble the day before and refrigerate, covered, until ready to cook. Or, cook the day before and reheat, uncovered, in a 350°F. oven for 15 minutes.
Can be frozen? No.
Can be doubled and tripled? Yes.
Good for leftovers? Yes. Eat cold. Or reheat.

Continued

235

12 whole chicken wings	2 tablespoons red wine or
½ cup honey	cider vinegar
3 tablespoons	
Worcestershire sauce	
4 tablespoons soy sauce	
2 tablespoons prepared	
mustard or 1 tablespoon	
dry mustard	

Preheat the oven to 350°F. with the rack in the lower third. Spray a large shallow baking dish with nonstick vegetable cooking spray.

Use a large knife or cleaver to cut the chicken wings in 2 pieces at the joint. Place the pieces in one layer, if possible, in the baking dish. Mix the remaining ingredients together and pour over the wings.

Bake 1 hour.

Buffalo Wings These are a spicy version of the above. Add several drops of Tabasco sauce to the sauce before pouring it over the wings. You can also add additional Tabasco sauce before serving. Or pass the bottle separately. Serve with a dish of homemade or bottled blue cheese dressing, the traditional dipping sauce for these wings. Recipes for homemade blue cheese dressing can be found on pages 140 to 141.

Sautéed Chicken Breasts

Preparation time: 15 minutes
Cooking time: 20 minutes
Yield: 4 servings
Can be made ahead? Only if you want to chill it and reheat it later or eat it cold. In this case, you can make it the day before.
Can be frozen? No.
Can be doubled and tripled? Yes. Cook one recipe at a time, and keep it warm, covered loosely with foil, in a 200°F. oven.
Good for leftovers? Yes. Will keep 3 to 4 days well wrapped and refrigerated. Reheat in the microwave or use cold by itself, in a salad, or as a topping for pasta or a baked potato.

2 whole boneless chicken	Pinch of pepper
breasts, skin on, split in	2 to 3 tablespoons olive oil
half	or butter
½ teaspoon salt	½ cup dry white wine

Rinse the chicken and pat it completely dry with paper towels. Season both sides with the salt and pepper. Heat the oil or butter in a large skillet. When it is hot, add the chicken, skin side down. Use a metal spatula or flat pot cover to push down on the chicken to flatten it while it cooks. After about 7 minutes, flip the chicken over and cook the second side for about 9 to 10 minutes, again pressing down on it with a spatula or pot cover. Use a knife to cut into the chicken. Make sure it is cooked all the way through. If not, cook a few more minutes.

Remove the chicken from the pan and pour off all but a few tablespoons of fat. Add the wine and cook over high heat, scraping the drippings from the bottom and sides of the pan to incorporate them into the wine (this is what makes the sauce taste good). Cook for 1 minute more and pour the sauce over the chicken.

Baked Chicken Breasts
with Honey Mustard Sauce

This is a one-dish meal.

Preparation time: 20 minutes
Baking time: 30 minutes
Yield: 6 servings
Can be made ahead? Yes, up to 12 hours ahead. Cover and refrigerate.
Can be frozen? Yes. Freeze either whole or in individual portions in foil containers if you plan to reheat it in the oven or in plastic if you plan to reheat it in the microwave.
Can be doubled? Yes. Use a larger pan and cook, covered, 10 to 15 minutes longer before removing top for the last 10 minutes.
Good for leftovers? Yes. Both reheated and cold.

1 cup raw long-grain white rice
2½ cups canned chicken broth, or 1 chicken bouillon cube dissolved in 2½ cups hot water
3 whole boneless chicken breasts, skins on or off (up to you), split in half

1 cup plain yogurt
½ cup honey
⅓ cup Dijon mustard
2 tablespoons dark brown sugar
1 tablespoon soy sauce

Continued

237

The Secret Life
of Chicken Breasts

Want to cook something that everyone likes, is easy to fix, and makes you look as if you've been slaving away for hours in a hot kitchen? The secret is boneless chicken breasts. Make no mistake, this isn't a new breed. They originally came with bones, but some obliging butcher took them away to make your life easier. All you have to do is pay a little more money for them.

If you aren't on a diet, you leave the skins on, season them with a little salt and pepper, and sauté them in olive oil and butter. Add a little white wine and you're all set. Or, broil them or bake them in a nice sauce. (Don't panic, real recipes follow.)

Or, if you're watching your calories, you can remove the skin and poach the breasts in a little chicken broth.

Or, you can place them between two pieces of waxed paper or plastic wrap and flatten them with the side of a large knife or cleaver, roll them around some stuffing, and bake them.

Pretty soon you'll get so good at this that you'll start inventing your own recipes!

One whole breast will feed two people. It gets cut in half, either by the store or by you. You might have to make a choice between whole or halved boneless chicken breasts with or without skins *and* something called "supremes," which are a part of the breast. Go for the cheapest item. (It won't be the supremes.) It won't kill you to pull the skin off the breasts and cut them in half to save a few cents either.

If you buy pre-packaged chicken breasts in a supermarket, make sure to check the package date. Don't buy the chicken more than one day before you plan to cook it. Raw chicken is very perishable.

Preheat the oven to 375°F. with the rack in the center position. Spray a casserole with nonstick vegetable cooking spray or coat it lightly with vegetable shortening. Pour the rice over the bottom of the prepared dish, then pour in the broth. Rinse the chicken well and pat it dry with paper towels. Layer the chicken over the rice.

Combine the remaining ingredients, mix well, and spread over the chicken. Cover loosely with foil and bake for 20 minutes. Remove the foil for the last 10 minutes of baking time.

Chicken Millie

This is my mother's recipe and the first fancy dish I learned to make. Take heart. I was twenty-six at the time. Don't make the mistake I did and serve it with the toothpicks still in place.

To make the job easier, prepare the wild rice stuffing the day before and refrigerate it until ready to use.

Preparation time: 1 hour
Cooking time: 40 minutes for the stuffing; 40 minutes for the chicken
Yield: 8 servings
Can be made ahead? The stuffing can be made the day before and the chicken can be stuffed up to 6 hours before cooking. Cover and refrigerate until ready to cook.
Can be frozen? Yes. Cool slightly first, then freeze in either a foil pan or a freezer-to-oven dish. Add ½ cup liquid (orange juice, water, or chicken broth) to the dish before reheating. Reheat, covered, in a 350°F. oven for about 30 minutes, or until a knife inserted in the center comes out hot. It helps to defrost the chicken in the microwave or in the refrigerator first.
Can be doubled? Yes.
Good for leftovers? Yes. Both reheated or cold. Slice and add to a salad.

4 large chicken breasts, skin on, split in half
1 recipe Wild Rice with Pecans (page 211)
One 10-ounce can chicken broth
1 cup orange juice
⅓ cup Grand Marnier (optional)
Salt and pepper to taste

Preheat the oven to 350°F. and spray a casserole or baking dish with nonstick vegetable cooking spray. Rinse the chicken and pat it dry with paper towels. Place each breast half between two pieces of waxed paper. Use the flat side of a large knife or a cleaver to hit the chicken until it is flattened and approximately one and a half times its original size.

With the skin side down place about ⅓ cup of the wild rice in an oval mound in the center of the breast. Roll the chicken up around the stuffing and secure it closed with a toothpick (you may want to use two), pulling the skin around to form a ball shape. Make sure enough of the toothpick protrudes to enable you to remove it after cooking.

Prepare all the chicken breasts this way. You may have some stuffing left over. If so, place it on the bottom of the pan as a bed for

the chicken. Place the chicken, seam sides down, in the prepared dish.

Combine the broth, the orange juice, and the optional Grand Marnier. Pour over the chicken and bake, uncovered, for 1 hour. At the end of that time, remove the chicken from the baking dish to a serving plate, and pull out the toothpicks. Strain the sauce and season it with salt and pepper to taste. Serve with the chicken.

Speedy Mexican Chicken

Preparation time: 10 minutes
Cooking time: 40 minutes
Yield: 4 servings
Can be made ahead? Yes. Cover and refrigerate until time to cook.
Can be frozen? Yes, but it loses lots of personality.
Can be doubled and tripled? Yes.
Good for leftovers? Yes. Reheat in a covered dish in the microwave or in a conventional oven.

2 whole boneless, skinless chicken breasts, split in half
One 12-ounce jar salsa, mild, medium, or hot, depending on your taste

1 cup plain yogurt
1 cup grated Cheddar or Monterey Jack cheese

Preheat the oven to 350°F. with the rack in the center position. Spray a baking dish with nonstick vegetable cooking spray or grease it lightly with vegetable shortening.

Arrange the chicken in one layer in the baking dish. Combine the salsa and the yogurt, then divide the mixture among the 4 pieces, spreading it over the top of each piece.

Sprinkle with the cheese and bake for 40 minutes. Serve with rice.

Roast Chicken

A simple roast chicken can be one of the most mouth-wateringly delicious meals you can make. Your kitchen will take on a heavenly smell and your stomach will say thank you.

This is not a great challenge, nor does it take a terrific amount of time. For a minimal amount of effort you will feel like a world-class cook, and the leftovers are divine.

It is definitely worth the effort of locating a fresh chicken, one that has not been frozen. The best and freshest chickens usually come from butcher shops as opposed to the cellophane-wrapped ones that come from the supermarket.

Preparation time: 25 minutes
Cooking time: about 80 minutes
Yield: 4 servings
Can be made ahead? Yes. But it's not nearly as good.
Can be frozen? Leftover meat can be trimmed off the carcass, placed in a plastic container or plastic bag, and kept frozen for 3 months.
Can be doubled? Yes. Buy 2 chickens the same size instead of a larger one, for faster cooking.
Good for leftovers? Yes. Delicious cold, sliced in a sandwich or in a salad.

1 fresh 4- to 4¼-pound roasting chicken
2 to 3 tablespoons vegetable shortening, butter, or margarine
1 medium onion, finely minced
1 teaspoon dried thyme
1 teaspoon salt
½ teaspoon pepper

Preheat the oven to 425°F. with the rack in the center position. Spray a shallow baking dish with nonstick vegetable cooking spray.

Remove the package of innards from the cavity of the chicken. Rinse the chicken well, including the cavity, with cool water. Pat dry with paper towels.

Place the chicken, breast side up (the side that is more rounded), in the baking dish. Rub the skin with the shortening. Sprinkle the onion, thyme, and salt and pepper over the chicken. Insert a meat thermometer downward into the thicker part of the breast.

Place the chicken in the oven and reduce the heat to 375°F. Cook the chicken for 20 minutes a pound, or until the thermometer reads 180°F. Check it once in a while to make sure the top isn't burning. If it starts to get too brown, cover it loosely with a piece of foil, shiny side down.

If you don't have an oven thermometer you can usually tell if the chicken is done when the juices run clear (as opposed to pink) when you press the tip of a knife into the dark meat and you can very freely wiggle the legs. You will see the skin and meat begin to pull away from the bone when you move the leg. When in doubt, cut into the leg meat to see that it's not pink. Make sure it's done before you serve it. There is nothing less appetizing than undercooked chicken.

When the chicken is done, remove it from the oven and let it sit on a carving board for 15 minutes. If you aren't an experienced carver, then do this in the kitchen. Use a large, very sharp knife and start with the breast meat. Slice down in not-too-thin pieces. Don't be afraid to use your fingers. (I am assuming you have carefully washed them first and are dexterous enough not to cut them off with the knife.)

Use the tip of the knife to sever the thigh joints and the wing joints. Carve any remaining meat (don't forget to flip the bird over and check the back side). If you are a very slow carver, place a large piece of foil over the chicken you have already cut to keep it warm. Serve.

Variation Peel and slice thinly 2 or 3 large potatoes and 1 large onion. Layer them under the chicken before you place it in the baking dish. Sprinkle the vegetables with 2 tablespoons butter or oil and ½ teaspoon salt. The potatoes and onions will brown while the chicken is roasting. Serve the vegetables on the side.

Ivy's Turkey Breast

About five years ago I wrote a book called *Indulgences: One Cook's Quest for the Delicious Things in Life*. Out of dozens of recipes for fancy stuff like caviar and truffles the hands-down winner for most popular recipe was one for turkey breast with dried apricots and orange juice. It was given to me by my very wonderful friend and cook *extraordinaire* Ivy Feuerstadt, who lives in Newton, Massachusetts.

Whenever a novice cook asks me for something that's easy to make but will make a big impression, I recommend this dish. You can make it the day before and reheat it. I think it tastes even better that way.

Turkey breasts are generally available in meat markets, or you can buy them frozen in the supermarket. Make sure the breast is

242

thoroughly defrosted before you prepare this dish. You must use a meat thermometer or an instant read thermometer to ensure that the turkey is fully cooked.

Preparation time: 25 minutes

Roasting time: Depends on the size of the turkey breast—about 15 to 20 minutes per pound, or an internal temperature of 185°F. on a meat thermometer

Yield: About 3 to 4 servings per pound

Can be made ahead? Yes. The day before. Slice the meat when it's finished cooking and layer it back into the pan on top of the sauce. Cover the pan and refrigerate. Before reheating, skim off any visible fat, add about a cup of water, and cover the pan loosely with foil. Heat in a 350°F. oven for 20 minutes, or until the sauce is bubbling and the meat is hot.

Can be frozen? Yes. Cool and store in a plastic container. Partially defrost in the refrigerator. Reheat in the microwave or in a conventional oven, adding more liquid if necessary.

Good for leftovers? Wonderful. Serve cold or reheated in a sandwich.

1 fresh or defrosted uncooked whole turkey breast, with the skin on
⅓ cup vegetable shortening
2 teaspoons salt
Black pepper to taste
4 large onions, peeled and thinly sliced
4 large carrots, peeled and sliced

1 cup dried apricots
1 cup golden raisins
One 6-ounce container partially defrosted orange juice concentrate
One 10- to 12-ounce jar apricot preserves
2 cups dry white wine, or canned chicken broth

Preheat the oven to 350°F. with the rack in the center position. Spray a large roasting pan with nonstick vegetable cooking spray.

Rinse the turkey breast and pat the skin completely dry with paper towels. Place the breast in the roasting pan. Rub the vegetable shortening all over the skin, then sprinkle with the salt and pepper. Place the vegetables, apricots, and raisins around the turkey.

Combine the orange juice concentrate, the preserves, and the wine or broth. Mix well and then pour over the vegetables and fruit in the pan. Add a little water if necessary to make sure there is at least 2 inches of liquid in the bottom of the pan.

Insert a meat thermometer in the thickest part of the breast. (If you use an instant-read thermometer, take a reading in the thickest part of the turkey after it has cooked for 1 hour.) Roast until the turkey reaches an internal temperature of 185°F., roughly 15 to 20 minutes per pound. If at any time during the cooking, the top of the turkey starts to get too brown, cover it loosely with a piece of foil.

Let the turkey cool for 15 minutes in the pan, then slice it, layering the meat back into the vegetables and sauce in the pan. Serve with rice or noodles or Noodle Pudding (page 197).

This also makes delicious sandwiches.

How to Roast a Turkey

Use a meat thermometer and you can't go wrong. When at all possible, it's best to use a fresh turkey. Plan enough ahead of time and ask your supermarket to order you one. However, if you do buy a frozen turkey, you must defrost it before cooking. Do this in the refrigerator; it will take several days.

Please see the directions on page 247 for how to stuff the bird.

Preparation time: 25 minutes (up to 45 if you plan to stuff the turkey)
Cooking time: 20 minutes a pound (see cooking chart on page 86)
Yield: Figure 1½ pounds per person. (No one actually gets that much turkey to eat since half the weight of the bird is in the bones.) This will give you some leftovers.
Can be made ahead? Only if you want to serve it cold. Reheated turkey is only good for leftovers.
Can be frozen? Boned, cooked turkey meat can be frozen in heavy-duty freezer bags for up to 3 months. Defrost in the refrigerator.
Can be doubled? You can make 2 small turkeys if 4 people insist on drumsticks. Otherwise make a larger one.
Good for leftovers? Fabulous. Plain, in a sandwich, in soup, casseroles, over pasta, in hash. . . . I could go on forever and so will you if you roast a twenty-pound turkey to feed 6 people.

1 fresh or defrosted 12- to 15-pound turkey
1 onion, peeled and cut in half, plus 3 onions, peeled and sliced
2 stalks celery, rinsed
2 tablespoons vegetable shortening

4 cups canned chicken broth, or 4 cups hot water in which 2 chicken bouillon cubes have been dissolved
Salt and pepper to taste

Preheat the oven to 375°F. with the rack in the lower third. Remove the paper or plastic bag from inside the neck or body of the turkey. This contains the neck, heart, and liver. Discard. Place the turkey in the sink and rinse it under cold running water, especially the cavities. Pat dry with paper towels. Place the halved onion and celery in the large cavity.

Lightly spray a large roasting pan with nonstick vegetable cooking spray. Place the turkey in the pan, breast side up. If you want to stuff the turkey, forget the onion and celery, and refer to directions on page 247. Some people like to use a roasting rack. The heat will then be able to circulate around the turkey more efficiently. The down side is that it can be a mess to clean. If you do use a rack, spray it well with cooking spray first. Place the sliced onions in the bottom of the roasting pan.

Use cotton kitchen string to tie the legs together at the ends. This will keep the meat from drying out.

Rub the vegetable shortening all over the outside of the turkey (This will turn it golden brown as it cooks) and sprinkle with salt and pepper. Insert a meat thermometer pointing down in the breast, but do not let it touch the ribs. Place the turkey in the oven. Note that the cooking time will be approximately 20 minutes a pound, until the thermometer reads 170°F. Write down the projected finish time. Set a timer for 30 minutes. At the end of that time, use a baster (a hollow plastic or metal tube with a rubber bulb on the end) to bathe the turkey with some of the broth. Reset the timer another 30 minutes and baste again. Continue basting like this throughout the cooking time, increasing the frequency to every 15 minutes during the last hour. When you run out of broth, use the pan drippings.

If you find the top of the turkey browning too rapidly, cover it loosely with foil, making sure the shiny side is down.

When the thermometer reads 170°F., remove the pan from the oven and let the turkey sit, undisturbed, for 15 minutes. Then remove the thermometer and the string. Transfer to a carving board.

Carving and Gravy

Use a large serving fork and a large spoon to move the turkey to a cutting board. Pour the juices from the roasting pan into a saucepan. Drop in 5 ice cubes, which will help solidify the fat, and set the saucepan aside.

What to Do with
Turkey Leftovers

In addition to standing in front of an open refrigerator, picking at the turkey carcass, you have a number of easy, delicious options you can do with leftover turkey and stuffing. For instance:

- Make a turkey and Cheddar sandwich with (or without) bacon and a dab of mustard or Russian dressing on the bread or roll of your choice.
- Dice the turkey and serve it on top of a salad.
- Use the turkey to stuff a baked potato, top it with cheese, and run under the broiler until the cheese melts.
- Combine the turkey in a casserole with cooked rice, a can of cream of mushroom soup, and a cup of white wine or a cup of milk, top with leftover stuffing and grated cheese, and bake in a 350°F. oven for 25 minutes.
- Dice the turkey and serve with mayonnaise, tomato, and sprouts in a halved large-sized pita pocket.
- Make small patties out of the leftover stuffing and cook in a skillet in a tablespoon of butter or margarine.
- Use the stuffing to fill an omelet.

Use a long, very sharp knife to slice the breast meat into thin slices. Then either cut the drumsticks off at the thigh joints to serve whole or carve them up for dark meat. Remove the wings (use kitchen scissors or a serving fork for this) so that you can carve the white meat under them. Use two large serving spoons to flip the turkey over and carve the meat on the other side. If you find the carved meat is getting cold, place a large piece of foil over the serving platter while you finish.

After the meat has been carved and placed on a serving plate, remove the ice cubes and as much fat as possible from the top of the gravy. Set the pan over high heat until the juices simmer. Reduce slightly and taste for seasoning, adding salt and pepper if necessary. If you want thick gravy, stir 1 or 2 tablespoons of Wondra (instant flour) into the simmering liquid, whisking until it dissolves, which should be right away, and cook until the consistency becomes thicker. Season to taste.

To Stuff a Turkey

The very easiest way to make stuffing is to start with a product like Pepperidge Farm stuffing mix, which is basically a bag of seasoned bread cubes. The corn bread is my favorite as I find its flavor the most interesting. To this you add water and other seasonings of choice. I like to add pecans and grated Cheddar cheese and some chopped chili peppers. You might want to add sautéed mushrooms, onions, and peppers. Anything is possible.

You'll need approximately 5 cups of stuffing for a 12- to 15-pound turkey. Prepare the stuffing. You can do it the night before. However, *it is dangerous to stuff the bird ahead of time*. You're asking for food poisoning. Stuff the turkey while you're preheating your oven. Loosely fill the large cavity with stuffing. Don't be tempted to pack it in as tight as you can. Leftover stuffing can be put in the neck cavity or cooked in a separate container alongside the bird.

Pull the flap of skin down over the stuffing. Grocery and hardware stores sell an inexpensive and handy little turkey trussing kit that consists of some long metal pins and white kitchen string. These make it easy to stitch the cavity closed, which keeps the stuffing in.

After the turkey is roasted, remove the stuffing with a large spoon. Do not store the stuffing inside the turkey, for the same reason you don't stuff it ahead of time. Serve hot.

Use ground turkey instead of ground beef or pork in casseroles and meat loaves.

My Favorite Turkey Soup

Preparation time: 20 minutes
Cooking time: 1½ hours
Yield: 8 to 10 servings
Can be frozen? Yes.

1 turkey carcass, plus any leftovers, including the skin
4 carrots, sliced
2 large onions, chopped
3 stalks celery, sliced
One 16-ounce can whole or chopped tomatoes

6 cups canned chicken broth, or 6 cups water and 3 chicken or vegetable bouillon cubes
1 cup lentils, rinsed and picked over for stones
Salt and pepper to taste

Select your largest pot. If the carcass won't fit in in one piece, break it in half. Add the vegetables and the broth or the water and bouillon cubes. The liquid should just about cover the turkey. If it doesn't, add a bit more water. Set the pot over high heat and bring the liquid to a boil. Reduce the heat so that the liquid just simmers, and cover. Cook for 1 hour.

Use a slotted spoon to pick out the carcass (it will be in several pieces) and the skin, and discard. Add the lentils and cook 30 minutes, or until they are soft. Taste for seasoning. Remember that canned broth and bouillon cubes are very salty.

Meat

Chili

Here's a simple yet classic recipe. If you want to make this a vegetarian dish, omit the ground beef and substitute an equal amount of diced tofu.

 If you are cooking and freezing meals, then think about storing single servings of this chili in 16-ounce plastic containers.

Preparation time: 30 minutes
Cooking time: 20 minutes; then 1 hour (plus)
Yield: 8 large servings
Can be made ahead? Yes. Up to 3 days. Cover and refrigerate. Add ½ cup water before reheating. Stir frequently. Or reheat in the microwave or in a covered ovenproof dish at 350°F. for 25 minutes.
Can be frozen? Yes. Consider storing in single portions, such as in covered 1-pint plastic containers. Defrost in the microwave or in the refrigerator. Reheat in the microwave, in the oven (see above), or in a heavy pot on the stove. Add a small amount of water to keep the chili from burning and stir frequently.
Can be doubled? Yes.

Continued

2 tablespoons vegetable oil
2 large onions, peeled and
chopped
3 cloves garlic, finely
chopped
1 large green bell pepper,
chopped
2 pounds lean ground beef
Three 1-pound cans
tomatoes, plus liquid
from the cans

Two six-ounce cans tomato
paste
Three 1-pound cans red
kidney beans, drained
2 cups water
1½ teaspoons salt
3 to 4 tablespoons chili
powder
Tabasco or other hot sauce
Salt and pepper to taste
Grated Cheddar or
Monterey Jack cheese
Sour cream

Heat the oil in a large pot. Add the onions, garlic, and bell pepper, and cook over medium heat, stirring frequently and taking care that the garlic doesn't brown. Crumble the ground beef into the pot and continue to cook, stirring frequently, until the meat is well browned.

Add the tomatoes, the tomato paste, the beans, the water, and 2 tablespoons of the chili powder. Bring the mixture to a boil, then reduce the heat to a low simmer. Cook, uncovered, for at least 1 hour (the longer the better), stirring occasionally to make sure the bottom isn't burning.

Season with additional chili powder if desired, Tabasco, and salt and pepper. Garnish with grated cheese and a dab of sour cream on each serving.

Buy lean cuts of meat and trim off all visible fat. Cook chicken with the skin on for flavor, but remove it to serve.

No-Bean Chili

Can't handle beans? No problem. Here's a chili for you with a special "secret" ingredient.

Preparation time: 30 minutes
Cooking time: 2½ hours
Yield: 6 to 8 servings
Can be made ahead? Yes. Up to 3 days. Keep covered and refrigerated. Warm on the stove top over low heat, stirring frequently. Add water if necessary to keep from burning.
Can be frozen? Yes. Consider freezing in individual portion-sized containers for convenience and to speed defrosting. Defrost and heat in microwave, or defrost in refrigerator and heat on stove top, adding water if necessary to keep from burning.
Can be doubled and tripled? Yes.
Good for leftovers? Yes. Cover and refrigerate. Will keep for 5 days. Use plain, as a filling for omelets or baked potatoes, in salad, or on a hamburger bun.

2 tablespoons vegetable oil	1 tablespoon chili powder
2 pounds lean ground chuck	1 teaspoon pepper
1 large onion, peeled and chopped	2 tablespoons Worcestershire sauce
One 6-ounce can tomato paste	2 teaspoons salt
	3 cups water
	1 tablespoon unsweetened (baking) chocolate, cut into small pieces

Heat the oil in a large skillet or saucepan, add the ground beef and onion, and cook over moderate heat for 10 minutes, stirring occasionally. When the meat is browned, add the remaining ingredients and mix well to combine.

Simmer, uncovered, stirring occasionally, for 1 hour. Add 1 cup more water. Cook another 2 hours. Add more salt and chili powder if necessary. Serve over rice and with grated cheese, sour cream or plain yogurt, and chopped tomatoes, if desired.

Beef Bourguignon à la Bag

The thing I hated the most about making beef stew (I couldn't even pronounce *bourguignon* until last year) was the cleanup. No matter how I sprayed or greased the pan, there was always this baked-on mess that took too damn long to clean up to make the project worthwhile. Reynolds (God bless them) changed all that when they invented Oven Cooking Bags. Now you make make a perfectly delectable beef stew in a plastic bag, and have no cleanup whatsoever. Ain't science great? Look for them in the plastic wrap/aluminum foil aisle of the market.

Preparation time: 20 minutes
Cooking time: approximately 2 hours
Yield: 6 servings
Can be made ahead? Yes. Up to 1 day. Refrigerate after cooking. Skim off any visible fat, and reheat either on top of the stove, adding more liquid if necessary to keep it from burning, or in the oven in a covered pan at 350°F. for 20 minutes, or until hot.
Can be frozen? Yes. Consider freezing in one-serving portions in pint plastic containers for microwave reheating, or in small aluminum dishes for oven reheating. Partially defrost in the refrigerator, cover the top with foil, and heat for 20 to 30 minutes in a 350°F. oven.
Can be doubled and tripled? Yes. Use the largest bag and a large roasting pan.
Good for leftovers? Yes. Wonderful. Cover and refrigerate up to 4 days, reheat on the stove top (adding more liquid if necessary to keep from burning), in the microwave, or in the oven in a covered baking dish.

2 pounds beef chuck, cross rib, or top sirloin, cubed	*3 large potatoes, peeled and cut into chunks*
1 large onion, peeled and chopped	*1 cup dry red wine*
3 large carrots, peeled and sliced	*½ cup water*
10 large mushrooms, sliced	*1 teaspoon salt*
2 cloves garlic, peeled and chopped	*½ teaspoon pepper*
	One 10- or 12-ounce can or jar tomato sauce
	½ teaspoon dried oregano

Preheat the oven to 325°F. Place the beef and the vegetables in a large Reynolds Oven Cooking Bag. Mix together the remaining ingredients and add to the bag. Secure the bag with the nylon tie and place it in a shallow roasting pan. Use the point of a knife to make six ½-inch slits in the top of the bag. Place the pan in the oven and

cook for 2 hours, or until the beef is very tender. You can test this by sticking a knife through the bag into the beef.

To serve, spoon the sauce over the meat and vegetables.

Brisket

Don't freak out when you see the long list of ingredients here. Shopping will be the major time-consuming activity, except for the actual cooking, and the oven does that while you do something else. Like the Beef Bourguignon on page 252, this cooks in a ovenproof plastic baking bag. You can find them with the plastic wrap and foil in your supermarket. You'll need a large-size bag for this recipe. The preparation is straightforward; the clean up is almost nonexistent, and the brisket . . . just like Mom's. Promise.

Preparation time: 40 minutes to 1 hour
Cooking time: 3 hours plus 20 additional minutes for reheating
Yield: 8 servings (with leftovers)
Can be made ahead? Yes, the day before. Slice the meat, cover, and refrigerate. Before reheating, skim the hardened fat off the cooking liquid. Layer the meat and liquid in a pan, cover, and heat in a 350°F. oven for 30 minutes, or until hot.
Can be frozen? Yes. Slice first and freeze with the cooking liquid. Defrost and follow the above directions.
Can be doubled? Yes.
Good for leftovers? Fabulous. Covered and refrigerated, they keep 3 to 5 days. Reheat as above or see recipe for Brisket Sandwich (page 254).

One 5-pound brisket (ask for the less fatty first cut)
¼ cup water
2 large onions, peeled and sliced
4 stalks celery, cut into ½-inch slices
One 12-ounce bottled chili sauce
4 cloves garlic, peeled and chopped
2 bay leaves
½ cup brown sugar, firmly packed

⅓ cup Dijon mustard
¼ cup soy sauce
¼ cup red wine vinegar
3 tablespoons molasses
1 can beer
½ teaspoon paprika
Salt and pepper to taste
4 potatoes, peeled, sliced, and simmered for 15 minutes

Continued

Preheat the oven to 325°F. with the rack in the lower third but not the bottom position. Place the brisket in the cooking bag and place the bag in a shallow roasting pan large enough to hold it comfortably. Add the water, onions, celery, chili sauce, garlic, bay leaves, brown sugar, mustard, soy sauce, vinegar, molasses, and the beer to the bag. Seal the bag and puncture the top in several places with a knife. Bake for 3 hours.

At the end of the cooking time, remove the pan from the oven and let the brisket cool slightly. Cut open the bag and remove the meat. Pour the sauce into a metal bowl.

Discard the bay leaves. Place the sauce in the refrigerator or freezer until it is cold and the fat congeals on top. Slice the meat and refrigerate until ready to serve.

Skim the fat off the sauce, then place the sauce and the meat in a casserole or heatproof serving dish. Add the paprika and the precooked potatoes, cover, and reheat on top of the stove or in the oven at 400°F. for 20 minutes. Add salt and pepper to taste.

Brisket Sandwich

Ah, the joys of leftovers. The best brisket sandwich is sloppy and a bit of a challenge to eat. Besides the brisket and sauce, you will need thick pieces of bread or a fat, soft roll to absorb the gravy or pan juices.

Preparation time: 10 minutes
Yield: 1 brisket sandwich
Can be made ahead? No. It will get soggy.
Can be frozen? No.
Can be doubled and tripled? Yes. Get extra bread or rolls and make sure you have enough meat and vegetables.

> *2 slices thick, coarse bread like pumpernickel, or an onion roll, or other bulky roll*
> *Dijon mustard*
> *Mayonnaise*
>
> *Several slices brisket (preceding recipe)—I like mine warm*
> *Pan juices, including pieces of onion, carrot, and potatoes*

Spread one piece of the bread or roll with mustard and the other with mayonnaise. Layer the brisket on one piece of bread or roll and add some of the cooked onion, carrot, and potatoes. Spoon on a little of

the pan juices and top with the other piece of bread or roll. You will have to eat this sandwich leaning well over and close to your plate because it should drip—that's part of the fun. Enjoy!

Millie's Flank Steak

This is from the same Millie of Chicken Millie. My mother, Millie Apter, made this dish at least once a week when we were growing up. It's easy and I'm hard-pressed to decide which tastes better—the hot steak or the leftovers in a sandwich.

Preparation time: 10 minutes, plus 1 hour for marinating
Cooking time: 16 to 20 minutes
Yield: Count on 8 ounces per person. You'll want to plan to have leftovers, so, if you're feeding 4 people, get a 3-pound flank steak. If you can't find a large one, then buy 2 smaller steaks.
Can be made ahead? Yes, the night before.
Can be frozen? No.
Can be doubled? Yes. Buy 2 steaks.
Good for leftovers? The best. See Flank Steak Sandwich on page 256.

> *1 flank steak*
> *1 small bottle Italian*
> * dressing*

Up to one hour before you plan to cook the steak place it in a large plastic bag and add the dressing. Close the bag and let the steak sit on the counter for 1 hour. (You can also do this in a covered glass or plastic container.) Marinate the steak longer—overnight, if you wish. In that case, refrigerate it.

When you are ready to cook the steak, set the oven broiler to high with the rack in the upper third of the oven, or preheat a gas grill to high, or light a charcoal fire. When the coals are white, it's ready.

If you are using the oven broiler, then line a shallow heavy-duty baking pan with foil, shiny side down. Remove the meat from the marinade and discard the marinade. Place the steak on the foil and use a sharp knife to score the meat in large Xs. Turn the meat over and score the second side. Broil for 4 to 5 minutes on each side for rare, 6 to 7 for medium, and 7 to 8 for well done. Cut into the meat in the thickest part to see if it is as done as you like.

Continued

255

Use a long knife to slice the meat on a slant into long, thin strips.

To barbecue: Drain and discard the marinade. Score the meat as above. Grill for 4 to 8 minutes on each side.

Flank Steak Sandwich

Preparation time: 15 minutes
Yield: 1 sandwich

*1 English muffin, halved
 and toasted
Dijon mustard
Mayonnaise
Several slices leftover flank
 steak*

*Lettuce and tomato
 (optional)
1 slice Cheddar cheese
 (optional)*

Spread mustard on one half of the English muffin and mayonnaise on the other. Layer on the meat and the optional lettuce, tomato, and cheese; cover with the other muffin half.

Meat Loaf

There are a million versions of this recipe. The main ingredients are ground meat, eggs, and seasonings. Some folks say meat loaf isn't meat loaf unless it contains bread crumbs (or some other filler) and a liberal dose of something red (like catsup or tomato sauce) on top.

Bowing to the purists, the first recipe is quite basic, followed by one with a few more ingredients that result in a slightly more upscale taste. Just remember, meat loaf right out of the oven is heavenly but meat loaf sandwiches are even better.

Mom's Basic Meat Loaf

Preparation time: 20 minutes
Cooking time: 1 hour
Yield: 6 servings
Can be made ahead? Yes, the day before. Cool 20 minutes at room temperature, then cover with foil, and refrigerate. Reheat, covered, in a 300°F. oven for 20 minutes. Or slice and heat on a plate in the microwave.
Can be frozen? Yes. Cool slightly, then wrap in plastic wrap, and refrigerate until cold. Freeze for up to 3 months. Defrost in the refrigerator or in the microwave. Reheat in the microwave or in a conventional oven. Cover tightly with foil so it doesn't dry out. Consider slicing the meat loaf and packaging single servings together in sandwich bag.
Can be doubled? Yes. Use 2 loaf pans.
Good for leftovers? Yes. It makes great sandwiches. Will keep 4 days, refrigerated.

1 pound lean ground beef
1 pound ground pork, or 2 pounds ground beef in all
2 eggs
1 cup tomato juice, or V8 vegetable juice
½ cup bread crumbs, seasoned bread crumbs, cooked white or brown rice, or rolled oats

⅓ cup Worcestershire sauce
3 tablespoons prepared mustard
1 medium onion, peeled and diced
1 envelope Lipton Onion Recipe Soup Mix
Catsup

Preheat the oven to 375°F. with the rack in the center position. Spray a 6-cup loaf pan with nonstick vegetable cooking spray. Place all the ingredients except the catsup in a large mixing bowl and work them together with your hands until they are well combined.

Place the mixture in the prepared loaf pan, patting it down while forming it higher in the center with a rim around the edge. Pour enough catsup on top to cover.

Put the loaf pan in a foil-lined roasting pan (to catch any overflow) and bake for 1 hour. Drain off any accumulated liquid before serving.

Mom's Slightly
More Upscale Meat Loaf

Preparation time: 20 minutes
Cooking time: 1 hour
Yield: 6 servings
Can be made ahead? Yes, the day before. Cool 20 minutes at room temperature, then cover with foil and refrigerate, or slice and reheat in the microwave.
Can be frozen? Yes. Cool slightly, then wrap in plastic wrap and refrigerate until cold. Then freeze (up to 3 months).
Can be doubled? Yes. Use 2 loaf pans.
Good for leftovers? Wonderful for sandwiches.

2 pounds lean ground beef
2 eggs
½ cup seasoned bread crumbs
One 8-ounce can tomato juice
1 teaspoon salt
½ teaspoon pepper

2 cloves garlic, peeled finely diced
1 large onion, peeled and diced
3 drops Tabasco sauce
1 teaspoon dried oregano
1 cup grated Cheddar cheese
One 8-ounce jar tomato sauce

Preheat the oven to 375°F. with the rack in the center position. Spray a 6-cup loaf pan with nonstick vegetable cooking spray. Place all the ingredients except the tomato sauce in a large mixing bowl and use your hands to mix until well combined. Place the mixture in the prepared loaf pan, patting it down while forming it higher in the center with a rim around the edge. Spread the tomato sauce on top.

Put the loaf pan in a foil-lined roasting pan (to catch any overflow) and bake for 1 hour. Drain off any accumulated liquid before serving.

Big purple grapes, a wedge of Cheddar or Brie cheese, and slices of French bread or crackers make an easy, elegant end to a meal.

Meat Loaf Sandwich

Preparation time: 5 minutes
Yield: 1 sandwich

> 2 slices bread of your
> choice, such as thick-cut
> challah, whole wheat,
> rye, pumpernickel, onion
> roll, and so on
>
> Grainy mustard
> 1 thick slice meat loaf
> (page 257), hot or cold
> Slices Bermuda (red) onion
> (optional)

Slather the bread with mustard, and layer on the meat loaf and optional onion slices. Top with the remaining bread.

Roasting a Beast

That's what we called it in our house. Roast beef was usually reserved for special occasions. Given the cost and the eating inclinations of the general public today (not that you'd be feeding the general public), roast beef is still reserved for special occasions when you are serving as few as six people and as many as ten.

There are "cheap" (cheap relative to a new Mercedes) and expensive cuts. The difference is the quality, the taste, the amount of waste, and the fact that even if you have all the teeth God gave you, you'll be chewing the cheap cuts until next Tuesday. Here is a clear case of you get what you pay for, so if this is a big deal affair and you want a drop-dead roast beef, then it's worth going for broke.

I suggest you invest in a boneless rib roast. It makes a splash, it tastes expensive, and it's hard to screw up. If you have a butcher, then get your roast there as opposed to in a supermarket. Tell the butcher how many people you want to feed and get a slightly larger cut, since leftover roast beef is wonderful. If you get your meat in the supermarket, count on 8 to 10 ounces of uncooked meat per person.

The butcher will tie the roast for you so it doesn't fall apart when you cook it. If you get a roast in the supermarket, ask the clerk to take it in the back and tie it. If you can't find someone to do this, then invest in some sturdy cotton (*not nylon*) string and tie the meat at 2-inch intervals to form a roll shape.

Continued

It's important to use a meat thermometer when you cook roast beef. That way you can be absolutely sure that you don't overcook it. Remember that the meat will continue to cook after you take it out of the oven, so don't let it go a few degrees higher "for good measure." You can count on between 15 to 20 minutes a pound, 15 for rarer and 20 for more well done. The roast should also be allowed to sit for 15 minutes after cooking and before carving, which will allow the juices to redistribute themselves inside the meat.

Preparation time: 15 minutes
Cooking time: 15 to 20 minutes per pound (use a meat thermometer and consult the temperature guide on page 86).
Yield: 8 to 10 ounces per serving; a 3-pound roast serves 4 to 5 with some leftovers
Can be made ahead? No.
Can be frozen? No.
Can be doubled? Yes. Use a larger roast or 2 smaller ones.
Good for leftovers? Yes. Makes great sandwiches, or serve cold on a plate. Or add to casseroles.

1 boneless rib roast, tied　　*1 teaspoon salt*
1 clove garlic, chopped　　*Black pepper to taste*
½ teaspoon dried rosemary

Let the meat come to room temperature by leaving it out of the refrigerator for an hour. (You will need a longer time with a very large roast.)

Preheat the oven to 400°F. and position the rack in the lower third of the oven. Spray a shallow baking dish with nonstick vegetable cooking spray or coat it lightly with shortening. Or line the entire pan with foil, shiny side down (this will make cleanup very easy).

Place the roast with the fat side up in the prepared pan. If you have a roasting rack that fits in the pan, you should use it, although it's not absolutely necessary. It allows the hot air to circulate around the meat and means it cooks a bit faster and more evenly. If you do use a rack, then spray it with cooking spray or coat it with shortening.

Rub the garlic over the ends of the roast (wash your hands in cold water to get rid of the smell). Sprinkle the top with the rosemary, salt, and pepper to taste. Insert a meat thermometer in the center of the roast.

Place the roast in the oven and immediately lower the temperature to 325°F. Cook the meat until the thermometer registers 130°F. for very rare, 140°F. for medium-rare, 150°F. for medium, and 160°F.

to 170°F. for well done. Remember that the beef continues to cook after you take it out of the oven.

Let the roast rest for 15 minutes and then slice it as thick or thin as you like.

Variations Here are a few suggestions to alter the master recipe:

- Peel and thinly slice several Idaho potatoes. Place them around the roast beef before cooking. Sprinkle with salt and pepper and drizzle with a tablespoon of olive or vegetable oil.
- Boil some small red or new potatoes for 10 minutes. Drain, toss with butter, salt and pepper, and add to the roasting pan for the last 20 minutes of cooking.

How to Make Gravy
from Pan Drippings

After you cook a chicken or a roast beef in the oven or after you sauté fish or veal or chicken or steak in a pan on top of the stove you have some liquids and solids left in the pan. This is an accumulation of fat and other liquids from the food, plus what you have added during the cooking, and drippings, those little brown pieces that are stuck to the sides and bottom of the pan, or float around in the leftover fat and liquid. These bits are loaded with flavor and you can use them to make a quick sauce for your food.

Preparation time: 20 minutes
Cooking time: 20 minutes
Yield: about 1 cup
Can be made ahead? No.
Can be frozen? No.
Can be doubled? No.
Good for leftovers? Yes. Store in a covered container and reheat in a small pan or in the microwave. Serve with leftover meat.

The first trick is to drain off as much fat as possible. Tip the skillet, frying pan, or roasting pan over a metal can in the sink and slowly pour off as much fat as you can. Return the pan to the stove. (It's okay to use a baking dish *except if it's glass*.) Add any of the following:

- 1½ cups canned beef or chicken broth or 1½ cups water with 1 bouillon cube

Continued

- 1 cup heavy cream, or ½ cup broth, or dry wine
- 1 cup chicken broth and ½ cup dry white wine (for fish or chicken)
- 1 cup beef broth and ½ cup red wine (for red meat)
- 1 cup chicken or beef broth and ½ cup beer

Pour the liquid of your choice into the pan and set the pan over high heat. Bring the liquid to a boil and use a wooden spoon to vigorously scrape the sides and bottom of the pan to incorporate the drippings into the boiling liquid. Cook for about 15 minutes over high heat until the liquid is reduced by one-third.

Taste for seasoning and add salt and pepper if desired. This will make a thin sauce. If you want something thicker, like gravy, add 1 tablespoon Wondra (instant flour) and cook another few minutes until thick.

Butterflied Leg of Lamb

I guess some cooking authority thought that when you take the bones out of a leg of lamb it looks like a butterfly. Hmmm . . .

Whatever you choose to call this, it's easy (the butcher removes the bones) and makes a great dinner when served with garlic bread and salad. You can marinate the meat up to 24 hours or for as few as 2 hours to give it added flavor. Grill (broil) it in the oven or on a gas or charcoal barbecue.

Preparation time: 15 minutes
Cooking time: 20 to 30 minutes
Yield: 6 servings
Can be made ahead? Only if you want to serve it cold.
Can be frozen? No.
Can be doubled? Yes.
Good for leftovers? Excellent. Wrap well in plastic wrap and refrigerate for 3 to 4 days. Thinly sliced, it makes great sandwiches, salads, and fillings for tacos. Or use as a topping on a baked potato.

½ cup olive oil
3 tablespoons vinegar
8 cloves garlic
1 teaspoon dried rosemary
1 teaspoon salt

1 teaspoon pepper
One 5-pound leg of lamb, butterflied (have a butcher do this)

At least 2 hours and as much as 24 hours before cooking the lamb prepare the marinade: Pour the oil and vinegar into a large bowl or a flat-bottomed container. Use the flat side of a large, heavy knife to

262

smash each garlic clove; don't bother removing the peels. Add to the oil. Add the rosemary, salt, and pepper and mix.

Lay the lamb in the marinade, then turn it to coat the other side. Cover with plastic wrap and refrigerate for 2 to 24 hours, turning the meat over once or twice during this time.

To broil: Preheat the broiler to high and set the rack in the upper third of the oven, about 5 to 6 inches away from the heat source. Line a shallow broilerproof baking dish or roasting pan with foil, shiny side down. Drain the meat and lay it on the foil. Broil for 12 to 15 minutes, then turn it over, and broil another 12 to 15 minutes. Cut into the meat at its thickest point to see if it's done. The inside should be pink. You can also use an instant-read thermometer—120°F. would be very rare; 130°F. to 135°F., medium-rare; 140°F., medium; and anything over that well done.

Let the meat rest in the pan for 15 minutes before transferring it to a cutting board and slicing it on the diagonal across the grain.

To barbecue: Preheat a gas grill to high or heat a charcoal fire until the coals are white. Grill the lamb for 12 to 15 minutes on each side. Proceed as above.

To Broil Lamb Chops

Preparation time: 10 minutes
Cooking time: 12 to 15 minutes
Yield: 2 servings
Can be made ahead? No.
Can be frozen? No.
Can be doubled and tripled? Yes. Be careful about draining the fat often; there
 will be a lot of it.
Good for leftovers? You can trim the meat from the chops and refrigerate it,
 well wrapped in plastic wrap, for up to 3 days

> *4 lamb chops*
> *2 tablespoons A.1. Steak*
> *Sauce or other sauce*

Preheat the broiler to high with the rack in the upper third of the oven. Line a shallow baking dish with foil and wrap the foil up and over the edges. (This will make cleanup easier.) Coat each lamb chop with the steak sauce and then place the chops close together but not touching on the foil.

Continued

Lamb Chops

You know how when you go to a restaurant and tell the waitperson that you want your meat rare, medium, or well done—except it isn't usually delivered exactly that way? Now you get to cook it exactly the way you like. This takes a bit of practice, and there is a trick if you don't mind getting your fingers "dirty."

Since meat is protein, it gets firmer the longer it cooks. Raw meat will feel positively squishy. Very rare meat will be browned on the outside, yet still feel pretty squishy when you poke it with your finger. Medium-rare will feel less so. Medium will offer more resistance, and well done, almost none. The only way to learn the feel of the meat relative to its "doneness" is by experience. A good way to practice is with lamb chops, which (although some may argue with me) taste delicious when they are rare and still taste fine when well done.

You can cook lamb chops in a pan on top of the stove, but it makes a hell of a mess, not to mention a fire hazard, because of all the fat that splatters around. The best way is to broil or barbecue them.

There are several cuts of lamb chops: shoulder, loin, blade, and rib. The ritziest are the rib chops since they have the best meat with the least amount of gristle and other waste. Try to select chops of the same thickness so that you can assume they'll all cook the same length of time.

Broil for about 5 minutes on each side for rare, 6 minutes for medium, and 7 minutes for well done. Halfway through the broiling it's a good idea to drain off the fat in the pan into a can. Place the can in the sink and use a long fork or spatula to hold the lamb chops in place while you tilt the pan over the can. Do not pour the fat down the drain.

Turn the lamb chops and broil the second side. The cooking time depends on the thickness of the chop. Try pressing the meat with your finger. If it offers little resistance, it's rare; slight resistance, it's medium; and if it feels firm, it's well done. The foolproof way to test is by cutting into a chop.

To Barbecue Lamb Chops

Preparation time: 10 minutes
Cooking time: 12 to 15 minutes
Yield: 4 servings

> *4 lamb chops*
> *2 tablespoons A.1. Steak*
> *Sauce or other steak*
> *sauce*

Coat both sides of each lamb chop with the steak sauce. Cook over a gas grill preheated to "high" or over white-hot charcoal briquettes for 4 to 6 minutes on each side, depending on the thickness of the chops and the desired degree of "doneness."

Honey Baked Ham

We're talking easy here, with decidedly delicious results. Of course the end product will depend heavily on the quality of ham you begin with. Shop around and ask your butcher for advice. Stay away from heavily salted hams that have a lot of fat.

Preparation time: 15 minutes
Cooking time: 1¼ hours
Yield: 4 to 5 servings per pound
Can be made ahead? Yes. The night before. Slice for serving cold.
Can be frozen? Yes. But it will lose some of the nice texture. Use frozen pieces of ham in soups and stews.
Can be doubled? Yes. If you have a large enough oven, bake 2 hams.
Good for leftovers? Excellent. Wrap well in plastic wrap or in a plastic bag and refrigerate for up to 5 days. Reheat in foil. Add to casseroles and soups, or use cold in sandwiches or salads.

> *One 6- to 8-pound smoked,* *⅓ cup Dijon mustard*
> *fully cooked ham* *¼ cup soy sauce*
> *One 8-ounce jar apricot* *½ cup orange juice*
> *preserves* *½ teaspoon ground cloves*
> *½ cup honey* *½ teaspoon powdered*
> *ginger*

Preheat the oven to 325°F. Spray a roasting pan with nonstick vegetable cooking spray (this will make cleanup easier) or line the pan with

Ham Sandwiches: Variations on a Theme

If you are used to making sandwiches with that boring thin-sliced ham from the deli, making them with your own leftover baked ham will be a remarkable revelation.

Bread-wise, try an onion roll, pumpernickel or dark rye bread, whole-wheat pita, or a cheese croissant. Spread with mustard—grainy, honey, or Dijon—or Major Grey's Mango Chutney (available in the condiment section of the grocery store). Add a slice of Cheddar, Brie, or goat cheese. Top with sprouts, a thick slice of tomato, Bermuda onion, or slices of apples or pears. Enjoy!

foil. If you have a roasting rack, spray it as well and place it in the pan. Place the ham on top. If you don't have a rack, just place the ham in the pan.

Insert a meat thermometer into the center of the ham. Combine all the remaining ingredients and mix well. Brush the ham with the glaze and bake for 1¼ hours, basting every 30 minutes, until the thermometer reads 140°F.

Remove the ham to a carving board and let it stand for 15 minutes before cutting.

Suggested accompaniments: Noodle Pudding (page 197) or Stove-Top Sweet Potatoes (page 226), and Coleslaw (page 136).

Desserts

Baked Desserts

Gingerbread

This old-fashioned treat makes a quick dessert and a delicious snack.

Preparation time: 30 minutes
Baking time: 35 to 40 minutes
Yield: 6 to 8 servings
Can be made ahead? Yes. The day before, but it's not as good. Try to make it and frost it the day you plan to serve it. Store at room temperature.
Can be frozen? Yes, but not frosted. Cool completely. Wrap in plastic wrap or store in a plastic bag. Defrost at room temperature, wrapped.
Can be doubled? Yes. Use 2 pans and bake the layers at the same time.
Good for leftovers? Yes. Will keep well wrapped in plastic wrap at room temperature for 1 day, and refrigerated, 2 days.

Continued

2/3 cup dark brown sugar,
 firmly packed
1/2 cup molasses
2/3 cup boiling water
4 tablespoons butter, cut
 into chunks, at room
 temperature
1 teaspoon baking soda

2 extra-large eggs
1/2 cup raisins (optional)
1 1/2 cups flour, measured
 after sifting
1 teaspoon cinnamon
1 teaspoon powdered ginger
1/4 teaspoon cloves
1 recipe Gingered Cream
 Cheese Icing (follows)

Preheat the oven to 350°F. with the rack in the center position. Butter and dust with flour a 9-inch square baking pan. By hand or in the bowl of an electric mixer set on slow speed, blend together the sugar, molasses, boiling water, and butter. While the mixture is still hot, add the baking soda, eggs, and optional raisins.

Sift together the flour, cinnamon, ginger, and cloves. Add to the batter and mix well, taking care not to incorporate too many air bubbles into the batter.

Pour into the prepared pan and bake for 35 to 40 minutes, or until a cake tester inserted in the middle comes out dry. Cool slightly.

Serve with whipped cream or cool completely and frost.

Gingered Cream Cheese Icing

4 tablespoons butter, at
 room temperature
4 ounces cream cheese, at
 room temperature
1 1/2 cups confectioners'
 sugar, sifted after
 measuring

1 teaspoon vanilla extract
1/4 cup finely chopped
 candied ginger (optional)

In a bowl beat the butter and cream cheese together until smooth. Beat in the sugar, mixing until smooth. Mix in the vanilla and optional candied ginger. Chill briefly before frosting the gingerbread.

Desserts

I have a mug that's inscribed with a great line: "Life is uncertain, eat dessert first." Judging from the number of desserts in this book, I don't need a mug to remind me of the divine order of dishes of the universe. Desserts were the very first thing I learned to make and my passion for them remains to this day.

The great thing about desserts and the novice cook is that even a near-miss (short of a raw cake or omission of a major ingredient like sugar) usually tastes pretty good and is wildly appreciated by all those who consume it.

I've divided desserts into three sections: baked desserts including cakes, pies, and cookies; fruit desserts; and ice-cream desserts. I've carefully chosen recipes that are simple and don't take a very long time to execute. Obviously, it will take longer to bake chocolate chip cookies than to scoop some ice cream into a dish and pour some sauce over it, but just because you haven't baked before doesn't mean you can't turn out a wicked batch of cookies. Trust me, read, and follow the directions and you'll be ready to give Mrs. Fields a run for her money.

Every good meal (and I'm talking dinner here, kid, not breakfast) deserves dessert, even if it's as simple as a slice of melon or a dish of applesauce. Save the heavy calorie hitters for when company comes so you're not faced with the dilemma of eating a whole ice-cream pie.

Just remember to raise a glass of milk to me when you bite into your very own homemade brownie. I'll be standing right behind your shoulder, smiling and proud and looking for the biggest piece.

It's easier to beat egg whites that are at room temperature. Always use a spotlessly clean metal bowl and clean beaters as well. Make sure not to get any egg yolks into the whites. Until you get proficient at separating eggs, it's a good idea to separate the yolks into one small cup and the whites into another. Break one egg at a time. That way if you break a yolk you won't mess up your recipe.

Fudge Brownies

Chocolate heaven! Don't overbake and they'll be very moist. Don't be tempted to cut these until they cool. The optional chocolate chips will turn them into chocolate chunk brownies.

Preparation time: 20 minutes
Baking time: 20 to 25 minutes
Yield: 2 dozen brownies
Can be made ahead? Yes. The day before. Cover and keep at room temperature.
Can be frozen? Yes. Cool completely first. Defrost at room temperature, completely covered.
Can be doubled? Yes. Use an 15 × 11-inch pan and bake 5 minutes longer.
Good for leftovers? You probably won't have any left over, but if you do, wrap the brownies well in plastic wrap or store in a covered plastic container and keep at room temperature for up to 1 week.

1 cup (2 sticks) butter, cut into pieces
4 squares (4 ounces) unsweetened chocolate, chopped
2 cups sugar
4 eggs
1 cup flour, measured after sifting
1 cup walnuts or pecans, broken into medium-sized pieces (optional)
1 cup chocolate chips, semisweet or mint (optional)

Preheat the oven to 375°F. with the rack in the center position. Lightly coat a 12 × 9-inch baking pan with butter or vegetable shortening.

Place the pieces of butter and chopped chocolate in a large metal bowl and set the bowl over a saucepan of gently simmering water. Stir occasionally until the mixture melts and is smooth. Remove from the heat.

Stir in the sugar and the eggs, one at a time, mixing gently until incorporated. Gently stir in the flour and the optional nuts and chocolate chips. The less you beat the mixture, the more tender your brownies will be.

Spoon and scrape the batter into the prepared pan and bake for 20 to 25 minutes, or until the top has a thin shiny crust and the sides have just begun to pull away from the pan. Cool completely, then cut into squares.

Oatmeal Cookies

These are worlds better than store-bought.

Preparation time: 25 minutes
Baking time: 15 to 20 minutes
Yield: 4 dozen cookies
Can be made ahead? Yes. Cool completely and store in an airtight container at room temperature. They'll keep for 2 weeks.
Can be frozen? Yes. Cool completely first, then store in airtight freezer bags. Defrost at room temperature, in the bags.
Can be doubled? Yes. Make twice the recipe and bake several batches of cookies, reusing the aluminum foil. The dough can remain at room temperature while the cookies bake, but the later batches will spread more if the cookie sheet is very hot, so leave extra room between each cookie.
Good for leftovers? Yes, if there are any.

> *3 cups flour, measured*
> *after sifting*
> *1 teaspoon baking soda*
> *1 teaspoon salt*
> *1 teaspoon cinnamon*
> *3 cups regular (as opposed*
> *to quick-cooking)*
> *oatmeal*
>
> *1 cup granulated sugar*
> *1 cup dark brown sugar,*
> *firmly packed*
> *1 cup raisins*
> *1 cup vegetable oil*
> *2 eggs*
> *⅓ cup milk*

Preheat the oven to 375°F. with the rack in the center position. Line 2 cookie sheets with aluminum foil.

Sift the flour, baking soda, salt, and cinnamon into a very large mixing bowl or pot. Mix in the oatmeal, both sugars, the raisins, oil, eggs, and milk. Mix very well until the ingredients are well combined. Drop the batter in rounded tablespoons, the size of large walnuts, onto the prepared cookie sheets. Bake for 15 to 20 minutes, reversing the cookie sheets once halfway through the cooking time. If the bottoms are burning, place another baking sheet under each of the original ones and try baking one sheet at a time.

Remove the cookies to a rack to cool.

Carrot Cake

Next to Mud Pie, this is our family's all-time favorite dessert—especially the frosting.

Preparation time: 30 minutes
Baking time: 50 to 60 minutes
Yield: 10 servings
Can be made ahead? Yes. Up to 1 day before. Cover with plastic wrap and leave at room temperature. Frost the day you plan to serve it.
Can be frozen? Yes. Although it's better to freeze it unfrosted.
Can be doubled? It's better to make the recipe 2 times than to try to crowd both pans in the oven at the same time.
Good for leftovers? Yes. Will keep 3 to 4 days, well wrapped, in a cool place or up to a week in the refrigerator.

2 cups flour, measured after sifting	*3 cups grated carrots (approximately 3 very large carrots)*
2 cups sugar	
2 teaspoons baking powder	*4 eggs*
2 teaspoons baking soda	*1 cup walnuts, chopped*
1 teaspoon salt	*½ cup raisins*
2 teaspoons cinnamon	*1 recipe Cream Cheese*
1¼ cups vegetable oil	*Frosting (follows)*

Preheat the oven to 350°F. with the rack in the center position. Lightly grease a 12 × 9- or 13 × 9-inch baking pan.

Sift the flour, sugar, baking powder, baking soda, salt, and cinnamon into a very large mixing bowl or pot. Stir to blend well. Add the remaining ingredients and mix well. Pour into the prepared pan, smoothing the top, if necessary. Bake for 45 minutes, or until a cake tester or toothpick inserted in the center comes out clean and dry. Cool completely in the pan before frosting.

If you bake a cake that accidentally comes out of the pan in several pieces, you can turn it into another dessert by breaking it into chunks and mixing it with a cup or two of whipped cream. Turn into a serving bowl and call it a trifle. You can even mix in pieces of fresh fruit or berries.

Cream Cheese Frosting

I frost the cake right in the pan and then cut it into squares for serving. If you want to present a whole cake, then turn it out onto a cookie sheet or board, place a flat serving plate on top, and invert the cake. Then frost.

Preparation time: 20 minutes
Yield: Enough frosting for a 13 × 9-inch cake

4 ounces (½ cup) or half an 8-ounce package cream cheese, at room temperature

¼ cup (½ stick) butter, at room temperature
2 cups confectioners' sugar
2 teaspoons vanilla extract

Place the cream cheese and butter in a mixing bowl and beat until very smooth. Place the sugar in a sifter or fine-mesh strainer and sift over the cream cheese/butter mixture. Beat by hand or with an electric mixer until light and fluffy. Mix in the vanilla.

Quick Raspberry Sauce

This is delicious served with Sweet Cheese Pie (page 279) or vanilla ice cream.

Preparation time: 15 minutes
Yield: 6 servings
Can be made ahead? Yes. The day before. Store in a covered jar or plastic container and refrigerate.
Can be frozen? Yes. In a plastic container. Defrost at room temperature.
Can be doubled and tripled? Yes.
Good for leftovers? Yes. Store in a covered container; refrigerate 1 week.

One 10-ounce package frozen raspberries, partially defrosted
One 8-ounce jar raspberry preserves

2 to 3 tablespoons Grand Marnier (optional)

Place the raspberries with their juice and the preserves in a blender or food processor. Blend or process until smooth. Add the Grand Marnier, if desired.

Continued

If you want to remove the seeds from the sauce, pour it through a wire strainer, and push down hard with a wooden spoon to extract all the juice.

Strawberry Shortcake

I figure if I spend all year long virtuously eating no-fat low-cal frozen yogurt for dessert, come July, when native strawberries are at their sweetest, I can indulge in real strawberry shortcake.

There are three simple components to real strawberry shortcake: biscuits, strawberries, and whipped cream. Period. Now, you can buy your biscuits ready made in a bakery, or you can make them from scratch using the recipe below, or you can make them with Bisquick, which, frankly, I think is almost as good as homemade.

If you get the craving for strawberry shortcake in February and there isn't a fresh berry in sight, go ahead and use frozen ones. They'll be on the mushy, sweet side . . . but their taste will make it easier to dream of summer.

Preparation time: 30 minutes to make homemade biscuits; 20 minutes for a mix; and 20 minutes to assemble
Baking time: approximately 12 to 14 minutes
Yield: 8 to 10 servings
Can be made ahead? The biscuits can be made ahead, and the strawberries can be done up to 6 hours ahead. Wait until the last minute to whip the cream.
Can be frozen? The biscuits can be frozen in plastic bags. Defrost, covered, at room temperature; refresh in a 250°F. oven for 10 minutes, then cool.
Can be doubled? Yes.
Good for leftovers? The components are good, but the assembled dessert will get very soggy. The biscuits will keep a day, stored in plastic bags. The strawberries will get mushy, but are still edible up to 2 days after. Store in a covered container in the refrigerator. The cream will loose some of its oomph, but it will still taste good.

8 to 10 baking powder biscuits, either store-bought, homemade (recipe follows), or made with Bisquick (the directions are on the box)

3 pints strawberries
⅓ cup plus 3 tablespoons sugar
2 cups whipping cream
2 teaspoons vanilla extract

Place a large metal bowl and either a wire whisk, egg beaters, or the blades of an electric mixer in the refrigerator or freezer to chill.

Rinse the berries gently under cold water and cut off the stems and any white or moldy parts. Slice the berries and place them in a bowl. Sprinkle the ⅓ cup sugar over them and toss gently. Cover with plastic wrap and refrigerate unless you are serving them within the next 2 hours.

Whip the cream in the chilled bowl with the chilled beaters until soft peaks form. Beat in the 3 tablespoons sugar and vanilla. It is best to do this at the last minute or the whipped cream may get watery.

To serve: Cut each biscuit in half. Place one biscuit half on a dish or in a shallow bowl. Spoon a generous amount of strawberries and the syrup over it. Top with the other half, and drizzle with a little juice from the strawberries. Top with a generous dollop of whipped cream.

Variations You can use a combination of raspberries, blueberries, and blackberries as well as sliced peaches or nectarines.

Baking Powder Biscuits

Preparation time: 30 minutes
Baking time: approximately 12 to 14 minutes
Yield: About 16 biscuits
Can be made ahead? Yes, the day before. Cool and store covered.
Can be frozen? No.
Can be doubled and tripled? Yes.
Good for leftovers? Okay. Refresh in a 350°F. oven for 10 to 15 minutes.

2 cups flour, measured after sifting	1 teaspoon salt
2½ teaspoons baking powder	⅓ cup solid vegetable shortening
	⅔ cup light cream

Preheat the oven to 425°F. with the rack in the center position.

Place the sifted flour, baking powder, and salt in a sifter and sift into a mixing bowl. Use 2 forks in a crisscross motion to cut in the shortening until the mixture resembles coarse meal.

Use a fork to blend in the cream, adding just enough cream so that the dough is soft but not sticky. Lightly flour the counter or a wooden board and turn the dough out onto it. Knead briefly until the dough is smooth. Use your hands to pat the dough into a rough circle about ½ inch thick.

Dip the rim of a drinking glass or round cookie cutter with a 2-inch opening in flour, and use it to cut out the biscuits.

Place the biscuits on a heavy ungreased baking sheet, 1 inch apart, and bake for 12 to 14 minutes, or until golden brown. If you find the bottoms are getting too dark, place a second baking sheet under the first and bake for an additional minute or so. Cool on a rack or serve hot. These biscuits are best eaten fresh. However, they can be reheated and/or frozen.

Mud Pie

There is a peculiar genetic trait that runs in our family. We all share a passionate love for the combination of chocolate ice cream and frozen whipped cream. If you share that passion, then this is for you.

You have the choice of purchasing a ready-made cracker crumb shell—either graham or chocolate—or making one yourself (which you are perfectly capable of doing).

Preparation time: 25 minutes with a premade shell; 45 minutes when you make your own shell
Baking time: 5 minutes if you make your own shell.
Yield: 8 servings
Can be made ahead and frozen? Yes, and kept frozen for up to 3 days. You can actually keep it frozen much longer, but it will start to pick up the odor of other foods in the freezer.
Can be doubled? Yes. Make 2 pies.
Good for leftovers? This pie can be refrozen several times. Wrap it very well in plastic wrap and foil.

One 9-inch premade graham cracker crumb pie shell,
or
one 9-inch pie shell made from:
1 ½ cups graham cracker crumbs
2 tablespoons sugar
4 tablespoons melted butter

2 pints good-quality chocolate ice cream or chocolate chocolate-chip ice cream
1 pint whipping cream
4 tablespoons sugar
Chocolate sprinkles (optional)
1 large jar hot fudge sauce

Before you start, place your largest metal mixing bowl and an egg beater, a large wire whisk, or the beater to your electric mixer in the freezer or in the refrigerator. Or, if it's winter (and you don't live in Southern California), place them outside in the snow.

Next, create a large (pie-sized) space in your freezer by throwing out all those half-eaten containers of frozen yogurt and almost-empty bags of mixed vegetables. What are you doing with frozen vegetables, anyway?

If you are making your own pie crust, lightly grease a 9-inch pie plate with nonstick vegetable cooking spray or shortening. Mix the crumbs together with the sugar and butter. Stir with a fork or with your fingers to distribute all the ingredients.

Sprinkle the crumbs evenly over the bottom of the prepared dish. Use your finger tips to gently press them up against the bottom and sides. Try not to make the very rim too thin because it might burn. Bake for 5 minutes, then cool completely.

Let the ice cream soften slightly, then turn it out into a large bowl and mash it up until you can spread it. (Your mother used to yell at you for this: "Don't play with your ice cream." You used to reply, "But, I'm making soup.")

Use a rubber spatula to spoon and scrape the ice cream into the shell and mound it slightly in the center. Place the pie in the freezer while you whip the cream.

Pour the whipping cream into the chilled metal bowl and beat with the chilled beater until the cream forms soft and slightly firm peaks. Don't go overboard with the beating, or you'll have butter. Beat in the sugar.

Gently spread the whipped cream over the entire top of the pie. There will be plenty of whipped cream to play with, so go ahead and make swirls and dips. Just don't take forever because the ice cream will start to melt. Sprinkle the top with the optional chocolate sprinkles.

Return the pie to the freezer and let it stay there for at least 4 hours.

To serve: Heat the hot fudge sauce either in the microwave or by placing the opened jar in a pan of gently simmering water. Transfer the sauce to a socially acceptable pitcher and serve separately, letting your guests pour on their own. If you don't have a socially acceptable pitcher, slice the pie in the kitchen, pour on the sauce, and then serve it fast before the ice cream melts.

Chocolate Peanut Butter Pie

Your guests will yell for seconds.

Preparation time: 25 minutes
Cooking time: 35 minutes
Yield: 8 servings
Can be made ahead? Yes. The day before. Cover with plastic wrap and store at room temperature.
Can be frozen? Yes. Cool completely first, then wrap well in plastic wrap. Defrost at room temperature, wrapped.
Can be doubled? Yes. Use 2 pie plates.
Good for leftovers? Yes. Can be stored at room temperature for 1 day, then refrigerated for 5 days. Wrap well in plastic wrap for storage.

1 cup dark brown sugar, firmly packed	*⅔ cup chunky peanut butter*
1 cup Bisquick	*8 ounces chocolate chips*
2 extra-large eggs	*1 cup chopped dry roasted peanuts*
1 cup heavy cream	

Preheat the oven to 350°F. with the rack in the center position. Spray a 9-inch pie plate with nonstick vegetable cooking spray or coat it lightly with solid vegetable shortening.

By hand or in the bowl of an electric mixer, beat the sugar, Bisquick, eggs, cream, and peanut butter until the mixture is fluffy. This will take about 1 minute in the electric mixer and longer by hand.

Pour and scrape the batter into the pie plate and bake for about 35 minutes, until puffed and dried in the center and a cake tester or toothpick inserted in the center comes out clean.

Remove the pie from oven and sprinkle the chocolate chips on top. As soon as they melt, spread them over the top with a rubber scraper or spatula. Sprinkle the chopped peanuts on top. Let the pie cool completely before serving.

Keep a box of brownie mix on hand as well as a package of chocolate chips and a can of walnuts or pecans. You can use them to doctor up a mix to make a dessert that tastes almost homemade.

Sweet Cheese Pie

If you love cheesecake, this is for you. You can buy premade graham cracker crumb crusts in the supermarket. This good news makes an easy dessert even easier. Or you can make your own. I refer you to my recipe for a graham cracker crumb crust on page 276.

Preparation time: 25 to 40 minutes, depending on the pie crust situation
Cooking time: 24 minutes
Yield: 8
Can be made ahead? Not more than 1 day. Keep refrigerated and covered with plastic wrap. Add the fruit just before serving.
Can be frozen? No.
Can be doubled? Yes. If you have 2 pie plates.
Good for leftovers? Yes. Although it may look a bit messy. Cover with plastic wrap and refrigerate for up to 3 days.

*1 premade 9-inch graham
cracker crumb crust, or
1 recipe homemade crust
(pages 276 to 277)
12 ounces cream cheese
(not whipped), at room
temperature
2 extra-large eggs
½ cup plus ¼ cup sugar
1 teaspoon vanilla extract*

*2 cups (1 pint) sour cream
2 cups fresh or defrosted
berries of your choice,
such as sliced
strawberries, blueberries,
raspberries, pitted
cherries, or blackberries,
or a mixture of these*

Preheat the oven to 350°F. with the rack in the center position. Bake the premade pie shell for 5 minutes, and remove it to cool, but do not turn off the oven. Make a homemade crust as directed, bake it, and let it cool.

Either by hand or with an electric mixer, beat the cream cheese until very soft. Add the eggs and continue beating until they are thoroughly combined. Beat in the ½ cup sugar and the vanilla.

Pour and scrape the batter into the prepared pie shell, and use a rubber scraper to smooth the top. Bake for 20 minutes. Remove from the oven.

Turn the oven up to 400°F. Combine the sour cream and the remaining ¼ cup sugar. Spoon this mixture over the top of the hot pie and smooth the top with the rubber scraper. Return the pie to

the oven and bake exactly 4 minutes. Remove the pie and cool for 20 minutes. Refrigerate for several hours. The pie will become firmer when cold.

Spoon or arrange the berries of your choice on top of the pie just before serving.

Fruit Desserts
❖

Strawberries with Raspberry Sauce

When I lived in New York City in the late sixties, there was a restaurant called Casa Brasil that served this elegantly simple dessert. The best time to make it is when strawberries are at their most flavorful—in the summer. You use frozen raspberries for the sauce.

Preparation time: 25 minutes
Yield: 4 to 6 servings
Can be made ahead? Yes. The sauce can, up to 8 hours. The strawberries can be prepared up to 4 hours before serving. Refrigerate until serving.
Can be frozen? No.
Can be doubled? Yes.
Good for leftovers? Yes. Although the strawberries will get soggy after 1 day.

2 pints very flavorful fresh
strawberries
2 tablespoons plus ¼ to ⅓
cup sugar
Two 10-ounce packages
frozen raspberries,
defrosted

2 to 3 tablespoons Grand
Marnier (optional)

Place the strawberries in a single layer in a colander. Discard any that are moldy. Spray the berries with cold water and shake the colander gently to drain the water.

Cut the hulls and any white flesh off the tops of the strawberries. If they are large, cut them in half or in quarters. Place them in a

bowl and sprinkle the 2 tablespoons sugar on top. Shake the bowl gently to distribute the sugar.

Place the defrosted raspberries and their juice in a blender or food processor. Add some of the remaining sugar and blend until smooth. Add the juice from the strawberries, blend again, and taste. Add more sugar if desired. Add the optional Grand Marnier and blend for a few seconds. If you want the sauce without seeds, then press it through a wide-mesh sieve set over a bowl. Discard the seeds.

To serve: Divide the strawberries among dessert dishes, wine-glasses, or bowls and spoon the sauce over them.

Stewed Fruit

Call it compote and serve it as a dessert after a meal. But also remember it's high in fiber and iron and goes down really easy for breakfast in a hurry. It's wonderful with a dollop of plain yogurt and a sprinkling of granola on top.

Preparation time: 10 minutes
Cooking time: 20 to 30 minutes
Yield About 10 cups fruit
Can be made ahead? Yes. Store in a sealed jar in the refrigerator up to 2 months.
Can be frozen? No.
Can be doubled and tripled? Yes.

1 pound pitted prunes
1 box dried apricots, or 10 ounces loose apricots
2 pounds additional dried fruits of your choice, such as apples, peaches, or pears
1 cup golden raisins (optional)

2 lemons, cut into quarters, seeds removed
1 quart (4 cups) orange juice
Additional orange juice or water

Place all the ingredients in a large saucepan. Cover and set over moderate heat until the orange juice starts to simmer. Lower the heat so that the liquid barely simmers and cook for 20 to 30 minutes, stirring occasionally, until the fruit is soft and most of the liquid is absorbed. Add a little more juice or water to keep the fruit moist.

Continued

Store in a sealed container in the refrigerator. The lemon is for flavor, although I like to eat it. Serve the fruit by itself, with some yogurt on top, or serve over hot or cold cereal.

To cook in the microwave: Place all the ingredients in a large glass bowl. Cover tightly with plastic wrap and cook on high for 15 minutes. At the end of that time test to see if the fruit is soft, or if more liquid is needed.

Baked Apples

These are the ultimate in comfort food. It takes a little practice to know when to remove the apples from the oven before they "explode." No matter what they look like, though, they'll taste terrific.

It's important to use the specified kind of apple.

Preparation time: 25 minutes
Cooking time: 30 to 40 minutes
Yield: 6 servings
Can be made ahead? Yes. Up to 3 hours. Keep at room temperature to serve.
Can be frozen? No.
Can be doubled? Yes. Use a much larger baking pan.
Good for leftovers? Yes. For up to 3 days. Cover with waxed paper or plastic wrap and refrigerate. Eat either cold (makes a great breakfast) or reheat in a microwave oven.

6 large apples, either Rome Beauty or Cortland
1½ cups dark brown sugar, firmly packed
3 tablespoons butter
½ teaspoon cinnamon, or ½ cup cinnamon red hots
1 cup water or apple cider
Heavy cream (optional)

Preheat the oven to 350°F. with the rack in the center position. Select a shallow ovenproof pan or casserole that will accommodate the 6 apples.

Stick a sharp teaspoon or grapefruit spoon deep into the top of each apple, making a circle around the stem, and then lift out the core. Scrape out any seeds.

Fill each cavity with brown sugar, and top with ½ tablespoon of butter and some of the cinnamon or candy. Place the apples in the baking pan, sprinkle with any remaining sugar, and add the liquid to the pan.

Bake the apples for about 30 minutes. Try to remove them from the oven while the skins are still intact. If they "explode," don't worry. Serve hot or cold, either plain or with a few tablespoons of heavy cream added to the baking liquid.

Baked Bananas

Commander's Palace, a truly wonderful restaurant in New Orleans, makes a very upscale version of this dish and calls it Bananas Foster. The combination of brown sugar, butter, warm bananas, rum, and melting vanilla ice cream is delicious beyond description. Here's a simple version of a classic dessert.

Preparation time: 25 minutes
Cooking time: 20 minutes
Yield: 6 servings (if you're willing to share)
Can be made ahead? Yes, partially, if you don't mind the bananas turning brown. Make up to 4 hours ahead, to ****.
Can be frozen? No.
Can be doubled and tripled? Yes.
Good for leftovers? Yes. Cover and refrigerate for up to 3 days. Eat cold or reheat in a small pan or microwave oven.

> *1 stick butter, melted*
> *⅔ cup brown sugar*
> *½ cup dark or light rum (optional), or orange juice, if you wish*
>
> *6 firm, ripe bananas, peeled*
> *1 pint vanilla ice cream*

Preheat the oven to 375°F. with the rack in the center position. Use about 1 tablespoon of the melted butter to coat the bottom and sides of an ovenproof baking dish. Combine the rest of the butter with the brown sugar and optional rum or orange juice.

Slice the bananas in half crosswise and then split each half down the middle lengthwise. Place them in one layer in the prepared dish. Pour the sugar/butter mixture over the bananas ****. Bake for 20 minutes, or until the sauce is bubbling.

To serve: Spoon 4 pieces of banana onto each dessert plate. Spoon some sauce over the top and add a scoop of vanilla ice cream. Serve immediately.

Cherries Jubilee

Promise me that before you make this, you'll tie your long hair back in a ponytail, roll up your sleeves, and, in the case of the gentlemen with flowing facial hair, don't bend over to get a closer look.

Preparation time: 15 minutes
Cooking time: 10 minutes
Yield: 4 to 5 servings
Can be made ahead? Yes. Three hours, up to ****. Leave the cherries at room temperature and reheat before proceeding.
Can be frozen? No.
Can be doubled? Yes. Use a bigger pan.
Good for leftovers? Yes. The sauce can be stored in the refrigerator for up to a week. Reheat and serve over ice cream, pound cake, or any fresh fruit.

*2 cups canned or bottled
 pitted sweet cherries (not
 maraschino)
1 tablespoon sugar
1 tablespoon cornstarch*

*⅓ cup kirsch (cherry
 liqueur) or brandy
1 pint best-quality vanilla
 ice cream*

Set a sieve over a 2-cup glass measure and drain the cherries into it. Mix the sugar with the cornstarch in a small pan and use a wire whisk to stir in 1 cup of cherry juice. Mix very well.

Place the pan over moderate heat and simmer 3 minutes, stirring constantly. The sauce will thicken slightly and become lighter in color. Add the cherries and the kirsch or brandy ****. Keep this mixture warm over very low heat while you spoon the ice cream into individual bowls.

Bring the bowls to the table, then hold a lighted match over the pan of cherries. The liqueur will ignite. When the flame goes out use a metal serving spoon to ladle the cherries and the sauce over the ice cream.

Ice Cream

Ice cream straight from the carton is scrumptious and totally appropriate when you're twelve years old and your mother has left you in charge of the house for the evening. Hershey's syrup straight from the can is a great accompaniment. Now that you own a serving spoon and a set of dessert dishes or bowls, it's time to use them while you look forward to that time when you find your own kid digging out the pieces of candy from that carton of Heath Bar Crunch you thought you had so carefully hidden behind the box of frozen waffles.

Premium ice cream with a simple topping makes an elegant and ridiculously simple dessert. If you're watching your calories, then use a good-quality frozen yogurt and stick to fresh fruit toppings.

The things that differentiate great ice cream from its ho-hum relatives are the amount of butter fat, which gives it its smooth, satisfying taste, and something called "overrun." Overrun is the process of beating air into the ice cream as it is mixed and frozen. If there was no overrun at all, the ice cream would be a solid frozen block and impossible to serve. A small amount of overrun makes for a dense, creamy, substantial product, while a lot of air makes for something that melts into a puddle or foam before you even get it into your mouth. That's why a pint of premium ice cream will cost as much as—or more than—a half-gallon of the run-of-the-mill stuff. The air makes up for much of the volume of the latter.

A simple ice-cream dessert does not have to be boring. You can even set it on fire!

Soften hard ice cream to scooping consistency in the microwave on high for 5 to 7 seconds.

Frozen low-fat yogurt can be substituted in any recipe in this book that calls for ice cream.

Fudge Sauce

Here's a down-home idea with a decidedly uptown taste. Be sure to use really good chocolate. I like Lindt extra bittersweet, Lindt Surfin, or Ghirardelli semisweet, but any premium semisweet or bittersweet chocolate will do.

Preparation time: 15 minutes
Cooking time: 15 minutes
Yield: 3⅔ cups
Can be made ahead? Yes. The sauce can be made 2 days ahead. Store in a covered jar or plastic container and heat over very low heat in a heavy-bottomed pan, stirring constantly.
Can be frozen? Yes. The best container is a heavy-duty plastic bag. Defrost by placing the bag in a pan of gently simmering water.
Can be doubled? Yes.
Good for leftovers? Are you kidding? It will keep 2 weeks in the refrigerator.

*12 ounces bittersweet or
semisweet chocolate
2 cups heavy cream
½ cup dark brown sugar,
firmly packed
3 tablespoons butter, cut
into small pieces*

*2 to 3 tablespoons rum or
crème de cacao
(chocolate liqueur)
(optional)*

Chop or break the chocolate into small pieces. Pour the cream into a medium saucepan and place it over moderate heat. Simmer the cream for 15 minutes. Watch it carefully since it will overflow easily.

Stir in the brown sugar and continue cooking until the sugar dissolves.

Remove the pan from the heat and add the chopped chocolate, stirring until it melts. Add the butter and stir until it is incorporated. Stir in the rum or crème de cacao, if desired.

Serve warm over the ice cream of your choice.

The sauce will thicken when refrigerated, but you can reheat it by placing the container in a shallow pan of hot water, or by placing it in the microwave oven for 20 seconds.

Variations Serve this over a brownie, either store-bought or home-made from the recipe on page 270. For a real blowout, top with whipped cream and nuts.

> **Y**ou can stretch the number of servings of a cake by serving less and topping it with a scoop of ice cream, fresh fruit, and/or fruit or Fudge Sauce (page 286).

Ice Cream with Fresh Fruit

You can substitute frozen yogurt or sorbet.

Preparation time: 20 minutes
Yield: 8 servings
Can be done ahead? Yes. The day before, up to **** and kept refrigerated.
Can be frozen? No.
Can be doubled? Yes.
Good for leftovers? Yes. Store in a covered container in the refrigerator for up to 3 days.

4 cups assorted cut-up fresh fruit, such as strawberries, raspberries, apples, peaches, nectarines, oranges, bananas, blueberries, kiwi, or pineapple

3 tablespoons sugar
⅓ cup kirsch or other fruit liqueur (optional)
2 pints vanilla or fruit-flavored ice cream, frozen yogurt, or sorbet

Place all the cut-up fruit in a large bowl or container. If you plan to use bananas, sprinkle them with a little lemon juice so they don't turn dark. Sprinkle on the sugar and add the optional liqueur. Toss gently and cover. Refrigerate for several hours or overnight ****.

To serve: Spoon some ice cream, frozen yogurt, or sorbet into individual bowls and top with the fruit and its juice.

Always defrost frozen desserts while they are still wrapped in plastic wrap. The moisture will condense on the outside of the package, not on the food.

If the bottom of a cake or bread scorches during baking, use a very sharp serrated knife to cut off the burned part. The burned bottoms of cookies can be gently scraped the same way. Next time you bake the recipe, try using the double baking sheet method (page 271).

An easy way to write Happy Birthday on top of a cake: Add a drop of food coloring to ½ cup Cream Cheese Frosting (page 273) and scrape the frosting into a small heavy-duty Baggie. Cut a tiny hole in one corner of the Baggie and use it as a piping tube. Try practicing by writing on the side of the frosting bowl. You can reuse the frosting that way.

A chilled bowl and beater make whipping cream much easier.

Drinks

White Wine Spritzer

When yuppies discovered they weren't getting a kick from Perrier and lime, they switched to this fairly benign drink.

Fill a wineglass half full with white or rosé wine. Add an equal amount of seltzer (sparkling water) and ice, if desired.

Bloody Mary

Fill a tall glass or goblet half full with tomato or V8 juice. Add the juice of ½ lemon, 1 teaspoon Worcestershire sauce, a dash of Tabasco, and vodka and ice. Some people like to add a celery stick.

You can make the tomato juice mix ahead and add the vodka to each individual glass as you make the drink. This way there will be Virgin Marys available if anyone wants one.

Red Tide Add 1 part clam juice to 2 parts tomato juice and 1 part vodka. Garnish with a boiled shrimp.

Mimosa

This is a terrific drink to serve before brunch since you get your OJ, made festive with the addition of champagne. Don't spend a fortune on the champagne. You can get a nice sparkling Spanish wine for six or seven dollars a bottle.
Yield: 8 to 10 drinks

Just before serving, mix together 2 quarts of chilled orange juice and 1 bottle of chilled sparkling wine or champagne. Serve in wineglasses or goblets.

Irish Coffee

The big trick to making Irish coffee is to pour the hot coffee into a glass and not have the glass explode. Don't use super-hot coffee and don't use a thin glass. A water goblet or beer mug is probably the best way to go. If in doubt, stick a metal spoon into the glass and then pour the coffee in. The spoon will absorb some of the heat.

Fill the glass two-thirds full with coffee (decaf or regular, but use brewed coffee), add a jigger of Irish whisky, and top with whipped cream.

Variations You can make French-inspired coffee by using Grand Marnier, Italian-inspired coffee with Amaretto, or Scotch coffee with Drambuie. You get the picture.

Frozen Daiquiri

You'll need a blender for this.

Preparation time: 15 minutes
Yield: 4 drinks

*1 small can frozen
 lemonade concentrate or
 daiquiri mix
1 small can measure rum,
 dark or light
Fruit of your choice:
1 large banana, sliced
1 cup halved strawberries*

*1 cup raspberries
1 cup sliced mango
1 cup pineapple, either
 fresh or canned, cut in
 chunks
2 ripe peaches, sliced
2 ripe nectarines, sliced
Ice cubes*

Scrape the frozen concentrate or the mix into the blender. Fill the can with rum and pour that into the blender. Add the cut-up fruit of your choice and 5 to 6 ice cubes. Blend for a minute until smooth. Serve immediately in a tall glass.

Hot Mulled Cider

This and a big bowl of pretzels or popcorn is all you need to warm you up and fill you up on a cold winter day.

Preparation time: 10 minutes
Cooking time: about 30 minutes
Yield: 6 to 8 servings
Can be made ahead? Yes. Just reheat when ready to serve.
Can be frozen? No.
Can be doubled and tripled? Yes.
Good for leftover? Yes. Refrigerate, then reheat before serving.

*1 half-gallon (8 cups) apple
 cider
2 cinnamon sticks
6 cloves*

*¾ cup apple brandy or
 apple jack
1 lemon, sliced*

Heat the cider together with the cinnamon sticks and cloves in a large pot. When it comes to a boil, reduce the heat to a simmer, and cook, uncovered, for 30 minutes. Use a slotted spoon to remove any froth or skin.

Continued

With the slotted spoon or a small strainer remove the cinnamon and cloves. Add the apple brandy or apple jack and lemon slices and serve in mugs.

Nonalcoholic Fruit Punch

Don't worry if you don't have a punch bowl. Make this in a soup pot or two pitchers. Serve with a soup ladle. If you prefer herbal tea, substitute it for regular tea.

Preparation time: 20 minutes
Yield: 12 to 16 servings
Can be made ahead? Yes. Up to 8 hours, except for the ginger ale, which should be added just before serving. Store in a covered pitcher in the refrigerator.
Can be frozen? No.
Can be doubled and tripled? Yes.
Good for leftovers? Yes. Will keep for about 3 days, in a covered container in the refrigerator.

1½ cups sugar (superfine, also called "bar sugar," if available)
1 quart hot tea (made with 1 quart boiling water in which 6 tea bags have been steeped for 20 minutes)
1 quart orange juice
1 cup lemon juice (fresh squeezed, not bottled)
1 quart ginger ale
3 oranges, thinly sliced

Add the sugar to the hot tea, stirring, until it is completely dissolved. Add the orange juice and lemon juice, and, just before serving, the ginger ale and orange slices.

Sangria

Sangria was the first wine cooler. It's a great drink to make when you have to serve a crowd. Just double or triple (or more) the recipe.

Preparation time: 15 minutes
Yield: 6 servings
Can be made ahead? Yes. Refrigerate until ready to serve.
Can be frozen? No.
Can be doubled and tripled? Yes.
Good for leftovers? Yes. Refrigerate for up to 3 days. The mixture may turn cloudy, but it's still okay to drink.

*1 orange (seedless, if
 possible), sliced
1 lemon, sliced
1 lime, sliced
1 apple, sliced*

*2 tablespoons sugar
 (superfine, if possible)
⅓ cup brandy
3 cups dry red wine*

Place all the ingredients in a large pitcher. Stir to dissolve the sugar. Refrigerate for several hours before serving.

Cookbook Shelf

If I've done a good enough job and inspired you to continue cooking, you should reach beyond these basic recipes to more challenging dishes. Here's a list of my favorite cookbooks to guide you in expanding your culinary repertoire.

General Cookbooks

Rombauer, Irma S., and Marion Rombauer Becker. *Joy of Cooking*. New York: Bobbs Merrill, 1975. Available in hardcover and paperback editions.

Child, Julia. *How to Cook*. New York: Alfred A. Knopf, 1989.

Claiborne, Craig. *The New New York Times Cookbook*. New York: Times Books, 1979.

Cunningham, Marion. *The Fannie Farmer Cookbook*. New York: Alfred A. Knopf, 1990.

Kitchen Science

Hillman, Howard. *Kitchen Science*. Boston: Houghton Mifflin, 1989.

McGee, Harold. *On Food and Cooking*. New York: Charles Scribner's Sons, 1984.

Health and Nutrition

Brody, Jane. *Jane Brody's Nutrition Book*. New York: W. W. Norton, 1981.

———. *Jane Brody's Good Food Gourmet*. New York: W. W. Norton, 1990.

Vegetable and Vegetarian Cooking

Morash, Marion. *The Victory Garden Cookbook*. New York: Alfred A. Knopf, 1982.

Katzen, Molly. *The Moosewood Cookbook*. Berkeley, Calif.: Ten Speed Press, 1974.

———. *Enchanted Broccoli Forest*. Berkeley, Calif.: Ten Speed Press, 1982.

Microwave Cooking

Kafka, Barbara. *Microwave Gourmet*. New York: William Morrow, 1987.

Bread Baking

Beard, James. *Beard on Bread*. New York: Alfred A. Knopf, 1988.

Desserts

Heatter, Maida. *Maida Heatter's Book of Great Desserts*. New York: Alfred A. Knopf, 1974.

Beranbaum, Rose Levy. *The Cake Bible*. New York: William Morrow, 1988.

Index

Page numbers in **bold type** refer to recipes.

298

300

307